P9-EGD-606

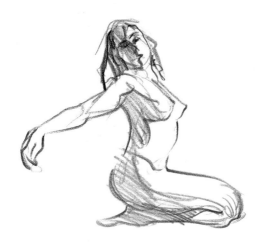

THE BIG BOOK OF THE
HUMAN
FIGURE

WITHDRAWN

BARRON'S

First edition for the United States, its territories
and dependencies, and Canada published in 2013
by Barron's Educational Series, Inc.

English-language translation © copyright 2013 by Barron's
Educational Series, Inc.
English translation by Michael Brunelle and Beatriz Cortabbaria

Original Spanish title: *El Gran Libro de la Figura Humana*
© Copyright 2013 by ParramónPaidotribo—World Rights
Published by Parramón Paidotribo, S.L., Badalona, Spain

All rights reserved.
No part of this publication may be reproduced or
distributed in any form or by any means without the
written permission of the copyright owner.

All inquiries should be addressed to:
Barron's Educational Series, Inc.
250 Wireless Boulevard
Hauppauge, NY 11788
www.barronseduc.com

ISBN: 978-1-4380-0343-6

Library of Congress Control Number: 2013930078

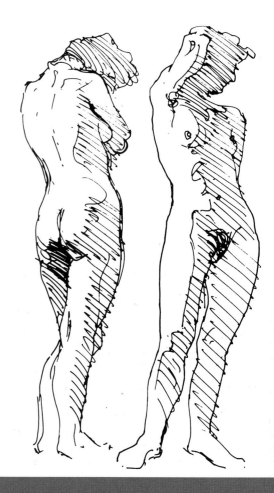

Production: Sagrafic, S.L.
Editorial Director: Maria Fernanda Canal
Editors: Mari Carmen Ramos and Tomás Ubach
Text: Gabriel Martín Roig
Exercises: Gabriel Martín and Óscar Sanchis
Collection Design: Toni Inglés
Photography: Estudi Nos & Soto
Layout: Toni Inglés

Printed in China
9 8 7 6 5 4 3 2 1

THE BIG BOOK OF THE
HUMAN FIGURE

BARRON'S

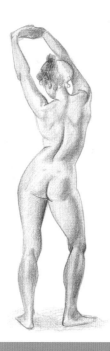

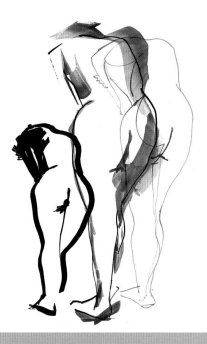

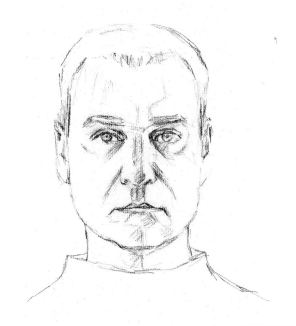

INTERPRETING THE FIGURE 104

ANALYZING THE PORTRAIT 136

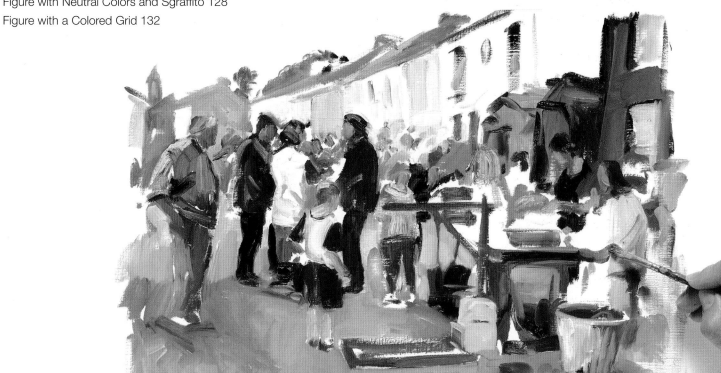

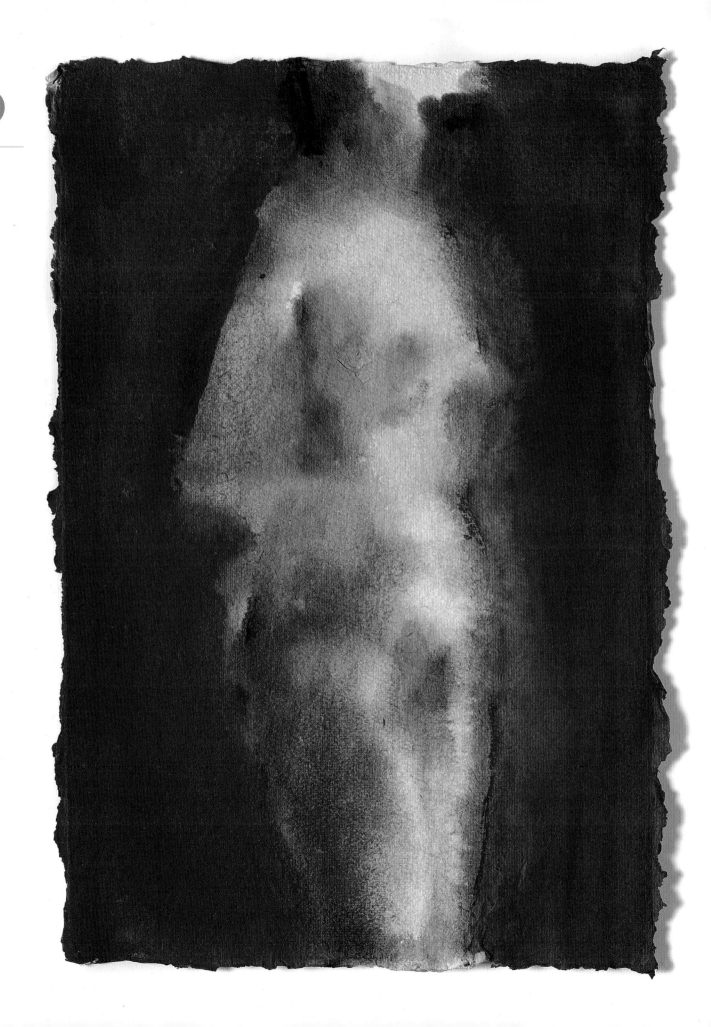

The Human Figure:
A Great Challenge for Artists

Throughout history, the ability to represent the human figure has inspired admiration for the most well-known artists, which shows how very relevant this skill is. Perhaps it is for this reason that it has always played an important part in all academic and apprenticeship programs. Drawing the model from life is a basic practice for art students because it activates their skills of observation and at the same time helps them develop all the techniques that will help them create an accurate representation. The human figure, along with the portrait, is one of the most difficult genres because it requires the artist to make use of all his or her skills and knowledge. Without a doubt, a person who is able to correctly draw a nude human figure can easily depict any other artistic theme.

Representing the human body is a complex exercise, which requires a good understanding of the forms and many hours of practice. The artist must concentrate on resolving the structure, the anatomy of the figure, and apply some general proportions to the body that allow little margin for error. The challenge of drawing the human figure is greater than that posed by other subjects, mainly because it demands extreme precision and because errors and inaccuracies cannot be hidden. When drawing a tree it is not very important to follow its exact shape since it does not depend on specific proportions, and the viewer is not bothered by a larger or a smaller branch because variations in size and shape are typical in nature. However, the human figure requires a more convincing reality, and any small mistake in proportion or detail is easy to observe.

It is not always necessary to draw a disciplined academic figure to achieve a convincing representation. You can also elect to make a loose, spontaneous, and emotive interpretation. However, to make a convincing loosely sketched subject, the artist must have a basic anatomical knowledge of the model. There always exists an esthetic, artistic intention that goes farther than a simple random representation or distortion of the subject. In other words, no matter how suggestive or moving the representation, the human content is unavoidable and comparisons made by the viewer are unavoidable.

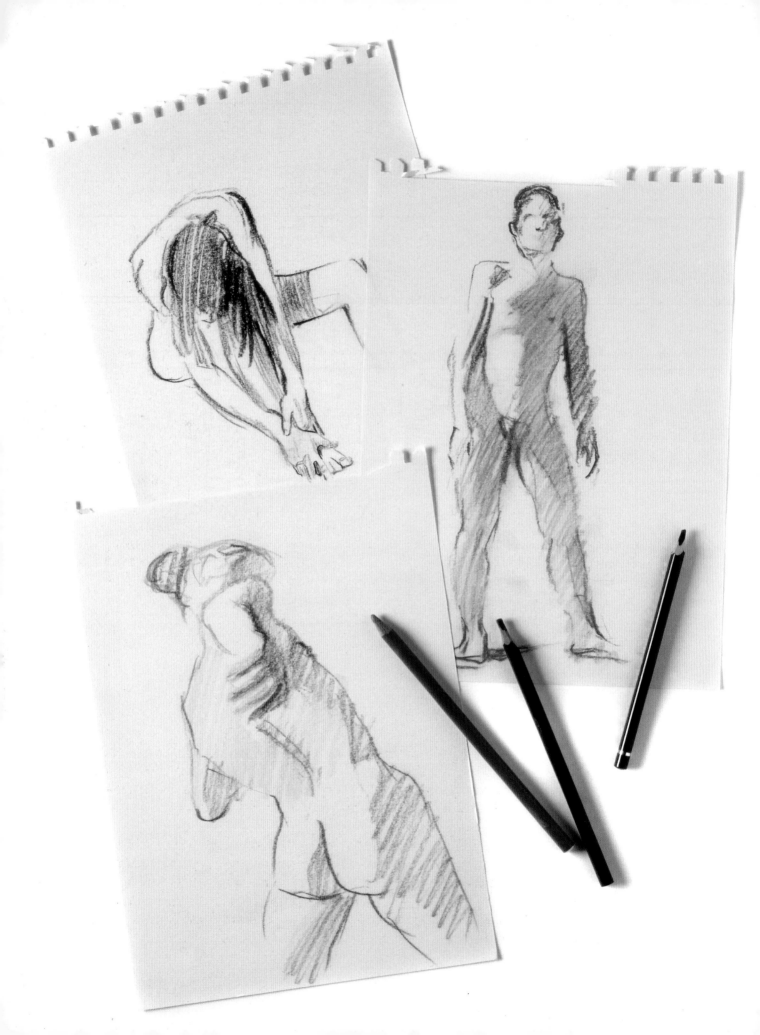

Understanding the Human Figure

The human figure is a volume with a solid structure, subject to specific measurements that establish an overall harmony. Your drawing must be well planned, it should contain a rational and understandable order, and the basic natural structures of the body must be translated, adjusted, and identified in a way that comes together in a harmonious manner.

In this section we will start right at the beginning, studying the structure, the proportions, and the synthesis of the human figure, to give beginning artists a general guideline to follow that will aid their understanding and help them create an appropriate representation. To do this, we will establish a minimal number of basic rules or precepts that will help you draw a balanced and coherent figure. The principles taught here are not blindly followed by all draftsmen and painters, but they are a very useful reference for approaching the genre with a guarantee of success.

Eugène Delacroix (1798–1863), *Page Of Sketches*. Synthesizing the figure is a very useful approach for the draftsman because it allows him or her to quickly represent any model in just a few seconds.

Structure and **Representation**

Without a basic knowledge of the proportions of the human body, anatomy, the construction of the parts, the effects of light and shadow on the flesh, and a deep analysis based on studies and sketches, it is practically impossible to draw or paint the human body.

But this does not mean that prolonged exhaustive scientific study of the bones and muscles is needed to be able to accurately represent the figure. This book approaches the difficulties posed in drawing the body with sketches and simple shapes that describe the artistic anatomy, using structures that create a recognizable and convincing image of the model. We make use of some diagrams that can be employed to reference the most important points of the figure, paying attention to the proportions to ensure a correct balance between the different components.

The Three Phases in Drawing the Figure

Understanding the human figure can be boiled down to three essential steps. The first consists of careful observation of the model to achieve an approximate representation, capturing the form and structure. In the second phase the anatomical knowledge of the artist is put to the test; the previously drawn shapes are modified and adjusted to accurately adhere to our understanding of human physiology. The third phase consists of adding artistic expression, that is, selecting what to emphasize and what to ignore so we can avoid creating an exercise that is too academic, and instead create a fresh, spontaneous, and emotional representation, which will be seen as the artist's personal interpretation.

The Articulated Mannequin

Having a small wood mannequin with articulated parts allows the artist to become familiar with the proportions of the figure and with its structure. Each part approximates the real volumes of the human body, and manipulating the parts helps the artist understand the structure of the figure, acting like a three-dimensional sketch.

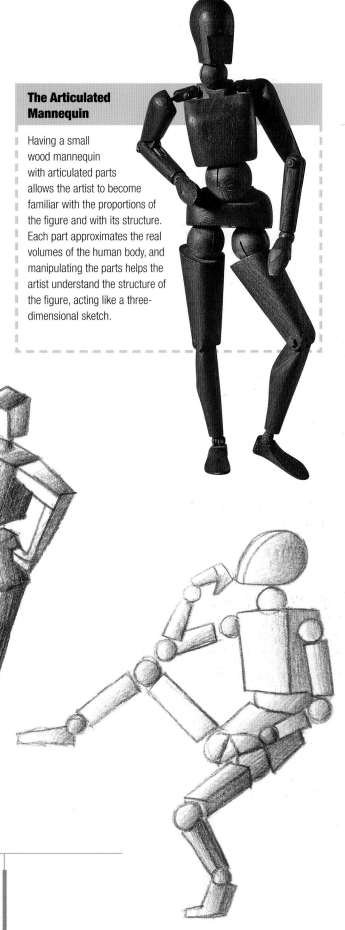

Different approaches to illustrating the body based on simple geometric shapes. Adding light shading will create a sense of volume.

Basic
Human Proportions

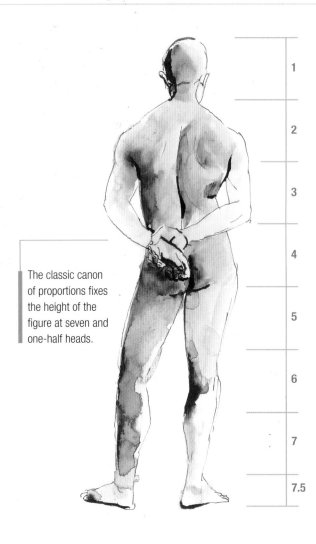

The classic canon of proportions fixes the height of the figure at seven and one-half heads.

To correctly begin a study of the nude figure, it is necessary to establish some general guidelines that allow you to address any type of figure based on a system of proportions. This system can be understood as a group of dimensional relationships at each part of the body in relation to the entire figure that make it possible to routinely deduce measurements and dimensions of the body. There is a canon for the male figure and one for the female, both shown in a standing pose.

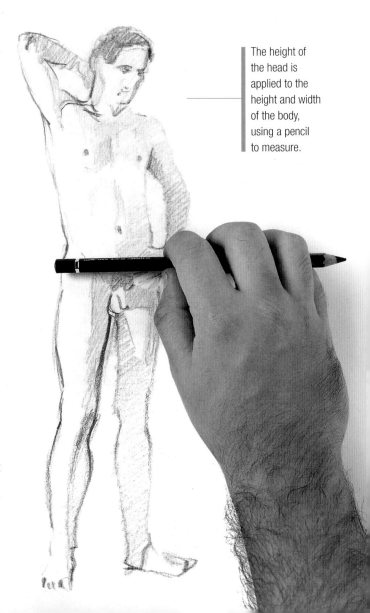

The height of the head is applied to the height and width of the body, using a pencil to measure.

The Canon of Proportions

The guidelines used for drawing a well-proportioned human figure originated as a canon or measuring system that originated in Classical Greece and has endured until the present day. According to this canon, the basic unit of measurement is the length of the head, which establishes a segment called a module. Thus, the height of the entire figure measures eight times the module and the width measures two, although in reality a height of seven and a half modules is more natural. This modular system allows you to also reference other important points that are a great help in understanding the anatomy and representing the figure: the position of the armpits, the navel, the nipples, the waist, the elbows, the pelvis, and the knees, that coincide with divisions indicated in the modular system of proportions.

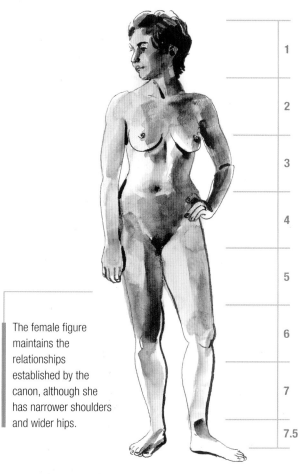

The female figure maintains the relationships established by the canon, although she has narrower shoulders and wider hips.

The Female Form

The morphological differences between the male figure and the female figure are mainly seen in her narrower shoulders and wider pelvis. Her height is a few inches shorter, but it also follows the canon of seven and a half heads in height. Other differences that must be mentioned are the breasts, which are somewhat lower than a man's; the waist, which is narrower than a man's; and the curve of the back, which is a bit more pronounced, and because of this the buttocks stand out more.

THE CANON IS A VERY STANDARDIZED VIEW OF THE BODY; IT DOES NOT CORRESPOND TO ANY PARTICULAR INDIVIDUAL BUT EXEMPLIFIES THE GENERAL IDEA OF THE MAN OR WOMAN.

The Child's Figure

The child's anatomy is characterized by a larger head with respect to the body. At around two years of age the total height of the child is four times the head, and the legs appear quite short. At five years the head continues to be very large proportionally, and the height is five modules. In the preadolescent, the height is six heads, and the midpoint of the body descends to the height of the pubic bone. Aside from the proportions, the drawing of the child's figure should have rounded forms, avoiding lines that are angular or too straight.

As a child develops, his or her head diminishes in size and the midpoint of the body moves downward from the stomach.

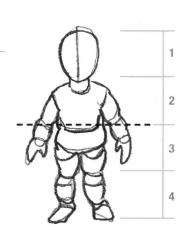

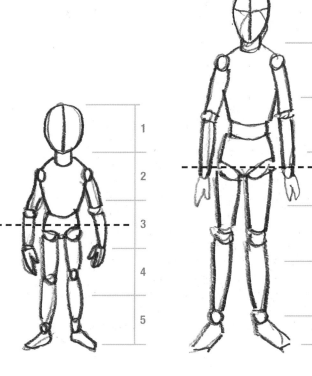

Basic Anatomy
of the Human Body

Many artists, who know nothing about anatomy, have been able to create perfect figures by just observing and interpreting the live model. But if the figure is going to be a recurring theme in your work, it will not hurt to have a basic understanding of artistic anatomy. In this section we present the internal structure of the human figure as an articulated whole and explain some strategies for transforming the complex anatomical forms into simpler ones that are easy to remember and reproduce. If you have no experience in drawing human anatomy, this manner of interpreting the figure will make it easier and simpler to sketch.

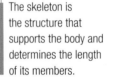

The skeleton is the structure that supports the body and determines the length of its members.

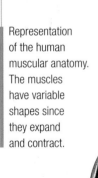

Representation of the human muscular anatomy. The muscles have variable shapes since they expand and contract.

Bone Structure

The skeleton is a structure of articulated bones that supports the body and protects the most vital internal organs. To draw the human body, it is not necessary to remember the shapes of all the bones, just the cranium, the hands, the rib cage, and the small bones of the feet. The longest bones are completely covered by muscles and can barely be seen. However, it is necessary to know their lengths and where they articulate, which coincides with folds and wrinkles in the skin.

The Muscles of the Body

The muscles are fibrous, meaty masses that move the body when they expand and contract. They cover all the bones, overlapping and interweaving with each other, which sometimes makes them difficult to identify and understand. The shapes we can see on the surface of the body result from the muscle masses, even the deepest ones, although the ones closest to the surface are of greatest interest to artists. A man will always have larger and more pronounced musculature than a woman, since the female body has a layer of subcutaneous fat that softens and smoothes the external shapes.

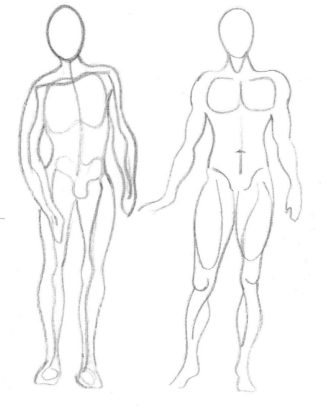

The figure is constructed by combining the internal structure of the skeleton with the exterior relief or topography added by the muscles.

A Synthetic Interpretation

Each muscle has a characteristic form that is useful to remember, at least in a simplified way, since the muscles affect the exterior aspect of the figure. A good strategy for remembering them is seeing them as simple shapes, separate pieces that fit together in the form of a puzzle. Then you can draw the outline of the body, which is determined by the relief of the muscle mass. You should carefully study the shapes made by curves in the outlines of the male and female figures; in the latter the arm and forearm are constructed with curves that narrow at the wrist and again at the elbow, while the waist forms a large outward curve that ends just above the knee.

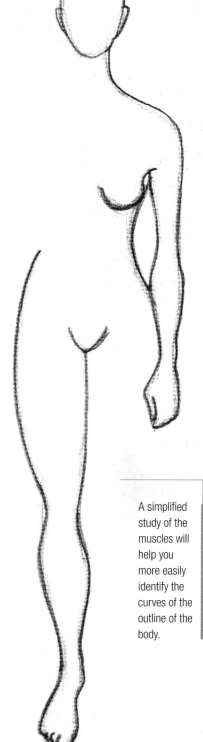

A simplified study of the muscles will help you more easily identify the curves of the outline of the body.

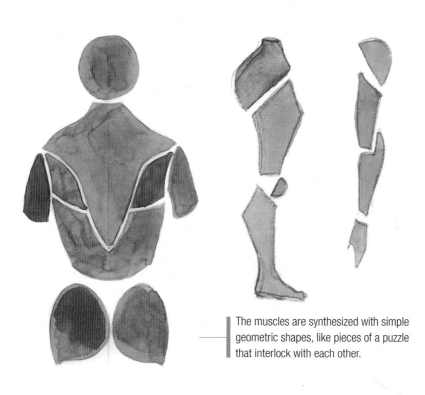

The muscles are synthesized with simple geometric shapes, like pieces of a puzzle that interlock with each other.

Constructing the Head

The head is the part of the body that is most intimidating for the artist, and a precise and accurate drawing of a head can only be made by the most able artists. But if you disregard the necessity of creating a likeness in the portrait, and follow a few specific parameters in constructing and understanding the head as a volume, it becomes quite simple. You just have to study it as one more form of the anatomy, based on a few simple proportions that will confer a human appearance to men and women alike.

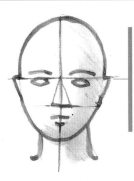

An oval and a vertical axis are the main references for drawing a simplified head.

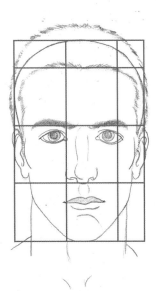

The canon tells us that the human head is three and a half modules high by two and a half wide.

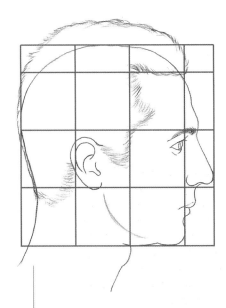

The head in profile is drawn in a grid that is three and a half modules high by three and a half wide. The base of the nose coincides with the ears.

The Head in a Few Lines

Making a simplified drawing of the head is very simple. Seen from the front, the head is oval, while from the side it is somewhat rounder. In the front view, if you draw a vertical line that divides the face in two you will have an axis of symmetry that will help you sketch in the features in proportion. The facial features are marked with horizontal lines that correspond to the hairline, the eyes, the nose, and the mouth.

Structure and Proportions

When faced with how high to place the eyes, mouth, and nose, artists can be assailed by all kinds of doubt, but this will pass when they consult the canon for the human face. The proportions of the face are equivalent to three and a half times the height of the forehead (from the hairline to the eyebrows) by two and a half times the width. Dividing the lower module in two halves will give you the lower line of the mouth. The size of the eyes is equal to the space between them, the width of the nose. The head in profile is more rounded and can be framed in a grid of three and a half modules. The same horizontal divisions applied to the front of the head are also seen on the profile, keeping in mind that the modules are identical in size to those used for the front view of the head.

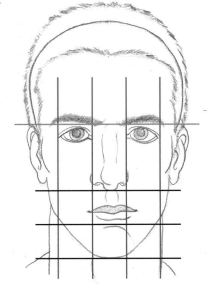

Notice that the distance between the two eyes is equal to the width of one eye, and that the bottom of the lower lip coincides with the line that divides the lower module.

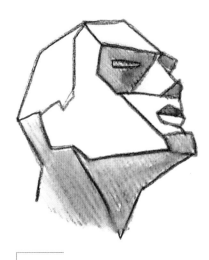

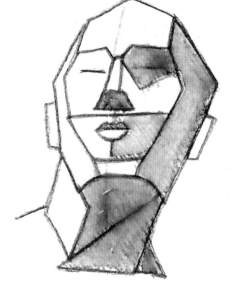

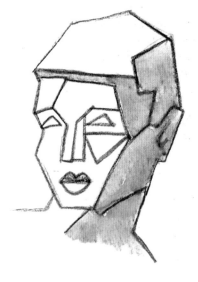

One way to understand the structure of the head and its volume is to draw it as a geometric object, shading the faces that are exposed to the least amount of light.

Volumetric Planes

Constructing a head with geometric planes is a simple exercise in synthesis that will help you better understand its structure, volume, and shading. The rounded forms completely disappear, and the straight sides and edges give the face an almost robotic appearance. This work of constructing with geometric shapes is completed with light shading, which can be a great help when representing the skin tones. The exercise is very similar to shading a polyhedron where the shading is a tonal gradation of flesh tones. The planes that receive the most light will be a light pink color, while those on the opposite side are dark brown. Logically, the areas with hair would be a different color from the face, and the hollows like the eyes and the side of the nose would appear darker.

THE PSYCHOLOGICAL CONTENT OF THE FIGURE IS FUNDAMENTALLY LIMITED TO THE FACE; THEREFORE, THE ARTIST MUST BE ESPECIALLY ATTENTIVE AND SENSITIVE IN DRAWING IT.

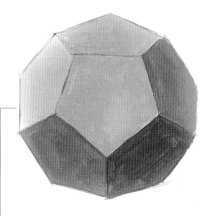

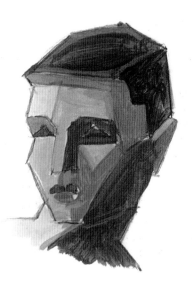

A polyhedron is a good reference for understanding how the planes of the head are constructed and how the light falls on them.

Shade the heads based on the polyhedron, using the same principle of light and dark tones.

Drawing the Trunk and the Back

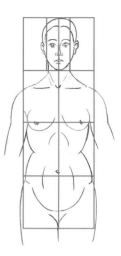

To understand the human torso, you must pay close attention to the divisions of the canon that coincide with specific points or areas of relief (nipples, navel, pubic bone). First, you must establish a vertical axis that divides the torso in two symmetrical halves; then, following the references given in the modules, add the most important anatomical features. The study of these measurements is important for achieving a well-proportioned drawing.

The male torso seen from the front has three modules. The proportion of the female trunk is similar to that of the man, with slight variations in the fullness and anatomical placement.

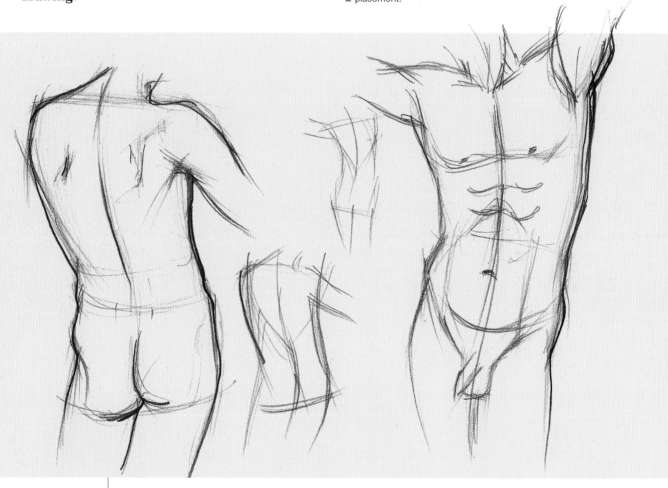

The neck adds great expressiveness to the torso; therefore, it is usually drawn inclined to break the symmetry of the spinal column.

Front View of the Trunk

The trunk occupies three modules of the academic canon, that is, it is equivalent to the height of three heads. In the masculine figure, the uppermost module corresponds to the neck and the pectoral muscles; the middle module begins at the lower line of the pectorals and ends at the navel; while the lowest consists of the space between the navel and the pubic bone. This distribution also exists in the female figure, with the difference that the breasts usually surpass the line of the uppermost module, and the torso is narrower. The masculine trunk is bulky and muscled, while the feminine trunk is rounded and has a sinuous outline that is expressed with a continuous line.

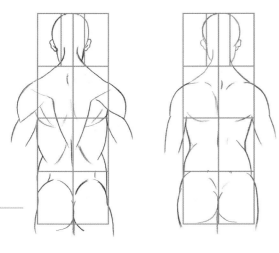

These are the main anatomical shapes of the male torso seen from behind. It is a good idea to identify them and see where they fit in each module. To the right is the female torso from behind with its basic anatomical references. Notice that her outline is more rounded than that of the male.

Back View of the Trunk

After analyzing the sketches of the rear view of the human body, you will see that the spinal column establishes an axis of symmetry in the body and creates the line on which the basic lines are established, remembering that the upper module contains the lower part of the neck to the shoulder blades. These create the most relief in the back, and they become more pronounced when the model has his or her arms open. The center module begins at the base of the shoulder blades and ends just below the waist. It is better defined in the front view than in the back, where it continues to the lower lumbar region. The third and lowest module frames the gluteus muscles.

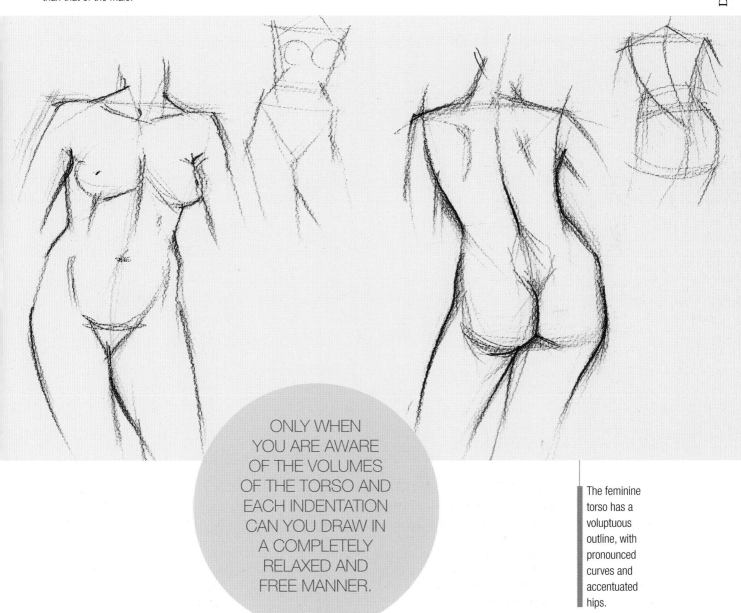

ONLY WHEN YOU ARE AWARE OF THE VOLUMES OF THE TORSO AND EACH INDENTATION CAN YOU DRAW IN A COMPLETELY RELAXED AND FREE MANNER.

The feminine torso has a voluptuous outline, with pronounced curves and accentuated hips.

Drawing **the Extremities**

Drawing the arms and the legs entails some difficulties that can be overcome with the use of a well-proportioned sketch. The main references of the arm are contained in a diagram of six modules. The elbow is exactly in the middle, while the wrist coincides with the upper edge of the lowest module. The leg can be diagrammed using four modules, with the knee exactly in the midpoint of the entire length. Using the modules that are shown here, along with a model or a photograph, you can create anatomically correct drawings.

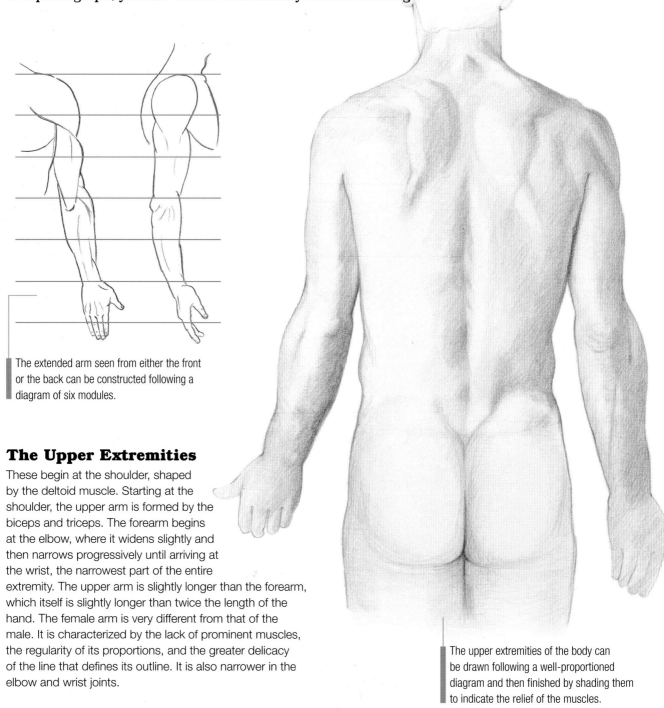

The extended arm seen from either the front or the back can be constructed following a diagram of six modules.

The Upper Extremities

These begin at the shoulder, shaped by the deltoid muscle. Starting at the shoulder, the upper arm is formed by the biceps and triceps. The forearm begins at the elbow, where it widens slightly and then narrows progressively until arriving at the wrist, the narrowest part of the entire extremity. The upper arm is slightly longer than the forearm, which itself is slightly longer than twice the length of the hand. The female arm is very different from that of the male. It is characterized by the lack of prominent muscles, the regularity of its proportions, and the greater delicacy of the line that defines its outline. It is also narrower in the elbow and wrist joints.

The upper extremities of the body can be drawn following a well-proportioned diagram and then finished by shading them to indicate the relief of the muscles.

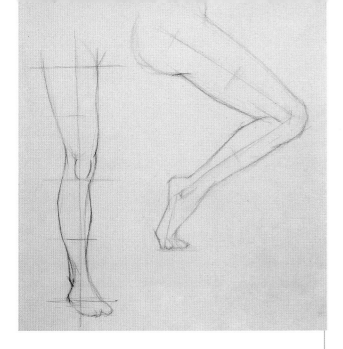

The Muscles of the Leg

The lower extremities essentially have two main parts: the thigh, consisting of the quadriceps and the sartorius, the largest and most prominent of the body; and the calf with its characteristic mass created by the tibialis and the gastroenemius muscles. Between these two parts is the knee, the articulation point that should be drawn with a prominent rounded shape. In women the thigh is narrower and the outlines softer and not as pronounced, and the circle of the knee barely stands out. The calf is not as large as the thigh, and the ankles are even thinner. Women's calves are not very prominent, but they become more rounded if they are wearing shoes with high heels.

The leg can be drawn using a vertical axis that runs its entire length. The divisions can be marked along it. When the leg is flexed the relationships between the proportions do not change; you can simply bend the axis at the knee.

The thigh is constructed with two full curves that converge at the knee, while the gastroenemius muscles cause the curve of the calf to stand out.

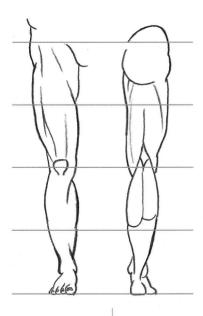

This illustration shows the modular diagram of the leg in front and rear views.

The quadriceps and calves are very prominent in the male figure.

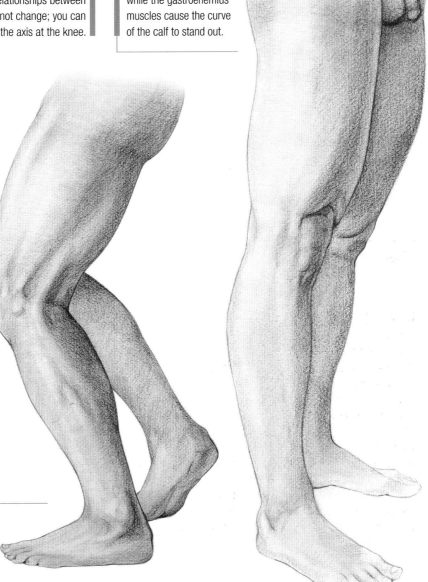

UNDERSTANDING THE HUMAN FIGURE
STRUCTURE AND REPRESENTATION

Drawing the **Hands and Feet**

The hands can be just as expressive as the face; for example, through gestures they can clearly communicate psychological suggestions to the viewer. In addition, they can be drawn in a very great number of different positions. Drawing the feet is less complicated than drawing the hands, since they are not able to move as much and are usually hidden by shoes. On the other hand, when they are visible, the way they look changes dramatically according to the angle at which they are seen and what action they are fulfilling, all of which tends to confuse more inexperienced artists.

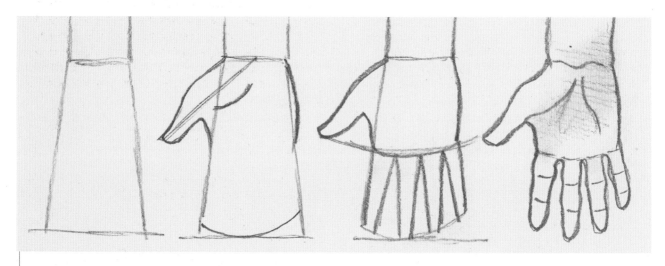

It is helpful to make a geometric sketch before beginning the definitive drawing. This will help you understand the structure and create a well-proportioned hand.

Structure and Synthesis of the Hand

The hand is attached to the arm by the carpal bones, and it is their bone structure that gives the wrist its characteristic form. You must consider two sides, the dorsal where the tendons and muscles of the forearm connect, and the palm, formed by numerous small fleshy muscles. The lines in the palm of the hand are useful for reinforcing the three-dimensional aspect of these padded areas. Each finger consists of three small bones, except for the thumb, which has two, and all of them can be articulated. When drawing the hand, we recommend blocking it in first using rectangular and geometric shapes. Draw the curve described by the fingers that open in a fan pattern. The thumb projects diagonally from the palm of the hand and has a clear curved tendency. If the sketch is well proportioned, it will be easy to continue adding details until the drawing is completed.

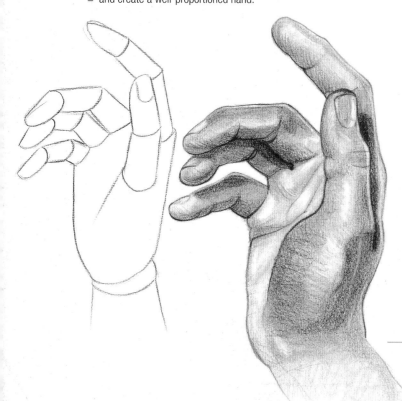

The hand is blocked in with cylindrical forms, with attention to each of the articulated divisions of the fingers. After this, the model can be adjusted to a more realistic representation before shading is added.

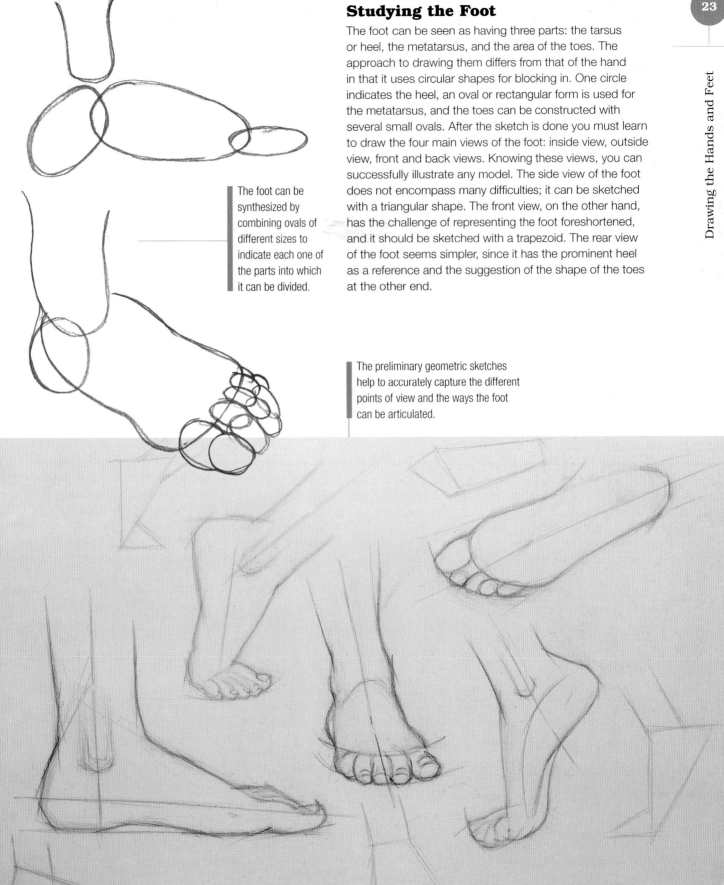

Studying the Foot

The foot can be seen as having three parts: the tarsus or heel, the metatarsus, and the area of the toes. The approach to drawing them differs from that of the hand in that it uses circular shapes for blocking in. One circle indicates the heel, an oval or rectangular form is used for the metatarsus, and the toes can be constructed with several small ovals. After the sketch is done you must learn to draw the four main views of the foot: inside view, outside view, front and back views. Knowing these views, you can successfully illustrate any model. The side view of the foot does not encompass many difficulties; it can be sketched with a triangular shape. The front view, on the other hand, has the challenge of representing the foot foreshortened, and it should be sketched with a trapezoid. The rear view of the foot seems simpler, since it has the prominent heel as a reference and the suggestion of the shape of the toes at the other end.

The foot can be synthesized by combining ovals of different sizes to indicate each one of the parts into which it can be divided.

The preliminary geometric sketches help to accurately capture the different points of view and the ways the foot can be articulated.

Blocking-in Simple Shapes

For artists with little experience, blocking-in a figure is usually a complicated subject; however, with just a few pointers this task will become easier. Blocking-in is the very simple and concise representation of the model that is the first step in creating a more detailed and definitive drawing. The blocking-in phase should resolve questions like framing, the space that the figure occupies on the paper and indicating the proportions, that is to say, the correct proportion of the figure.

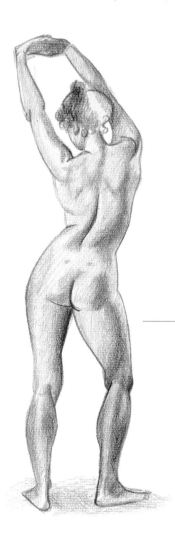

The synthesis of the form almost always suggests a general diagram in which a simple geometric shape can be inscribed.

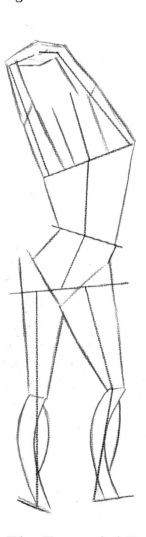

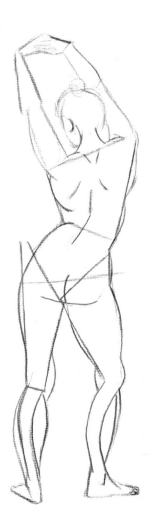

Developing the figure drawing: sketch the figure, keeping in mind the angles of the lines of the shoulders, the waist, and the hips; draw the outline with curved lines that follow the anatomy; and finally, suggest the volume with a premliminary application of shading.

The Essential Form

The preliminary sketch should intuitively capture the most important characteristics of the form, viewing the figure as a whole without getting lost in anatomical details and irrelevant aspects like the waviness of the hair or folds in the skin. It is a matter of capturing the most outstanding characteristics in a first sketch, leaving the esthetics for a later phase. It should express the structural characteristics and the attitude of the figure. These initial marks should be very lightly sketched; they should suggest the position and the dimension of each part of the body as well as the total height of the model. When you work with a light line, it is easy to erase and correct; when you construct the sketch the lines should be modified as many times as necessary until you arrive at the definitive form.

Simply blocking-in the figure with geometric shapes will create a preliminary figure that can be developed into a more definitive form.

Developing the Figure

As you create the sketch, you can set up a series of measuring points that will help capture the gesture of the body. You can indicate the slant of the shoulders, the lines of the waist and hips, and even some straight lines that will help show the internal structure of the body. After you have drawn the preliminary sketch using simple and stylized shapes and it seems that the proportions are realistic, you can begin the next phase: working on the characteristic forms of the anatomy of the figure with more careful, curving lines, ensuring that the new lines coincide with the preliminary sketch, and reproducing the undulating ins and outs at every part of the body to make its outline more understandable. The drawing can then be completed by modeling the parts with a simple play of light and shadow, highlighting the muscles to achieve a true sense of volume in the figure.

THE FIRST STEP IN BLOCKING-IN THE FIGURES IS TO INDICATE THE PROPORTIONS WITH SIMPLE SHAPES.

To block-in the figure look for internal rhythms and directions and reproduce them as if the figure were an abstract form.

To ensure a good sketch, an artist will make use of the pronounced curvature described by the spinal column, without forgetting the lines of the muscles.

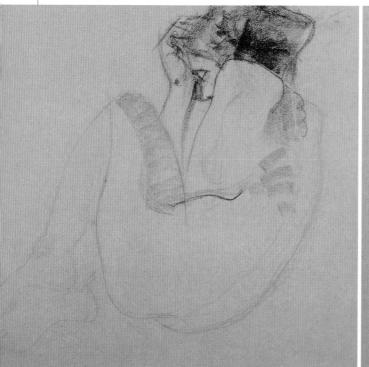

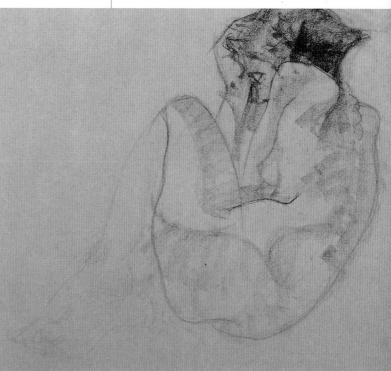

Understanding the **Pose**

The pose is determined by the areas of tension between the different parts of the body and by the feeling of balance transmitted by them. Although it is evident that a representation of a reclining, seated, or standing figure is generally static, many poses have an implicit effect of movement in a nude that is leaning or twisting his body or holding his arms and legs in a certain manner.

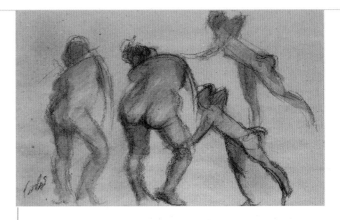

For an amateur to understand and capture a pose requires constant practice and a lot of trial and error.

Observing the Lines of the Body

When drawing the nude, you must first decide on the point of view; this means observing the model from different angles to find the most favorable angle. You will see that some postures better describe the male figure while others favor the female figure. After you have decided on a point of view, carefully observe the model to identify his or her pose, the position of the torso, which leg supports the weight of the body, which member is more in tension and which is more relaxed. It is important to observe the internal rhythms of the figure, whether it is active or in repose, evaluate the position of the pelvis and the spinal column, and understand how the external forms respond to the movement. This movement should respond to a natural gesture; otherwise, the false and artificial position will immediately be perceived as a defect in the form.

The position adopted by the parts of the body is important for converting an apparently static seated pose into a rhythmic composition that is full of tension.

The parts of the body twist to create more interest and avoid a static pose.

Capturing the Energy

Defining the slant of the shoulders, the waist, and the hips and adapting the extremities to the directions of the body can capture the essential gesture of the pose, casually suggesting its intention or movement. However, capturing the pose will be less mechanical if you are able to add rhythm and energy to the figure, that is, capturing its movement. All static poses have movement; this apparent contradiction is based on the fact that the members of the body give away an internal movement with their twists and turns. This means that when you draw, you can more strongly emphasize the pose by adding a certain amount of deformation with a more pronounced curve, more of a slant to the line of the shoulders, and so on, without going as far as to make it too exaggerated or even grotesque. It is a matter of strengthening the dynamic tensions contained in the figure so that the pose will be clearly visible.

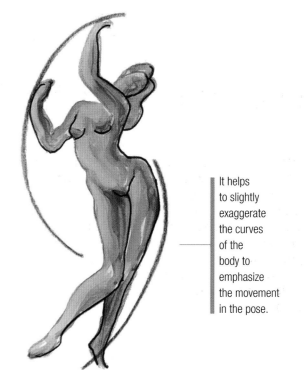

It helps to slightly exaggerate the curves of the body to emphasize the movement in the pose.

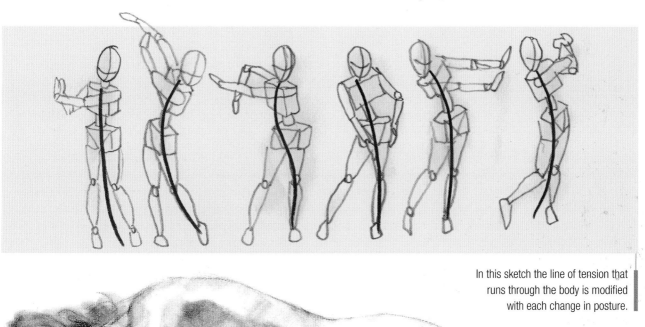

In this sketch the line of tension that runs through the body is modified with each change in posture.

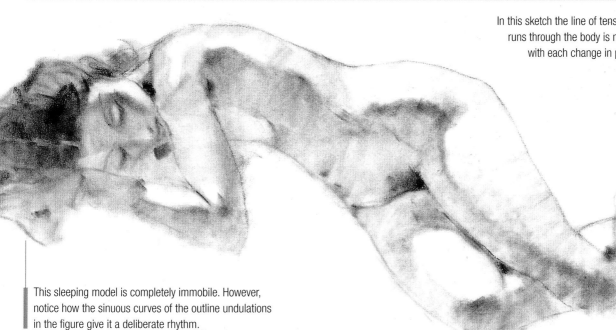

This sleeping model is completely immobile. However, notice how the sinuous curves of the outline undulations in the figure give it a deliberate rhythm.

The Nude:
Preliminary Sketch and Line Work

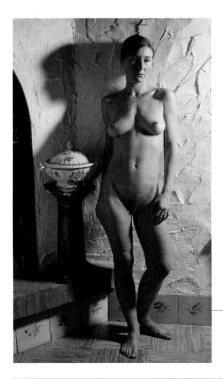

After you have studied the different parts of the body and have analyzed its structure, it will be time to put into practice some of the concepts you have learned, even if in a very simple way. The objective is to represent a female figure in a very sketchy manner with a burnt umber pastel crayon and a blending stick. Make a linear drawing that later will be completed with very flat, stylized shading that will help reinforce some shapes and illustrate the volumes of the figure. The composition of the drawing will not present a problem; the figure is centered on the paper, allowing you to adjust its proportions with no distortion.

The nude figure, next to a ceramic pot on a small column.

First block in the figure with a very light line, with slight pressure that will not make an indentation in the paper.

Rub the pastel stick on a piece of paper; then rub the tip of the blending stick in the powder and use it to lightly apply the preliminary shading.

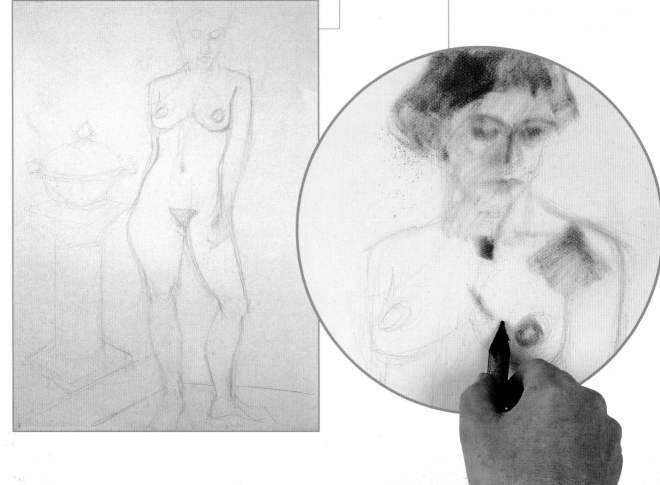

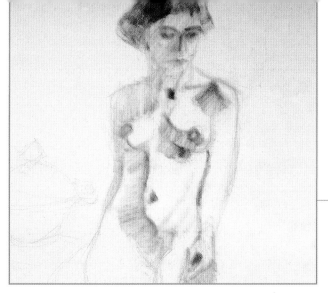

Continue using the blending stick as if it were a pastel stick. Use the tip to emphasize the outline of the figure and hold it at an angle to shade.

Drawing with the Blending Stick

The blending stick is a paper cylinder that is very useful for shading with some dry drawing media, but it can also be used as a drawing instrument. By impregnating the tip with pigment you can make light, diffused lines on fine-grained paper. First, rub a pastel stick on a piece of paper; then pick up the powdered pigment with the tip of the blending stick to charge it. When it has enough powdered color, you can make more intense lines and shading, and as you use the stick, the shading becomes more faint and delicate.

To draw with the blending stick you must first dirty the tip. This is done by vigorously rubbing lines made with a pastel stick.

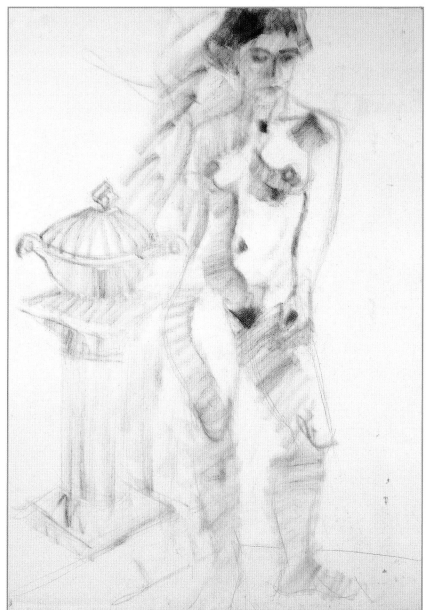

After going over the drawing with a pencil and adding some shading with the blending stick, you have a first general impression of the model. The ceramic pot does not require very much detail so it is left as a simple sketch.

Standing Figure in **Contraposto**

Rarely is the representation of a figure symmetrical; for any artist it is much more interesting to draw it a little off-center. The standing or seated contraposto posture is often used to break the symmetry and give the figure a certain rhythm. It is characterized by a lean in the opposite direction of the lines of the hips and shoulders, because the weight of the body rests on a single leg while the other seems relaxed. In the following exercise we show you how to proceed with a drawing of the male figure.

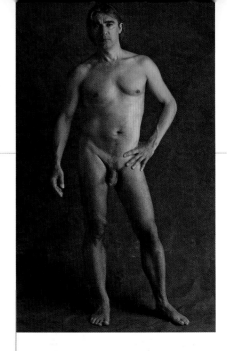

The contraposto is a resting position; in it the entire weight of the body is supported on one leg.

The relationship between the contracting and relaxing of the muscles in the figure determines the variation, the alternation of its external form, making the pose more interesting and balanced.

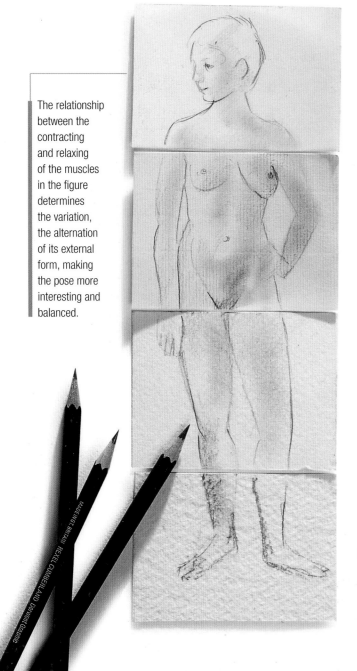

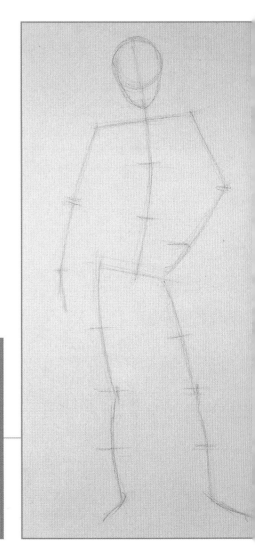

Before drawing you must construct the figure, synthesizing the skeleton with lines that define the slant of the shoulders, the line of the hips, and the slight curve described by the spinal column.

MADE IN GT BRITAIN REXEL CUMBERLAND DERWENT GRAPHIC

The Spinal Column, Axis of the Body

The pelvis is connected to the rib cage, the clavicles, and the shoulder blades by the spinal column, creating the axis of the body. This suggests that any inclination of the pelvis will affect the inclination of the shoulders (in the opposite direction), thus creating rhythm in the body.

Use a blending stick to lightly soften the lines made with a graphite pencil so they will not be so evident. This will create gradual shading that does not contrast too much.

Construct the body over the previous lines, making sure the parts of the body line up. The forms should be well proportioned, the outline drawn with slight curves that describe the male musculature.

After the line drawing is concluded, apply light shading to the figure with the side of the point of a graphite pencil so that the main masses can be seen. The lightest areas are left as the color of the paper.

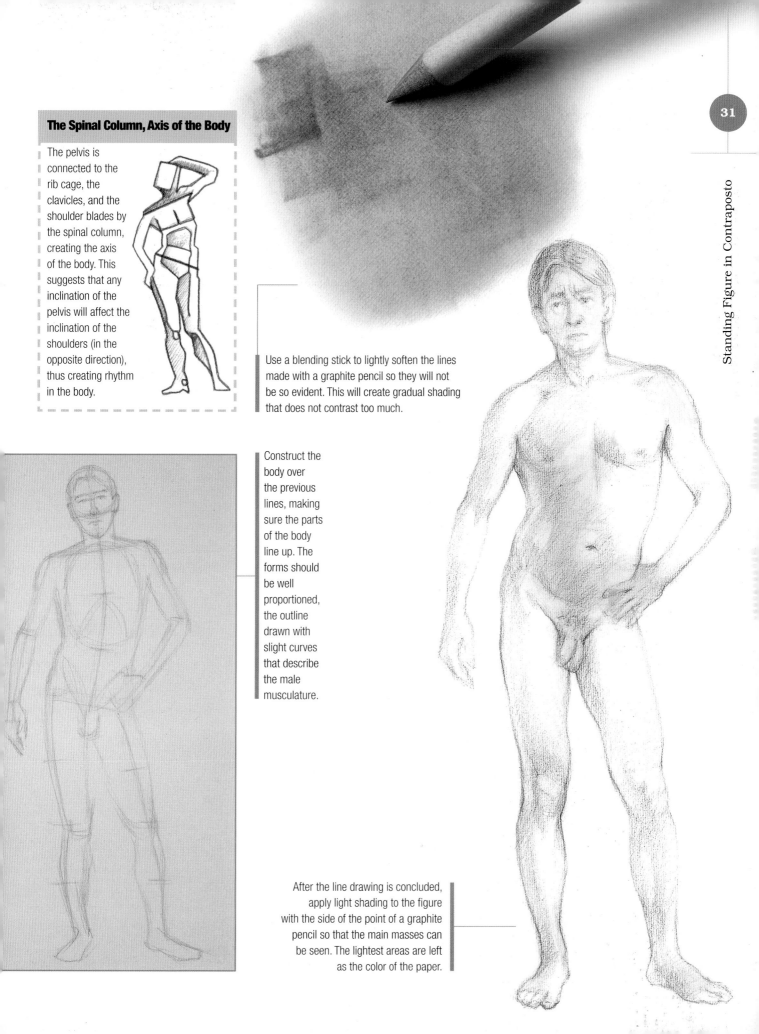

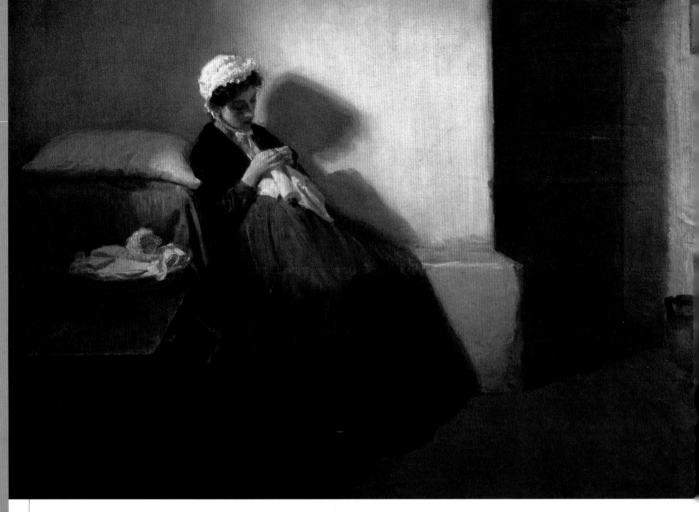

Gioacchino Toma (1836–1891), *Luisa Sanfelice In Prison*. The shadow is created by the light
areas and is used to describe the volume of the figure and the surrounding atmosphere.

Incidence of **Light on the Figure**

Light is one of the essential factors used for describing the volume of the figure, the relief, the space, and the atmosphere of the scene. The shadows on the figure and the projected shadows are as important as the light that falls on the figure.

By working with the balance of light and shadow, it is possible to create harmonies, change the continuity of the illuminated forms, contrast, emphasize, and highlight with glints of light the anatomical details of the model. In the search for an approach that will add greater variety and dynamism to the representation, light transforms the drawing of a figure that is too stiff and academic into a play or confrontation of lights and darks that freely alter the skin tones and boldly interpret the folds of the clothing. The quality of the light can be extremely simple or become very complex through the accumulation of shadows and reflections.

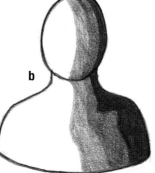

All of the shading on the body of this figure was done with the side of a crayon. This creates the impact of the highlighted arm.

Avoiding the Obvious Details

Shading a figure begins with synthesizing the shadows and progressively making them more complex. Never begin with small details when drawing an entire figure.

Simple Lighting

We recommend beginning with direct and simple lighting from a single source, which will clearly differentiate the illuminated and shaded areas of the model. There should be a very clear limit between the two zones. The most illuminated areas should be indicated with the first shading done with a charcoal stick, chalk, or pastel, applying a flat, uniform shadow. The result should show a well-defined limit separating the light areas from the shaded ones, emphasizing the illumination more than the volume of the figure. Then you can begin working with the values by adding a second color or applying more pressure to the drawing stick.

Basic Shading

There are three different ways to shade a figure. Block shading is characterized by covering the area opposite the light with a very dark, uniform color, as if it were a block with well-defined edges and no intermediate tones. Tonal shading assigns different values according to the intensity of the light in each area; it has intermediate tones, and the progression toward the darkest shadow creates a tonal scale. Chiaroscuro shading is based on gradations; there is no tonal scale. The shading is produced in a progressive manner, smoothly and without abrupt changes in tone. This last technique creates the greatest sense of volume.

Block shading is uniform and intense, with well-defined edges **(a)**.
Tonal shading assigns a different tone to each area according to its light **(b)**.
Gradations are the basis for chiaroscuro, which creates the greatest feeling of volume **(c)**.

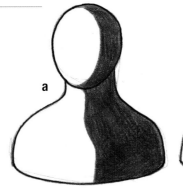

a

b

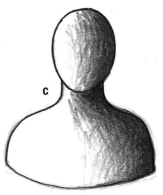

c

Shading the
Nude Figure

A drawing made with only lines does not define the volume of a figure very well; for this a combination of light and shadow is required. The objective of all shading is to achieve a three-dimensional effect or relief, and it should create a convincing sense of a solid figure. The best way to begin shading is to organize a group of tones that distinguish areas of light from areas of shadow; then, the artist must decide if he or she wishes to contrast these tones with chiaroscuro effects or smooth out the lights and shadows by blending the pigment with the intention of modeling the light. In the first case, the representation will create a stronger feeling of volume; in the second, the result is more atmospheric with a smoother transition of the shading on the figure.

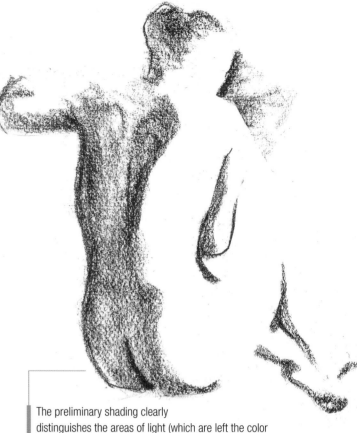

The preliminary shading clearly distinguishes the areas of light (which are left the color of the paper) from the areas where there is shadow.

 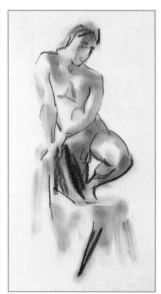

Adding shading gives a simple line drawing more body and solidity. A very schematic application of shadows is enough to give the figure a feeling of volume.

With dry techniques, use a flat drawing stick to apply the preliminary shading.

The Edges of the Shadows

The most common way of shading with dry drawing media is to drag the side of the stick across the support, using the whole side to make a wide full line that acts as a base that separates the areas of light from those of shadow. This preliminary application is later blended to create a tonal scale that will represent the progressive movement from the illuminated areas to the darker ones. In painting, the shading is first indicated with very dark diluted colors, drawing the edges of the shadows as solid blocks of color. From the shadow you move toward more illuminated areas blending each color with its adjacent one to create a natural flowing progression.

Techniques used for shading curved surfaces can easily be applied to the parts of the body. This sketch of an arm can be seen as a series of gradated cylinders.

Shading Cylindrical Shapes

When a light source illuminates a nude figure from a lateral point of view, one side of the figure is lit, while the other remains in shadow. If you are attempting to depict the roundness of the figure accurately, the best approach is to apply gradated shading that will begin to show the cylindrical volume of the torso and extremities. If you have trouble developing this shading, it can be very helpful to imagine the body made of cylindrical shapes like a doll and to conceive the head as a simple oval shape. Then you can personalize each shaded area, making the necessary changes that will match the details of the surface relief created by the muscles.

THE SHAPE AND DARKNESS OF THE SHADING SHOULD BE BASED ON THE CURVES AND RELIEF OF THE FIGURE.

Here is an example of the gradation technique applied with watercolors to describe the shading, and therefore the volume, of the figure.

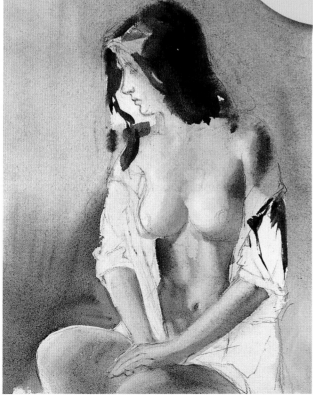

When painting with oils, the shading should begin very simply. The general distribution of the lights and shadows should be painted with diluted colors.

Values and **Modeling**

Values are tones, the different intensities of light that are seen on each part of the figure. The shading usually begins with dark values, which become lighter as the incidence of light increases. Working with three or four values is enough for the transition of dark to light to take place smoothly and without abrupt contrasts or too many breaks. Modeling is the direct result of applying the values of the light and shadows on the figure. It is mainly based on developing a large number of intermediate values so that the flesh tones of the model have a continuous surface and the transition between the lightest areas and the darkest shadows is smooth and progressive. This technique is very commonly used by artists who wish to give their drawings a finished and sculptured look.

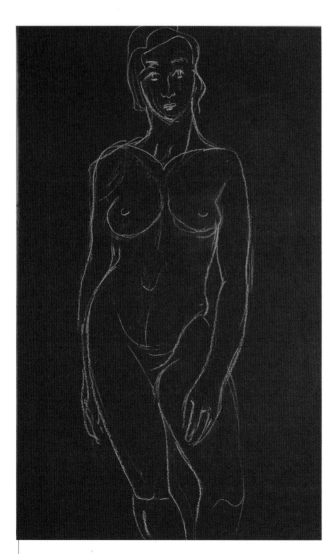

In the following exercise you will apply the basic values of light and shadow on a nude figure. Start by drawing the figure on brown paper with a white pastel stick.

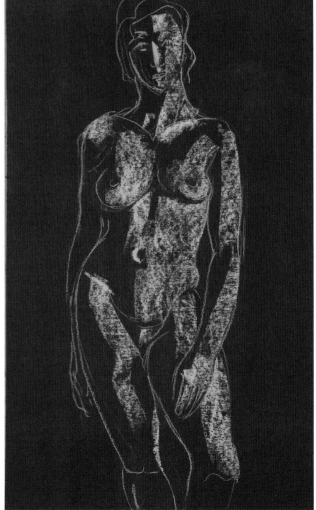

Apply the first areas of light on the figure with a Naples yellow pastel stick. Use the side of the stick to mark the area that receives direct light.

This model contains few values, that is, few different, distinct shades of light and shadow, and all of them are blended together for smoother continuity of the flesh tones of the model.

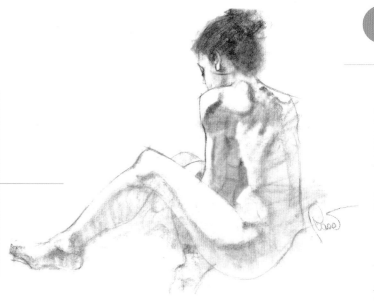

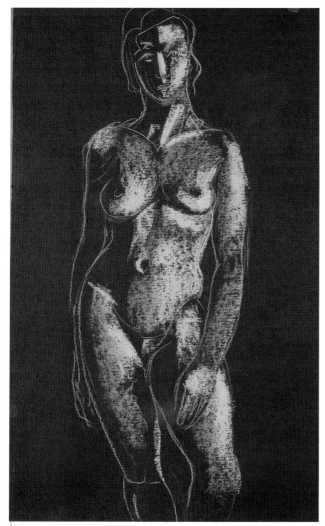

Create an intermediate value toward the areas of shadow with another darker color, in this case with ochre, to naturally connect the light tones with the dark ones.

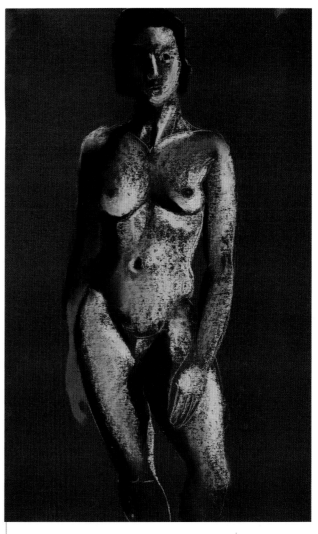

The areas in shadow are created by leaving the color of the paper, and less intense shadows can be colored with burnt umber and black. Do not blend the colors so that the value scale can be clearly seen.

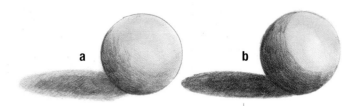
Quality of **Light**

Before drawing or painting a nude it is a good idea to try several different ways to light the model. The direction and intensity of the light is important, because it can emphasize or alter volumes and increase or diminish the contrast of the shadows; in other words, it can make certain aspects of the figure stand out or be less important. The richness of the reflections and shadows can be increased by surrounding the figure with elements of bright color that affect the color of the skin, giving it new shades and coloration. Thus, light reflected from a white fabric will lighten the shadows, while light reflected from red fabric will tint them that color.

From Chiaroscuro to Faint Light

Chiaroscuro is considered to be the most dramatic use of values that exists. It consists of placing the nude figure in a very intense, near light to divide the anatomy into areas that receive the direct impact of the light and very dark areas. Faint light is created by indirect, diffused, or filtered lighting, like the light that enters through a window covered with a curtain. It creates moderate contrasts with gradual transitions between the areas of light and shadow. It has an extended range of tones, and the middle tones predominate instead of the deep, dark ones.

This same sphere is subjected to two different lighting conditions: smooth tonal transitions caused by a faint light **(a)** and a strong chiaroscuro caused by a close, intense light **(b)**.

An intense lateral light creates very dark shadows on the opposite side of the figure. This can be resolved with a very strong chiaroscuro that emphasizes the volume of the figure.

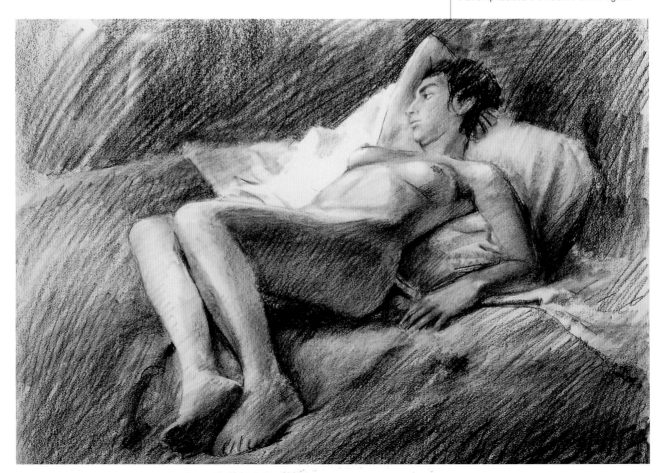

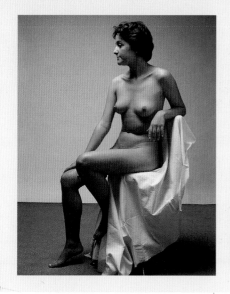
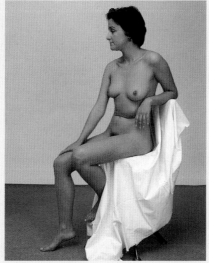
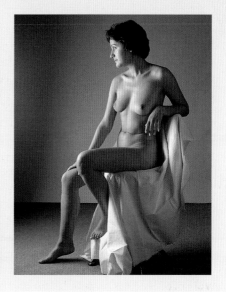

The intensity, diffusion, quality, and position of the light source all play an important part in changing the way that the human figure is perceived.

Tenebrism

Tenebrism is a traditional technique in which the figure is illuminated with a very faint light source, which is generally included within the drawing or painting. In chiaroscuro, the figure emerges from a dark background illuminated by a near, warm light that falls on the most prominent parts of the body. This very particular kind of light allows you to create very dramatic effects or a mood of great intimacy and tranquility. Tenebrism implies the use of chiaroscuro with strong contrasts and with very clear modeling where light and shadow violently fight to hold their places; the middle tones predominate, with very few strong highlights.

Overexposing the Light

When the model is illuminated by different sources of artificial and natural light, the shadows disappear, and only the outlines and strong relief of the body can be seen. The mid tones disappear, and the skin has a light and uniform tone.

In chiaroscuro, the figure emerges from a dark background. The light source is included in the scene, which gives it a feeling of coziness and intimacy.

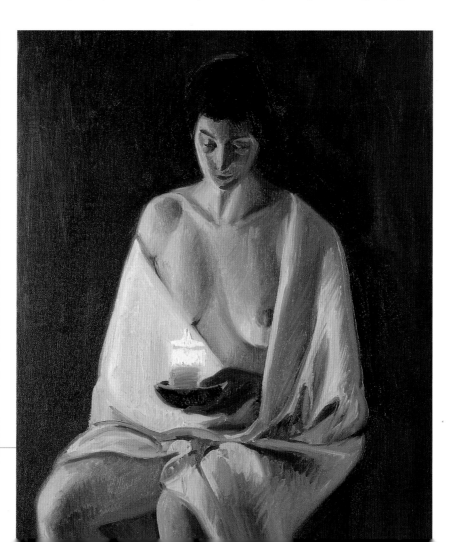

Outlines and
Quick Sketches

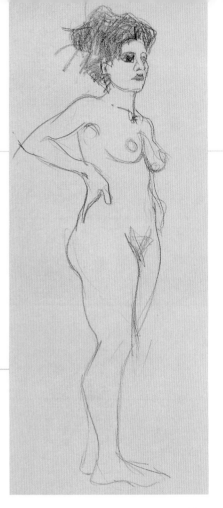

Making sketches of the figure is a work of investigation and searching. It does not try to be a detailed study; the main objective is a good description of the body in general, finding the most appropriate pose and composition, while exercising the hand and the eyes. A good figure sketch translates the complex forms of the human body into a very convincing and recognizable structure. These sketches can be done in charcoal, pastel, watercolor, and even oils; any medium is valid for trying new combinations of composition and color.

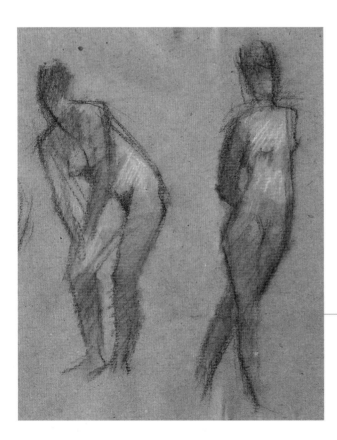

The sketch is above all a linear search, spontaneous and not too precise, that tries to capture a pose in a brief amount of time.

This sheet of sketches of a model has two poses made during the same session. Each one of them shows the characteristic schematic feeling of drawings done in two or three minutes.

Playing with the Lines

Controlling the lines is an important part of constructing a sketch, because it establishes a sense of direction, immediacy, and rhythmic cadences in the figure. It allows you to represent an apparently rigid and conventional pose with greater energy.

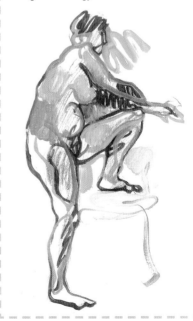

More Time Observing than Drawing

The secret to making good figure sketches lies in prolonged and detailed observation of the model: noticing which leg supports the weight, identifying the correct slant of the shoulders and the hips, and emphasizing the internal rhythm. You must devote more time to scrutinizing, looking, and trying to identify the key points of the pose than you do to drawing it. Once you are familiar with all the details, begin the drawing by blocking in with a few barely perceptible straight lines and simple curves to lay out the volumes of the figure on the paper. Then finish by adding more intense lines to create a very loose interpretation made with quick, gestural movements.

Color Notes

Painted sketches, sometimes referred to as color studies, should be loose and spontaneous, and have little definition in the faces and other superfluous details. The use of color should be subordinated to capturing the pose, the essential forms that define the figures, and the play of light and shadow should be interpreted in a very general manner. If you are using oils or acrylics, it is best to work "alla prima," that is, juxtaposing brushstrokes of colors that are blended or mixed with each other in a natural way, lightly moving the tip of the brush. The areas of shadow are resolved by adding darker colors to the still fresh previous ones.

You should always have small sketchbooks or loose sheets of paper at hand for making quick sketches.

The shapes of the figures are constructed over a very simple pencil sketch with brushstrokes of thick oil paint. Ignore the details, and focus on the effects of the light.

A sketch should suggest rather than explain. This representation with acrylics is based on synthesizing the form, which is completed by a suggestion of modeling with watercolors.

Male Nude **with Erasing**

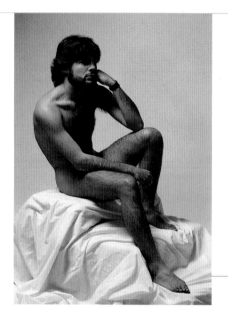

Charcoal is a volatile medium that allows you to create the deepest blacks and a rich wide scale of tones that can be adjusted by removing pigment with a cotton rag or blending with your fingers. Its instability allows you to recover the white of the paper by rubbing with an eraser, thus increasing the contrasts and adding a strong volumetric effect. The nude that is shown here can be considered a sketch; part of a previous drawing that covered the entire surface of the paper with charcoal. The form is constructed by erasing with a rag and an eraser, working on the illuminated areas of the model.

Cover the paper with a layer of charcoal, and then rub it with your hand to make the background a uniform gray color. Create the main areas of light on the figure with the side of an eraser; these will be the bases for the first lines drawn with the charcoal stick.

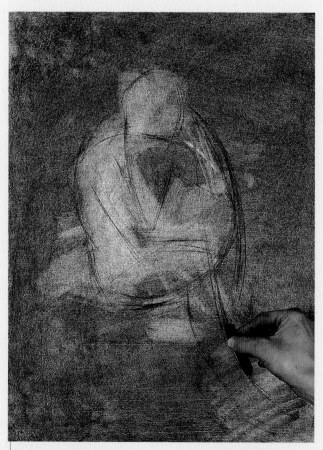

Use the edge of the stick to draw some very thin construction lines. Drag the stick lengthwise with some force to outline the main areas of shadow. The shadow is dark, blocky, and without any modulation.

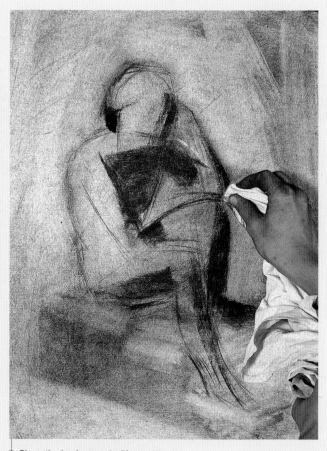

Clean the background with a cotton rag, taking care to not touch the outline of the figure and preserving the construction lines.

The eraser is used not only for correcting mistakes but also as a drawing tool.

Creating Form with a Rag

There are two basic ways of creating light in the drawing: wrapping a rag around your index finger so you can apply pressure to the paper and folding the rag to create a conical point.

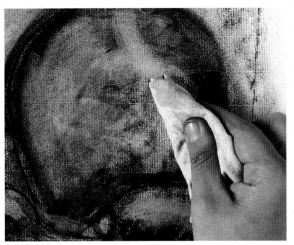

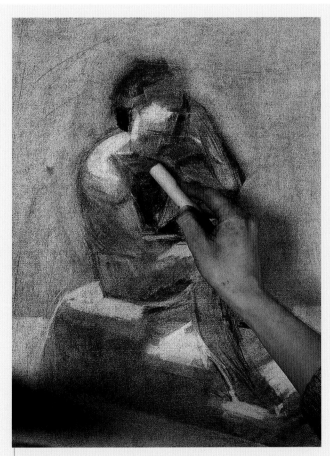

Using a kneaded eraser, create light regions in the areas of the strongest incidence of light on the figure. Press hard on the eraser to completely remove the layer of charcoal. Use a blending stick to blend the edges and better integrate the areas of light.

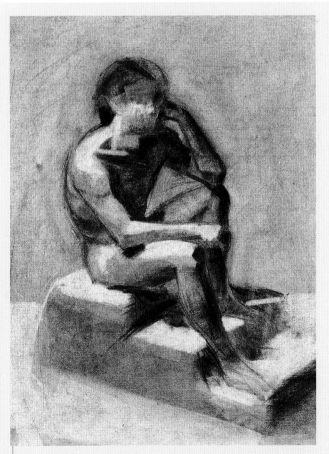

To finish, complete the drawing of the figure with the charcoal stick, strengthening the most outstanding contrasts and emphasizing some anatomical details like the shape of the clavicle and the roundness of the muscles of the arm. Go no further; leave the figure as a sketch.

Adding the Flesh Tones

Some artists with little experience believe that there is a flesh color that can be applied to all figures. This is not so. While it is true that pink and ochre are commonly used for skin tones, their use depends on the conditions of the light, the contrasts with the background, and the cool or warm tendencies of the model's skin. There are many variations, and when it comes to the color range that artists use, the skin color can be painted with some surprising tones.

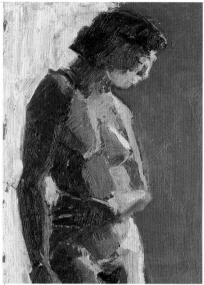

This nude was painted with a range of pink colors, created with burnt sienna, carmine, and violet in the shadows.

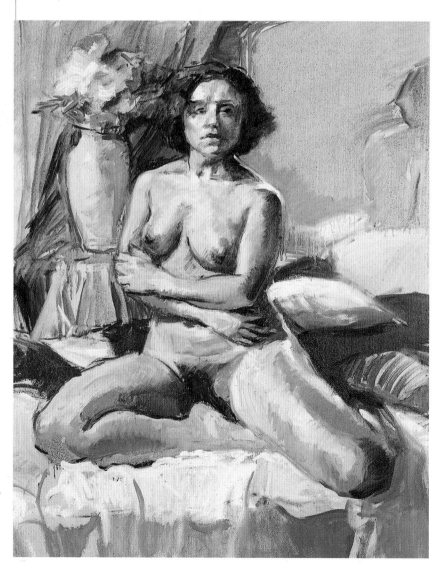

One way of darkening the flesh tones is to add the darkest colors of the background to the basic color of the skin, in this case green.

When the light that illuminates the model is very warm, use a range of colors that are more yellow and orange.

The quickest way to achieve the color of the skin is to make a mixture of carmine and yellow with a large amount of white **(a)**.
Another option is to combine orange, ochre, and white **(b)**.

a

b

The Colors That Should Be Used

Certain colors can be considered common to all types of flesh tones, while others usually are used only on the shaded areas of the skin. The first group includes ochre, raw sienna, and reddish Naples yellow. These colors are shaded with a touch of vermilion, carmine, yellow, or magenta (with the purpose of adding variety to the coloration resulting from different conditions of light), and they are lightened, mainly, with titanium white, zinc white, or Naples yellow. The flesh tones are usually darkened with burnt sienna, burnt umber, and violet. Another technique is to darken the skin with the colors that surround the figure; this will better anchor it to the background. In any case, these colors serve as a point of departure for experimenting with different options.

The skin on this male torso has a very warm tendency, created with a combination of yellows, oranges, and burnt umber in the areas of shadow.

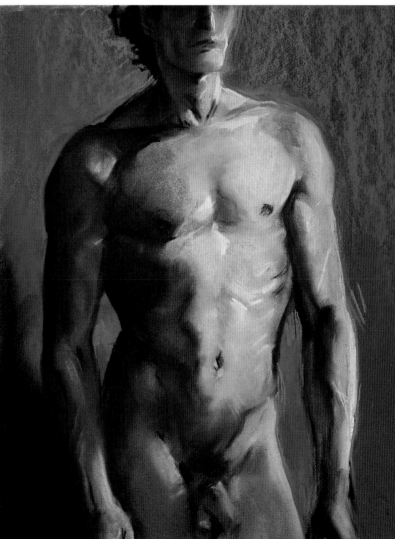

A Study of **the Flesh Tones**

In this section we will do a simple exercise with acrylics that shows how the skin color in a model changes based on the selected color ranges and the final interpretation. When it comes to the style, the brushstrokes, the materials, and the range of colors that are used, the flesh color will vary, and the modeling, that is, the tactile quality transmitted by the skin, will have a sketch-like and delicate finish.

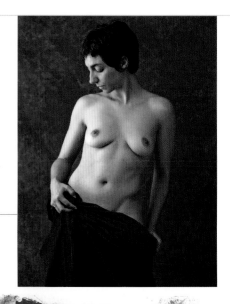

This female nude is bathed in an intense lateral light on the upper half of her body.

We will start with a first application of warm skin tones. Strokes of light orange and a medium tone orange are applied over a pencil drawing with short brushstrokes. They represent the most brightly lit parts of the figure.

Add burnt sienna and carmine to the previous orange, and brush them over the shaded areas on the right side of the body. Do not blend the strokes; they should remain with a clear intention of creating tonal scales.

Add small applications of burnt umber and burnt sienna to the edges of some members. Use the same colors to paint the hair and sketch in the drapery. When the figure is finished, cover the background with a mixture of blue and brown so the flesh tones will stand out.

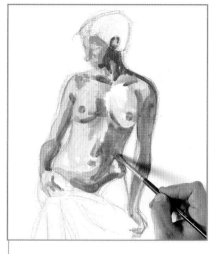

The figure is drawn with a 2B pencil. Mix a color with cadmium yellow, a touch of ochre, and a large amount of white, and spread it over the most well-lit parts of the body. Add a bit of water to the paint to make it flow better.

Use yellow ochre to add a second application of intermediate tones. Then paint the darkest part of the figure with a mixture of a little burnt sienna and a touch of ochre. Notice that three tones are enough to represent the action of the light on the figure.

Flesh Tones with Modeling

In the following version we will use ochre as the base color for the mixtures and add pink tones to it. Unlike in the previous painting, the flesh tones will be painted in more detail, doing some modeling with it. Although the application of the paint in the first phase is similar, a greater number of shades will be introduced as the exercise advances, with less contrast and smoother blended transitions from one color to another.

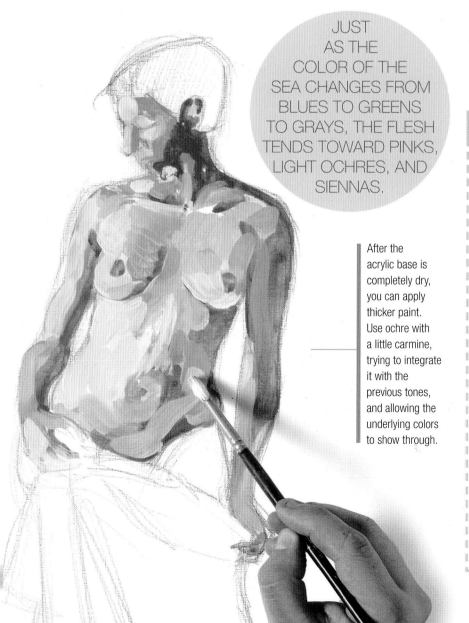

JUST AS THE COLOR OF THE SEA CHANGES FROM BLUES TO GREENS TO GRAYS, THE FLESH TENDS TOWARD PINKS, LIGHT OCHRES, AND SIENNAS.

After the acrylic base is completely dry, you can apply thicker paint. Use ochre with a little carmine, trying to integrate it with the previous tones, and allowing the underlying colors to show through.

The Color of the Background

The color of the skin should be considered in light of the color of the background. On a background of warm colors, the skin should show a cool pink tendency. On the other hand, on a background painted with blues or greens, it is better to use warm colors like yellow ochre.

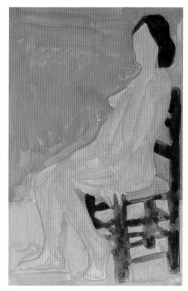

To do the modeling, you must first apply the colors next to each other to form a scale of very different tones.

While the paint is still wet, pass a clean brush along them to blend all the colors.

Pass the brush up and down several times to create a smooth transition from one color to another, with no perceptible edges. The result is modeling.

Blue in the Shadows

The warm flesh tones are usually darkened with earth tones, but when shadows are painted over pink flesh tones cobalt blue is often used, because it will create a violet shade.

Modeling communicates a sense of the smoothness and continuity of the skin. The edges between one shade and another look smooth, and the figure will have a very sculptured look.

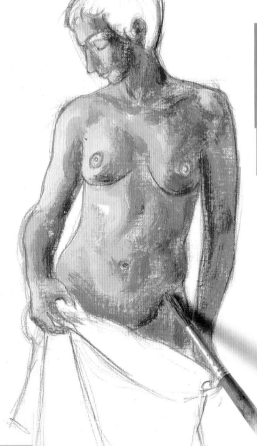

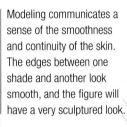

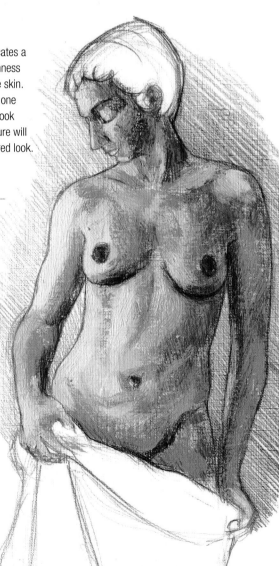

Add brushstrokes of light gray over the layer of fresh paint. Then begin modeling, trying to blend this gray with the flesh tone base color. When the paint is still wet, the colors will blend when a soft hair brush is lightly passed across them.

This tonal range is for a person with a pink or whitish complexion.

These ochre and orange tones would be best for the flesh of people with bronzed skin.

Raw sienna and burnt umber are important for painting the skin tones of people of mixed race and of African descent.

Free Interpretation of the Flesh Tones

Every artist represents the color of skin in a very personal way. Some painters begin with a basic mixture of carmine, yellow, and white, or ochre, orange, and white. Others prefer more daring color combinations, with very saturated colors like reds, carmines, yellows, and even violet and vermilion in the shadows, or pinks combined with blues. There is no universal skin color, and all flesh tones are free interpretations. However, there is a norm: the colors should always be at the service of the expression of the lights and shadows on the anatomy.

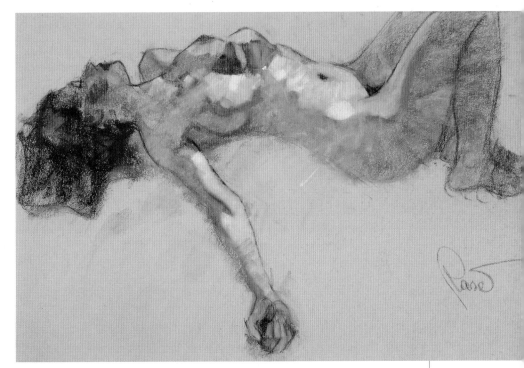

A daring interpretation allows the artist to develop the skin tones with very warm, saturated colors. In this figure painted with pastels, the intense yellows create the effect of bright light, while the oranges, reds, and carmines are used for the flesh colors that are in shadow.

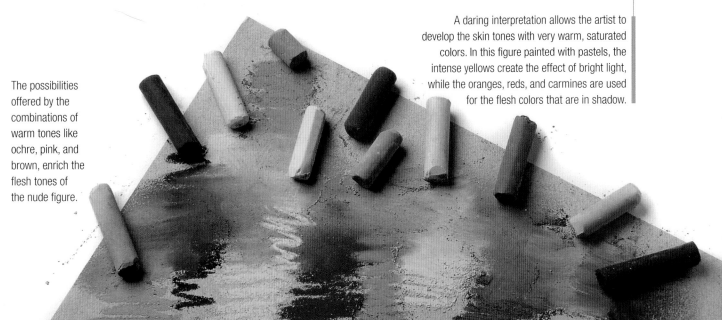

The possibilities offered by the combinations of warm tones like ochre, pink, and brown, enrich the flesh tones of the nude figure.

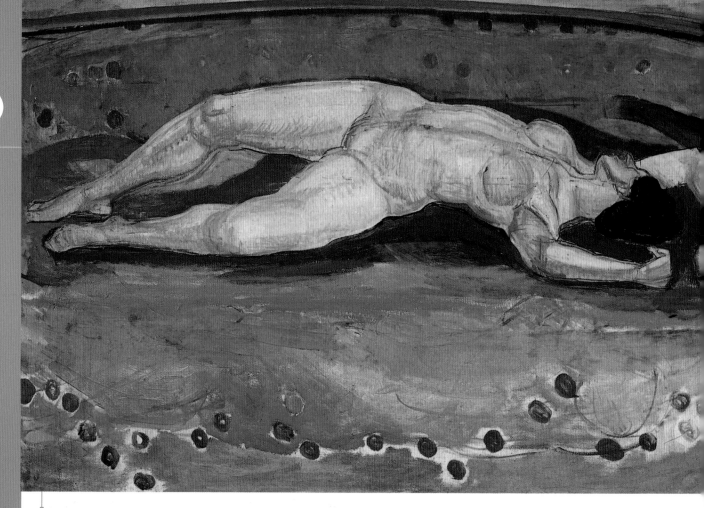

Ferdinand Hodler (1853–1918), *Desire*. Interpretations of nude figures have a strong personal component, even the most realistic and apparently objective ones.

The Beauty of the **Nude**

The nude is the most passionate and complex theme of any that can be attempted. The representation of a nude human body is full of very rich and sensual suggestions. In addition to offering the opportunity of studying a living form, its representation carries with it an emotional charge that has no comparison in any other artistic genre.

The nude not only attempts to capture a vision of the external appearance of the body but also expresses its human content. This means that it is much more than a group of measurements, objective data related to the view of the form, because it contains an emotional implication. It can be approached in many ways, from the most colorful to the most austere, but none of them should be in conflict with the originality of the pose, the compositional audacity, the sensuality, or the suggestiveness of the drawing. A naked body, no matter what the pose, should always insinuate, thrill, and be expressive.

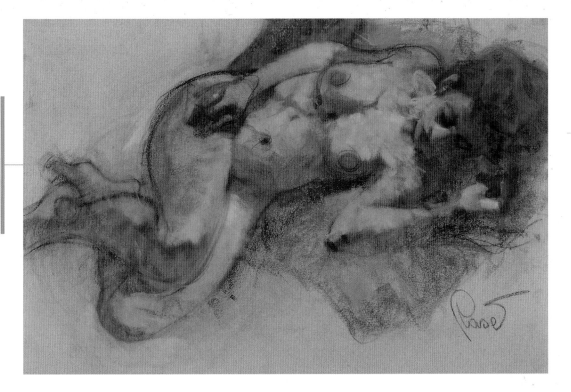

The pose, the model's attitude, and the exaggerating of the curves of the feminine anatomy together create a very sensual image of the nude.

Beginning with Realism

The best way to learn to draw a nude is to begin with a realistic interpretation, a clear representation of the human body, one that looks like the real thing, with the intention of depicting the truth of the figure with neither embellishments nor distortions. This must be a very careful, rigorous, and solemn interpretation that requires the artist's full attention and greatly individualizes the figure. Although the style and intentions of the artist might be far from a classical representation of the nude, it is necessary to make a realistic study of the figure as a starting point for any personal expression.

Depending on Sensuality

A realistic interpretation does not exclude the development of sensual, feminine, virile, and more refined aspects of the nude that are expressed through a suitable choice of poses, a greater permissiveness in the drawing, and the incorporation of backgrounds and complements of color that accompany the figure. Sensuality is a good antidote against excessive seriousness, which it battles with a touch of grace, charm, and even eroticism. The latter is traditionally more associated with the female figure than the male form.

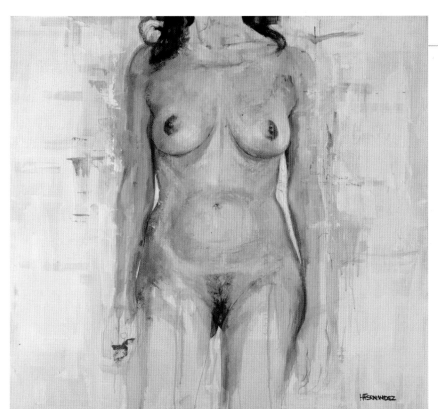

Realism is a scientific approach to the nude. The drawing follows the real figure very closely, and the colors are modeled and avoid abrupt changes of color.

Staying in Shape

Drawing the nude figure is a skill practiced by amateur and professional artists to "stay in shape" and not lose familiarity with the forms of the figure. The nude is the preferred subject for artists who wish to learn and are striving for mastery.

The Toilette, an Expressive Treatment

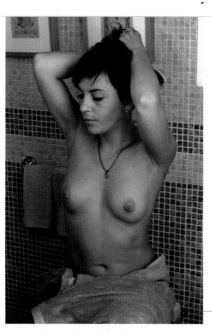

In a subgenre in painting, the nude is approached from an intimate and sensual point of view. It is known as the *toilette*, a theme that was popularized by the Impressionist and Post-Impressionist painters in the early 20th century, which represents the nude female figure in a private and personal environment: the bath. Here we present an exercise in oils, a portrait of a nude figure. The model is uninhibited in domestic repose, caught up in her self. Her pose and attitude acquire a much more normal feeling, warmer and more sensual.

The model is a nude figure shown from the waist up, putting up her hair.

A preliminary sketch is made with pencil, and then painted over with diluted cobalt blue. Wiping it with a rag will ensure that the cobalt blue will not mix with other paint, as well as lighten the lines and remove any impasto.

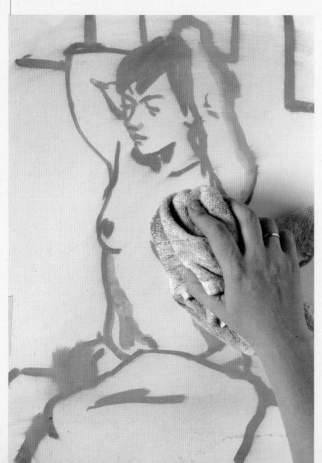

The first applications of color should be applied on the background and to the girl's hair. The flesh tones are built up with ochre, reddish Naples yellow, burnt sienna, and white, mainly in the illuminated areas.

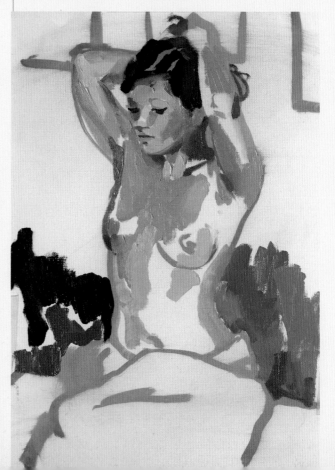

When the work is finished, notice the number of colors that make up the flesh tones, which might not have seemed appropriate but that create a rich and varied alternative when incorporated into the range of ochres.

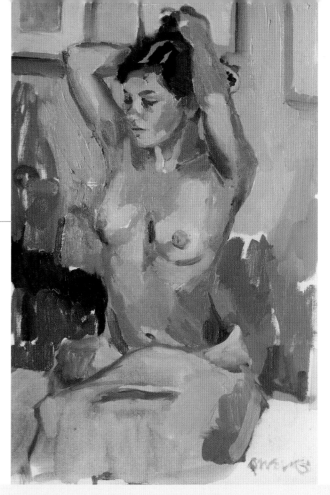

Here, the shadows on the flesh are created by adding violet and burnt sienna to the base color of the skin.

The shadows on the skin are painted with lavender tones made by mixing violet, burnt sienna, and white. The initial blue line is also covered with these tones so the figure will better blend with the background.

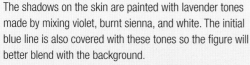

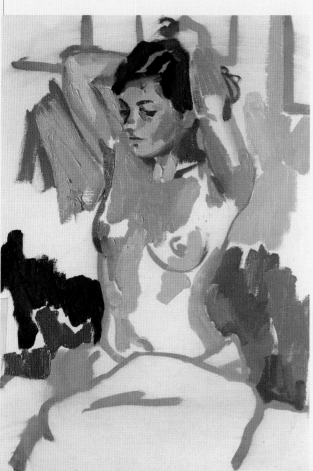

Paint the towel with diluted gray, and add thick brushstrokes of orange and magenta to the rest of the painting. The green color in the background reverberates in some shaded parts of the figure.

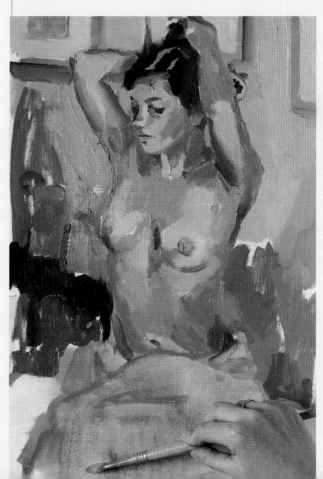

Realistic Interpretation
of the Flesh Tones

Realism attempts to represent the figure as it is seen, a detailed rendering of the real model with no liberties taken in the interpretation and a close recording of the chromatic range of the tones on the model in the particular conditions of light. The main objective is to capture the truth of the human figure through an analysis without distortions and embellishments.

Because making a detailed painting of an entire figure is a very arduous task, and we wish to learn to create the different colorations of the skin tones, here we propose practicing with just the torso of a seated feminine figure. In the following oil painting, we show a guideline that the author applies for constructing the different zones of light on the skin so as to produce in a very detailed and elaborate work.

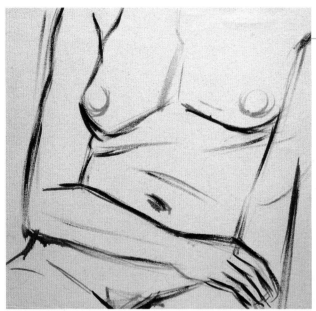

The main lines of the sketch are drawn with a fine brush and burnt sienna diluted in turpentine. The drawing is very schematic and dependent on the general painting.

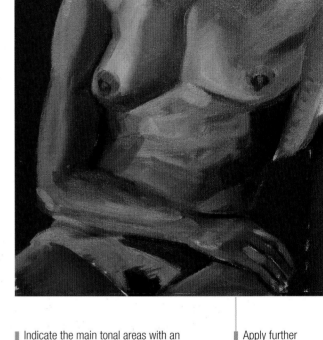

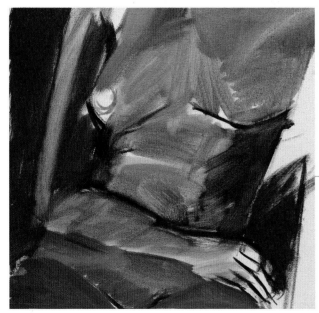

Indicate the main tonal areas with an overall application with a mixture of ochre, burnt sienna, English red, a bit of blue, and white to gray and lessen the saturation of the colors. The objective is to quickly cover the paper with heavily diluted paint.

Apply further applications of warmer colors with the addition of orange over the previous paint. The intermediate tones add continuity and help tie together areas of color that strongly contrast with each other.

The neutral colors for the skin tones are created by adding a small amount of white, which mitigates the strength of the flesh color and makes it grayer.

STARTING WITH A LOOSE AND GENERAL DEPICTION OF THE FLESH TONES, YOU CAN DEVELOP THE PAINTING UNTIL YOU ARRIVE AT A VERY DETAILED TREATMENT.

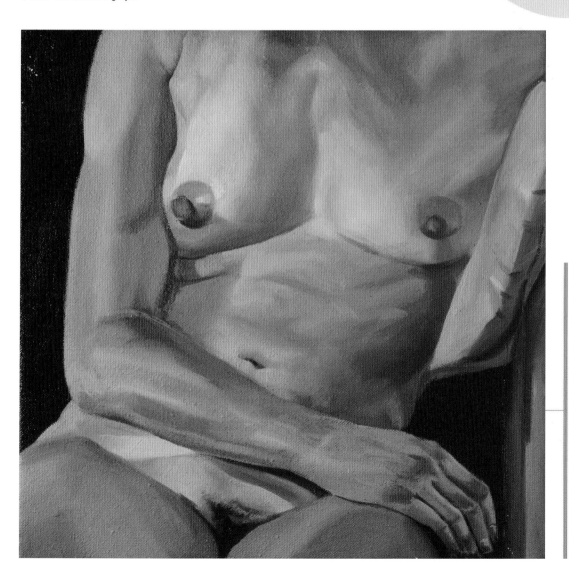

After several hours of work and multiple applications of pink and white tones, the nude looks very finished. The colors of the flesh are now very rich and include small amounts of blue and violet. No other technique has such a high level of finish as oil painting.

A Figure with **Markers**

Markers fall somewhere between drawing media and painting media. While they make uniform and continuous lines, the transparency of the ink allows you to create tonal values and superimpose transparent layers to create a rich variety of colors. In addition, the ones that are beginning to wear out make a less fluid and blurred line that can be used for gradations and integrating some very different tones. In the following exercise, the flesh tones are created by combining wide strokes of color made with chisel tip markers with overlaid hatching made with other markers with round fine tips.

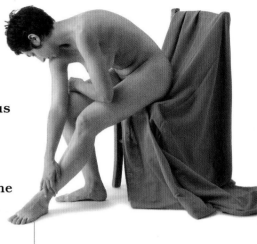

You must choose an interesting pose where the model shows an interesting play of light and shadows, with both areas very defined.

1. First draw a general geometric sketch with a graphite pencil to indicate the basic proportions. Add the anatomical details over this sketch, emphasizing the volumes of the muscles in the outline of the figure.

2. Partially erase the pencil drawing so that the lines will not be too perceptible. Go over the line with light ochre marker with a chisel point, and apply a preliminary shading, leaving the most brightly lit areas white.

3. Go over the line that outlines the body with a brown marker with a fine point. Also emphasize the relief of the figure, darkening the areas with the most shadow.

4. Color the hair with burnt umber, making it dark and dense, while leaving small reserves for the lightest locks of hair. Use a blue marker with a chisel tip to begin coloring the drapery with long wide strokes. You can also add small touches of transparent blue on the flesh tones.

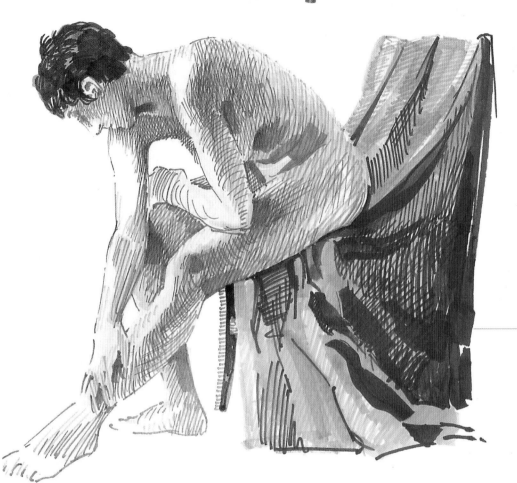

6. Use ultramarine blue to darken the folds of the fabric, combining blocky shadows with medium tones that are made with different hatch lines based on whether you are drawing a dark shadow or a medium tone. Light blue should then be used to add new colors to the skin tones to give them a chromatic fullness.

5. Cover the white areas of the drapery with light cyan blue. Some lines can be made quickly with a worn out marker. The blue tones on the leg represent the light reflected from the drapery, which enriches the play of light and shadow.

Figure with **Watercolor Chiaroscuro**

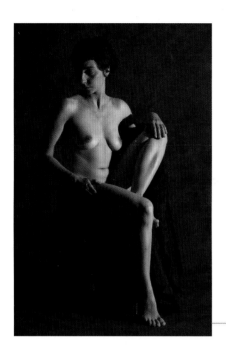

The objective of this exercise is to construct a nude figure in watercolor with chiaroscuro lighting effects that can be characterized by gradations going from light to the darkest shadows. You must keep in mind that when drawing a figure with this kind of lighting, the light does not strike the entire body equally. The part exposed to the light is painted with very diluted, almost transparent paint. In the dark areas superimposed layers of paint, or glazing, can be repeated until arriving at the appropriate intensity of the shadow. When painting with oils, the chiaroscuro effect is usually much stronger, the contrasts are very abrupt, and the half shadows or intermediate tones are reduced and give the extreme contrasts more importance. Watercolors, however, are a more delicate medium, with luminous colors, so the contrast between light and shadow will be more gradual.

The model is a female nude bathed in an intense lateral light that creates strong chiaroscuro contrasts.

1. Before beginning to paint, draw the figure by marking the main lines of the composition with charcoal to establish the pose and the proportions of the different parts of the body.

2. Make a more accurate drawing over the previously made sketch, indicating the anatomical forms of the members, the torso, and the elements of the face. Lightly erase the lines of the earlier sketch so the definitive drawing is as clear and clean as possible.

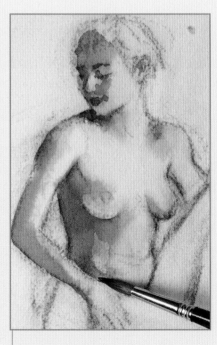

3. Before painting, very lightly wipe the drawing with a rag so the charcoal dust will not accumulate and ruin the luminous tones of the watercolors. Apply a first wash over the shaded areas of the figure with a mixture of sienna, and small amounts of ochre and carmine.

Dark Background

Figures that are painted with the chiaroscuro technique stand out best against a dark background. The contrast between the figure and the background increases the visibility of the outlines of the illuminated parts of the body, while the shaded areas will blend into the background.

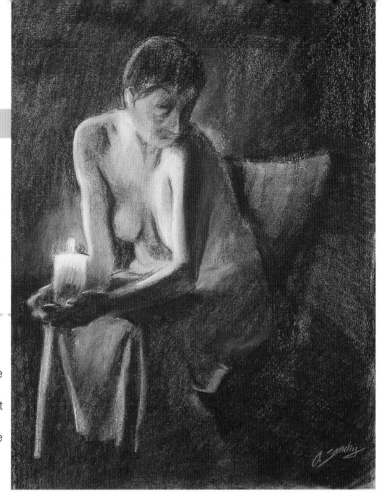

4. Paint the hair with burnt umber mixed with Payne's gray, leaving some light areas in parts of the hair. Darken the shadows with a new wash of burnt umber. You must work very carefully so you do not go over the edges of the drawing and put each shadow in its proper place.

5. The flesh tones of the leg are painted with a very transparent wash of sienna. This is left for a moment so the paper can absorb some of the water. Paint the shadow that appears on the left half of the arm; it is a blocky shadow with well-defined edges.

6. While the watercolor on the leg is still damp, paint the shadow that runs up and down with sienna and burnt umber. The dampness of the paper will soften the edge a little. Do not worry that the contrast of the shadow on the leg will be too much; the color of the wash will be lighter when it dries.

7. Allow the figure to dry completely, and in the meantime you can address the background. Moisten the lower part of the paper with a slightly damp sponge so you can blend the drapery on the chair while leaving a well-defined outline around the figure.

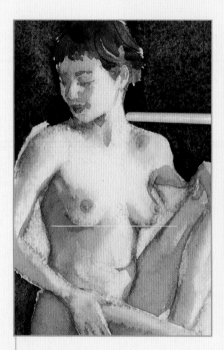

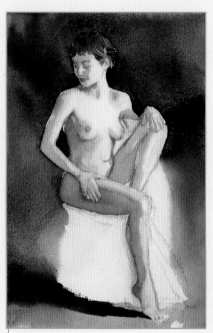

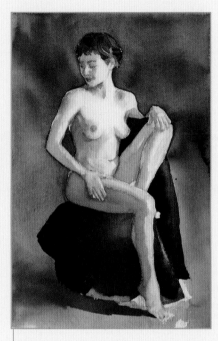

8. Use a wide brush to cover the entire background with dark green. Since this tool is not as precise as a fine brush, apply the wash near the figure, then use a reed pen or stick with a chisel point to extend the paint to the edge of the body to make a detailed outline.

9. Fill in the spaces between the arms with dark green. Darken this color with Payne's gray, and paint the shadow projected by the model's leg. Work dry, but as the shadow recedes dilute it with a wet brush.

10. Use darkened carmine with a touch of green to paint the drapery that covers the chair. Make some highlights in the damp wash by removing the paint with a dry brush; this will cause the white paper to show through.

Watercolor Shadows

Watercolors allow you to easily represent shadows. The brightest lit areas are created by leaving white reserves, while the shadows have delicate tonal transitions with gradations.

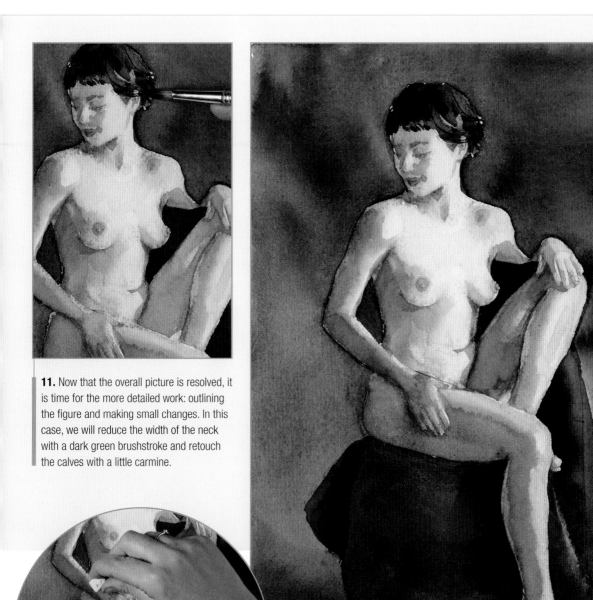

11. Now that the overall picture is resolved, it is time for the more detailed work: outlining the figure and making small changes. In this case, we will reduce the width of the neck with a dark green brushstroke and retouch the calves with a little carmine.

12. Paint the shadows of the drapery with a mixture of green and carmine. Paint on dry paper spreading thin gradated glazes with a dampened brush. To finish, add some highlights with lines made with a white wax crayon. These applications should be kept to a minimum so they do not affect the quality of the watercolor.

13. The work can be considered finished when it shows a convincing but attenuated contrast. The watercolor should not be overworked; it is preferable to maintain its freshness by treating the flesh tones and other painted areas with stylized brushstrokes and keeping the drapery dark.

Incidence of Light
on the Male Anatomy

The impact of light is the main cause for the relief on a body. When it hits laterally, the anatomical volumes are emphasized by the effect of the strong contrast between the most prominent areas, which are partially illuminated, and the shadows projected by them. Natural light is soft and homogenous, so it is preferable to use a lamp if you wish to highlight the male anatomy. In this pastel exercise, the artist was asked to illustrate the location and values of the light on the model while rendering the anatomy.

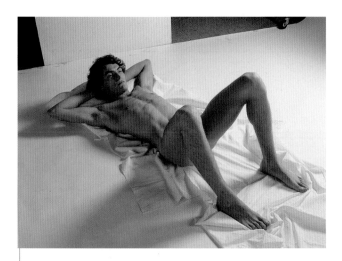

A strong artificial light illuminates the model from one side. The body seems clearly divided between light and shadow, and the perception of the anatomical relief is increased.

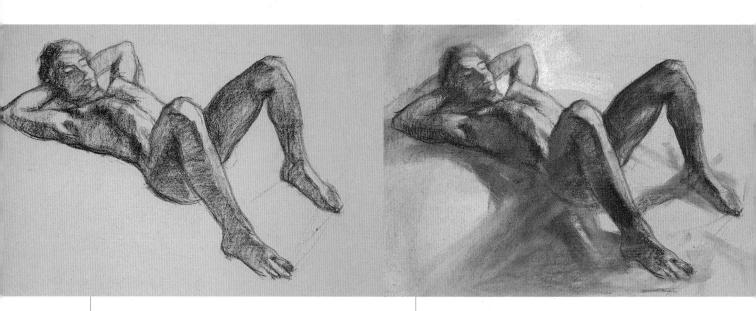

1. The figure is first sketched with a stick of sanguine chalk, which will be easy to erase if corrections are needed. The initial approach should focus on the exterior drawing and the outline of the body. The edges of the shadow will be drawn with a sepia color pastel.

2. Draw the shadow on the ground with gray, then use this pastel to add new tones to the model. Blend the shadows on the ground and on the model with your hand, paint the illuminated parts of the model with yellow, and make the background white.

3. The lines should not be thick and should be left visible in the lower areas. Add burnt umber to lessen the contrast, but the musculature should still be evident. Each plane of shadow should match and strengthen one of light. The folds of the fabric and the shadows on it should be suggested with just a few sketchy lines.

4. Since the contrast should be strong, apply more white in the area around the figure. The intermediate tones should be browns and sanguine, while the contrasts should be heightened by lightly drawing the shadows with a black pastel stick, using very little pressure.

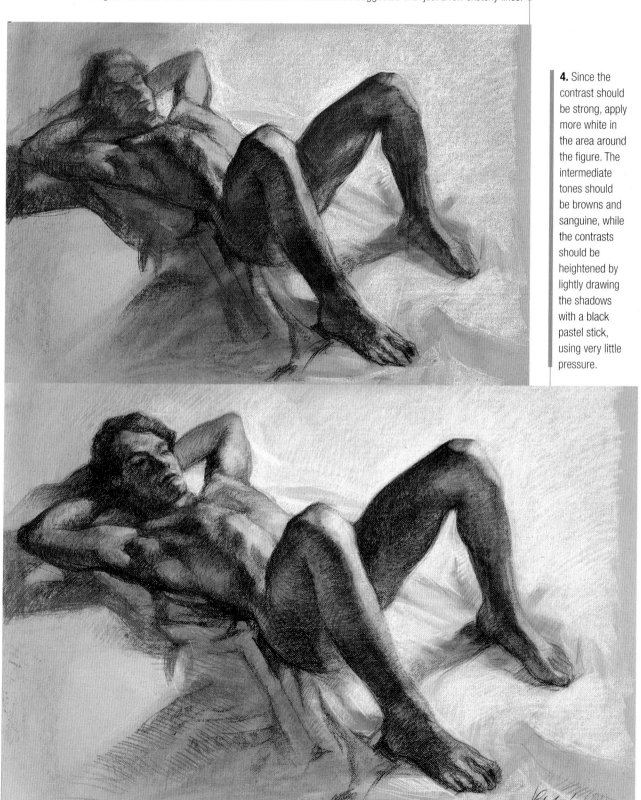

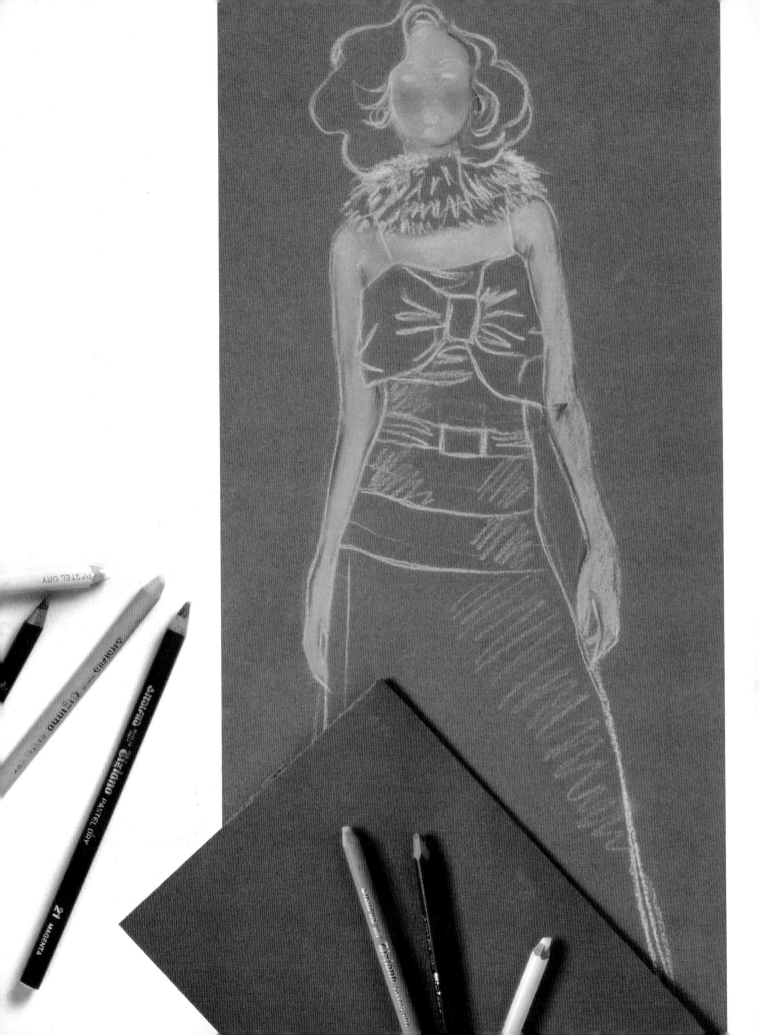

The Clothed Figure

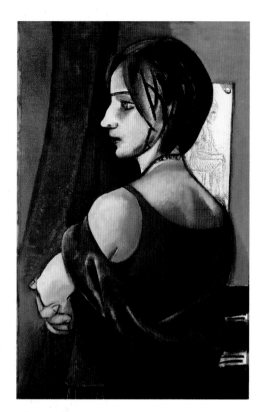

and Its Context

Even though clothing generally covers most parts of the human figure, a well-constructed drawing still requires that we pay attention to the proportions and the angles of the lines of the shoulders and the hips. Representing the clothed figure should not cause you to believe that you can hide or avoid certain anatomical issues, because the lines of the clothing adjust to the shapes of the muscles, and they often emphasize the twists and bends of the body in different poses. The posture and the tension in the body will variously show the most prominent parts of the figure, according to the article of clothing and the weight of the fabric: the breasts, the elbows, the buttocks, and the knees can all be detected through the gathering and the tension of the fabric. Therefore, in addition to the typical anatomical problems that come with the clothed figure, we must add the rendering of the folds and wrinkles of the clothing, which not only help show the incidence of the light, but also the positions adopted by the figure in different situations.

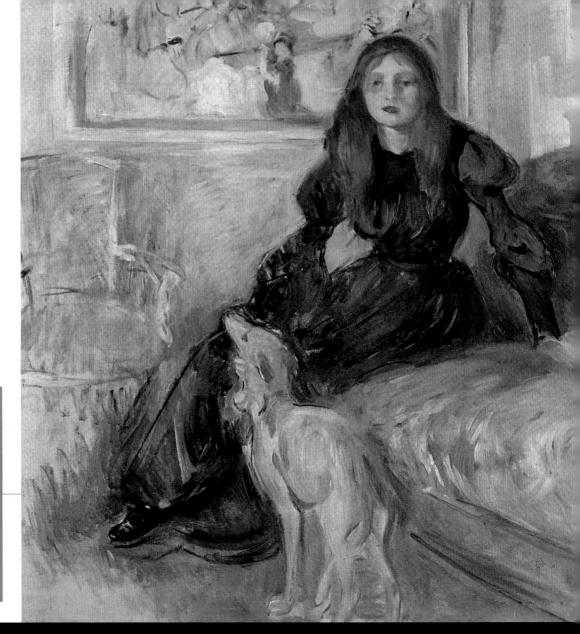

Berthe Morisot (1841–1895) was able to suggest Julie Monet's dress with very few well-placed brushstrokes. It is a loose fitting dress that tightly fits the body at the waist and in the arms.

Understanding the **Clothed Figure**

To accurately represent a clothed figure, it is not necessary to envision it nude and then cover it with fabric.

A clothed model should be approached the same way as a nude: block it in and try to understand it as a whole, with a pose and a general structure forming a unit. Very few items of clothing allow us to see the anatomy in detail; thus the shape of the body and the wrinkles in the fabric are conditioned by the type of clothing, its looseness, its weight, and the stiffness of the fabric. The colors and the folds in the clothing are a splendid linear complement to the form and the volumes of the human figure. The variety of the folds and even the patterns can become the center of artistic attention and interest.

Sketching the Clothed Figure

The easiest way to draw a clothed figure is to simplify it. First, block it in with geometric shapes, just as you would draw any object. Do not add details; in other words, ignore the texture and the folds. This first sketch should set the pose adopted by the model, with special attention paid to the geometric structure of the body parts (with simple volumetric forms) and to the appearance of the outline. Make modifications to accommodate the clothing on the outline of the figure (the greater thickness of the torso wearing a wool sweater, for example) and the edges of the clothing on the figure.

Stylizing the Clothing

When the clothing is complex, it can be constructed in small simple geometric units to make it more understandable, ignoring details and folds. Finish it with light, gradated shading.

The secret to sketching clothed figures is synthesizing, understanding human anatomy and attire as an inseparable unit.

Painting the Clothing

Recreating clothing requires paying attention to the materials and how articles of clothing with different textures fall on the body. You must pay special attention to the variations in color, how they are lighter or darker depending on whether they are in light or in shaded areas. We usually begin with a pencil sketch of the clothed model and then cover the body with a generalized color, differentiating the illuminated and shaded areas. Finally, the textures and folds are resolved with more careful and specific brushstrokes that follow the direction and curvature of the folds and hollows.

The first strokes of oil when painting a clothed figure should indicate the clothing as a study of light and shadow.

Painting **Clothing**

The most important aspects of the clothed figure are its colors, the fall of the article of clothing, and the folds that are formed. For both painters and lovers of color, the clothing can become a place where they have free reign for creating patterns, crazy combinations of colors, and unusual prints. The texture can also be very interesting; finding techniques that you can use for reproducing the tactile sense of some fabrics and materials is important.

Use watercolor on damp paper to reproduce the tactile feeling of an angora sweater.

Showing the Volume of the Figure

Clothing definitely hides the naked body, but the posture that it adopts can be more or less evident according to the pleats and folds that give us clues about the volume underneath. The wrinkles in a dress can be tighter and more numerous at the areas of the joints. On the other hand, the tensions of the fabric and the way that it folds give us information not only about the positions of the members but also the volume of the more outstanding parts like the buttocks, the breasts, the belly, and the knees.

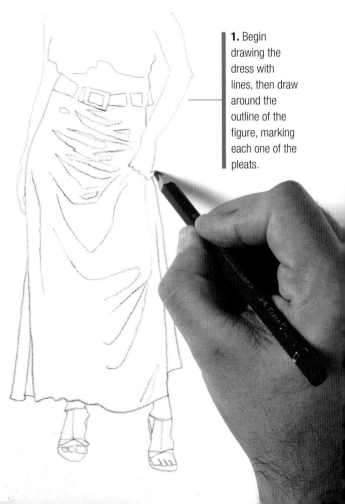

1. Begin drawing the dress with lines, then draw around the outline of the figure, marking each one of the pleats.

BE CAREFUL WHEN DRAWING TIGHT CLOTHING, BECAUSE IT WILL NOT HIDE DEFECTS IN THE ANATOMY AS WILL LOOSE CLOTHING.

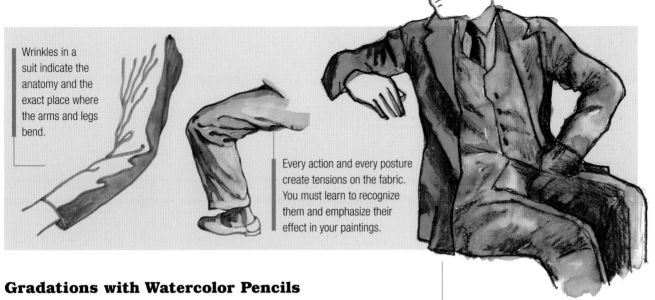

Wrinkles in a suit indicate the anatomy and the exact place where the arms and legs bend.

Every action and every posture create tensions on the fabric. You must learn to recognize them and emphasize their effect in your paintings.

Gradations with Watercolor Pencils

When painting clothing, the most important thing, besides showing the textures and highlights of the fabric, is accurately describing the folds and changes in color caused by the shadows. They appear in the areas inside the folds, while the parts that stand out the most are light in color. A simple exercise with color pencils will be enough to show this. Take two or three similar colors, like red and a couple of pinks, and combine them to illustrate the folds, the highlights, and the drape of the clothing. Watercolor pencils combined with a wet brush will work very well for delicate tasks: they make light tones and can make fine detailed finishes.

The modeling and shading sculpt the surface of the suit as if it were a statue and show where it moves in and out.

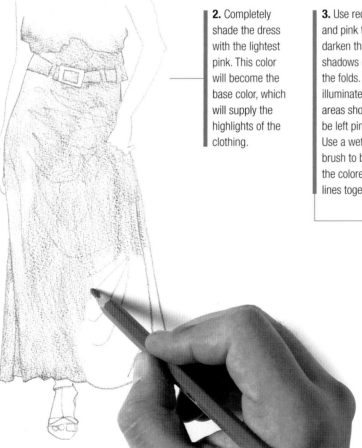

2. Completely shade the dress with the lightest pink. This color will become the base color, which will supply the highlights of the clothing.

3. Use red and pink to darken the shadows of the folds. The illuminated areas should be left pink. Use a wet brush to blend the colored lines together.

Folds and **Drapery**

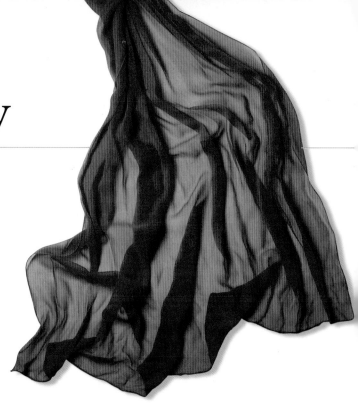

The relationship between the human figure and drapery dates back many centuries, when art students were required to exactly represent the folds of the tunics on classic statuary. These days, this need still exists because of the variety and importance of fabrics in contemporary wardrobes. Drapery presents a challenge in drawing and modeling that still occupies artists today who wish to represent the clothed figure.

Different Folds

To draw drapery well, you must perceive them as abstract forms, focusing on the fall of the fabric, the line of the fold, its placement, and the parabola described by its curve. We suggest practicing drapery by starting with a simple structure that synthesizes the way that the wrinkles are distributed: forming hollows, loops, or fan shapes. Based on these simple schemes, we can recreate different types of fabric by the treatment of the shading and modeling. It is a matter of learning to resolve the folds according to the fabric that the clothing is made of. If you are able to identify and reproduce these differences, you can render any kind of attire.

Drapery folds are drawn and painted by sketching curved shapes, which are then shaded with smooth gradations **(a)**.

Gathered drapery has diagonal folds; the shadows should be rendered in the interior space of each one **(b)**.

The folds can look like waves or arabesques; if the shading is very contrasted the feeling of relief is greater **(c)**.

Folds on the bias create a fan shape with tubular forms. To create relief you must create small gradations in each fold **(d)**.

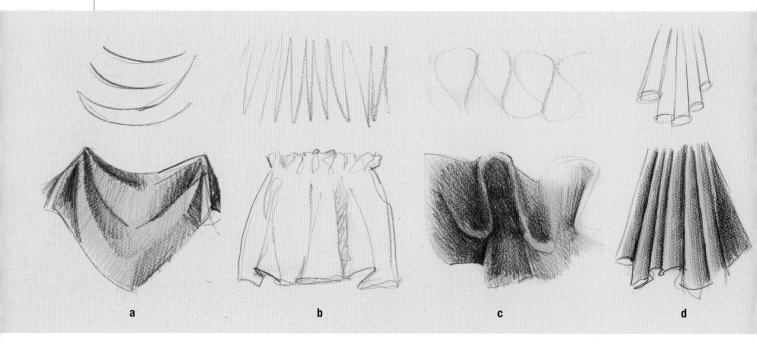

a b c d

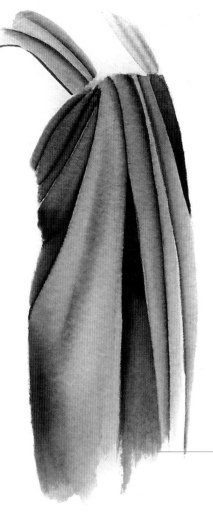

The Folds Define the Fabric

The stiffness, smoothness, and contrast used to render the wrinkles and folds of an article of clothing give us much information about the nature of the fabric that the clothing is made of. When it is heavy but malleable, it will have wrinkles with smooth gradations, and the shading will be extended across the entire surface of the article. There are very light fabrics that wrinkle excessively, an effect that can be resolved by drawing many tightly curved folds that are reminiscent of arabesques. In an article of clothing made of a stiff or starched fabric, the folds are large, very linear, and excessively geometric, and the fabric wrinkles with difficulty.

After the folds have been indicated with lines, make smooth tonal transitions with strongly contrasting shadows in the hollows. This is a beautiful example in watercolor.

To indicate the soft fabric of a jacket, the folds are smoothly gradated and made to not contrast much.

Silk and linen clothing usually wrinkle a lot, an effect that can be illustrated with exaggerated curves and arabesques.

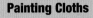

Painting Cloths

Nothing is better for practicing the treatment of folds in clothing than painting drapery. A cloth hung over a chair or from the edge of a table will be a good model. The goal is to convincingly capture the fall of the fabric and describe the contrasts of light and shadow.

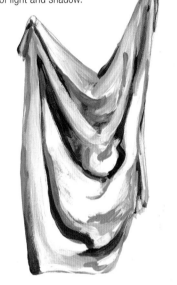

When the fabric is stiff, the folds create very strong geometric forms. Such dark shading indicates the incidence of very strong light.

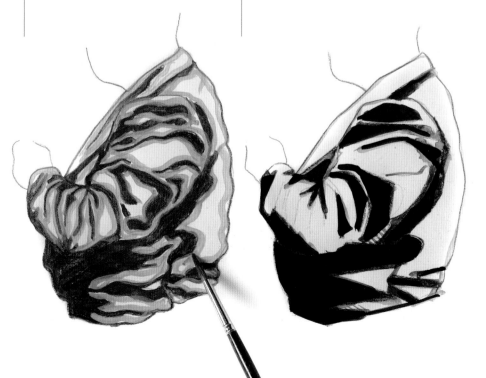

Approaching the **Clothed Figure**

Now that we know how to construct a drawing of a clothed figure, it is time to put our acquired knowledge into practice. We will begin with a very uncomplicated oil study: a seated figure with a very simple dress. The treatment will be very schematic to focus all our attention on achieving a good rendering of the volume of the figure and the conditions of the light, without getting into shading and details that could be distracting. We will be making a very simple drawing with charcoal over which we will add heavy applications of undiluted paint.

You must avoid mixing the paint with turpentine so it will be easier to mix and blend the different colors to create gradations.

1. Draw the seated figure with charcoal on canvas paper, which can be painted with oils. Go over the lines with diluted violet, and start the dress with just three tones: light lilac, medium blue lilac, and dark violet. These colors are blended to make gradations that describe the roundness of the parts of the figure, which can be seen through the dress.

Dressed Is the Same As Nude

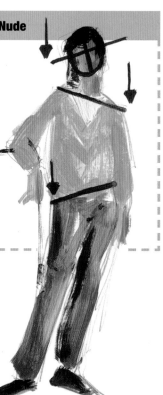

Although the figure appears to be dressed, the structure and articulated anatomy of the body are no different from a nude figure. Therefore, you must always be aware of the angles of the lines of the hips and of the shoulders to determine the pose.

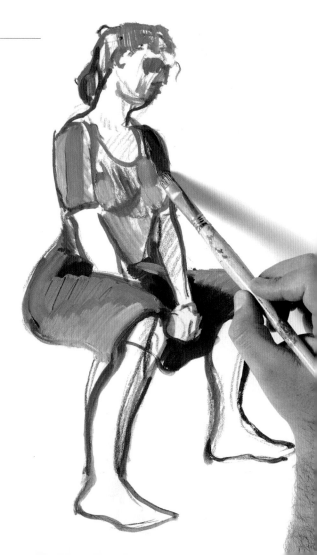

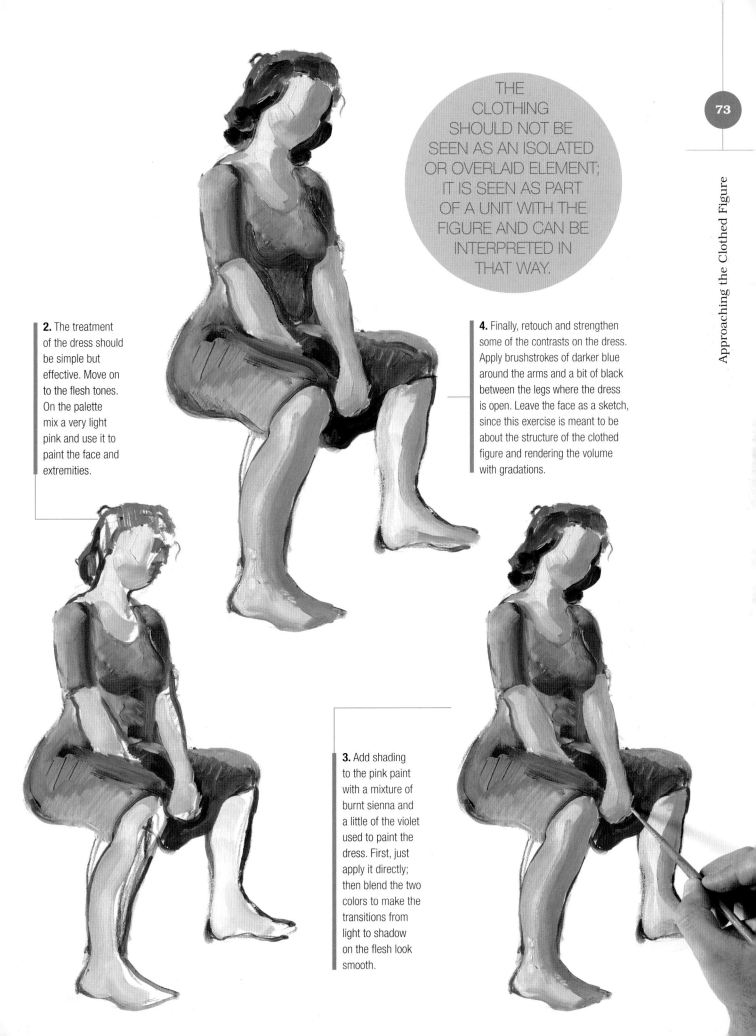

THE CLOTHING SHOULD NOT BE SEEN AS AN ISOLATED OR OVERLAID ELEMENT; IT IS SEEN AS PART OF A UNIT WITH THE FIGURE AND CAN BE INTERPRETED IN THAT WAY.

2. The treatment of the dress should be simple but effective. Move on to the flesh tones. On the palette mix a very light pink and use it to paint the face and extremities.

4. Finally, retouch and strengthen some of the contrasts on the dress. Apply brushstrokes of darker blue around the arms and a bit of black between the legs where the dress is open. Leave the face as a sketch, since this exercise is meant to be about the structure of the clothed figure and rendering the volume with gradations.

3. Add shading to the pink paint with a mixture of burnt sienna and a little of the violet used to paint the dress. First, just apply it directly; then blend the two colors to make the transitions from light to shadow on the flesh look smooth.

From the Sketch to the **Clothed Figure**

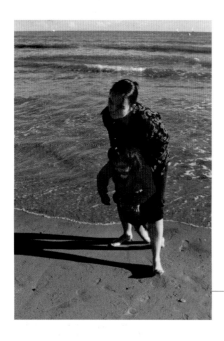

To block in a clothed figure, you must understand the model as a whole so that the clothing becomes part of an inseparable unit. Generally, when using a geometric approach, the figure is interpreted with very simple volumetric forms that are completed as the drawing advances by adding tones and details, the shadows and the folds of the clothing. This exercise with a clothed figure is very simple; it is a woman with a little girl at the beach. It is done completely in charcoal, a quick and direct medium that is very easy to change and correct.

It is a good idea to begin drawing the figures with simple, common clothing. A strong lateral light will help you in constructing the figures.

1. The two figures should not be considered separately but form a unit that can be synthesized with a few geometric planes, in this case a pair of cones and three circles of different sizes.

2. The inverted cone is the basis for the bodies of the two figures. The head and arms of the little girl are sketched as a circle, while an oval is drawn for the woman's head.

3. Continue working on the forms, erasing and redrawing when necessary. Little by little the form of the two figures will emerge, and the outlines of the woman and girl will be perceptible.

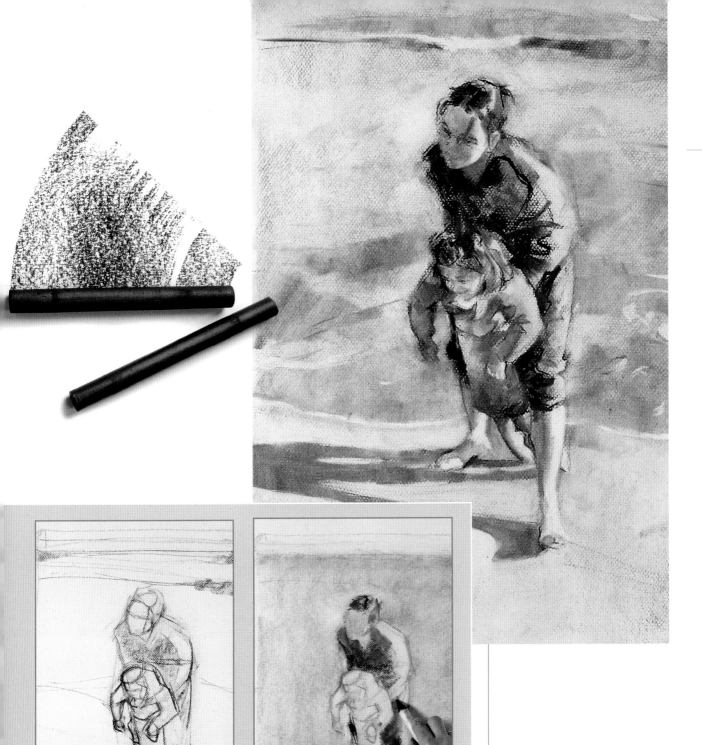

4. Thanks to the blocking in, it is now much easier to draw the two figures more accurately. Work on the arms and legs with darker and more detailed lines.

5. Use the side of the point of the charcoal stick to make the contrasting shadows on the clothing. The gradations that highlight the volume are made by rubbing the pigment with a blending stick.

6. The folds should be drawn darkly with curving lines, and an eraser used to create highlights. The finished drawing has a simplified tonal range, where the dark areas form solid masses that unify the image.

A Figure in the Street
with Watercolors

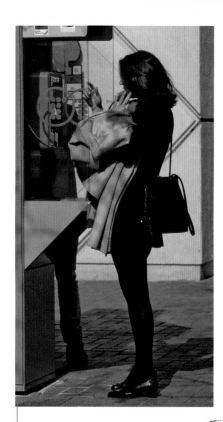

The model is a young woman standing at a telephone booth, so we know she will be in a more or less static position for a few minutes.

In the previous exercise you drew a clothed figure with charcoal; here, on the other hand, you will use watercolors to create a series of washes. This approach will give you a better idea of the challenges of representing the figure, combining color and light and a suggestion of the elements of the space that the model occupies. Watercolors allow you to work outdoors and capture real figures in the street, quickly and with no technical complications. This can be finished with just a few strokes of color.

IT IS NOT NECESSARY TO ADD FOLDS OR SHADING; APPROXIMATE THE FIGURE WITH VERY LITTLE MODELING.

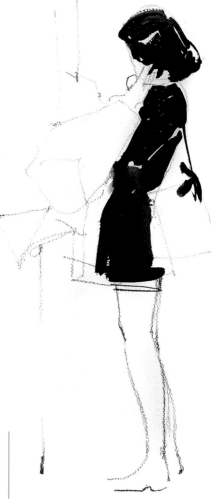

1. The preliminary sketch is important in capturing the elegant outline of the figure and her posture in front of the telephone booth. Draw the body's outline with just a few lines, even continuing the line underneath the clothing to better understand the rhythm of the figure.

2. Mix carmine, ultramarine blue, and a little black for painting her hair and jacket. The wash should not go outside the lines of the drawing. Leave a white line on the paper so you can later draw the outline of her arm.

Sketching Figures

When painting people in the street, it is better to use very few colors. The brushstrokes that define the clothing are quite flat, and the shadows and wrinkles are barely indicated. Some parts of the body can even be left unfinished.

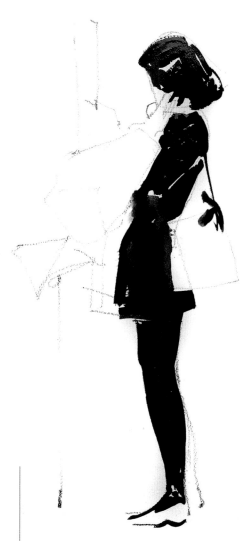

3. Using the mixture of black and carmine, continue downward with a dark stroke to define the legs. The volume will be created by a faint carmine tone that runs down the middle of the leg. Start on the bag using the tip of the brush and a minimum amount of pressure to create a very fine line.

4. Paint the overcoat with diluted carmine and a touch of blue. There is no need to make a study of the folds; the treatment should be very stylized, leaving the paper white in the lightest areas. The same goes for the bag, whose reflections can be represented with three white spaces. Suggest the hands with a little ochre and pink, and using several mauve lines, you can create an indication of the telephone booth.

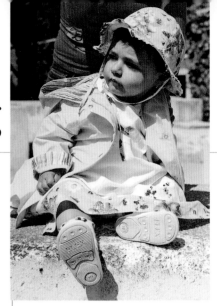

Oil Sketch:
An Interest in Clothing

Oils are an ideal medium for creating the texture and folds in clothing, especially when there are many different shades, colors, kinds of folds, and even prints. To become familiar with the techniques, it is a good idea to make several studies of clothed models: adults, senior citizens, and even children, painting the clothing in a loosely sketched style. To practice, repeatedly brush with the tip across the different colors to slightly blend them with each other so that the modeling will not be too hard and contrasting.

The folds and light and shadows that describe them are an ideal complement to the volumes of this young model.

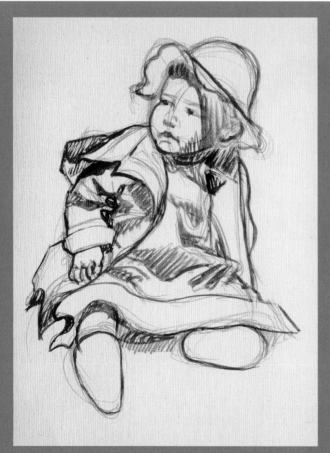

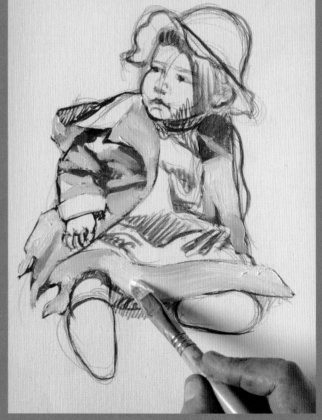

1. Make a pencil drawing, and when it is blocked in to your satisfaction go over it with a very fine brush and violet paint that has been heavily diluted with turpentine. Use the same color to indicate a few of the shadows.

2. Build up the girl's jacket with three or four different yellow tones. The color should be thick from the start. It is a matter of applying an approximate color in each area and then adding some white to the illuminated areas and violet and burnt sienna in the shadows made by the lapels and the wrinkles.

The gradations appear right next to the folds, with the lightest values in the high parts and the darkest in the hollows.

When the light is bright and the clothing is very wrinkled, the lines of the folds should be clearly visible.

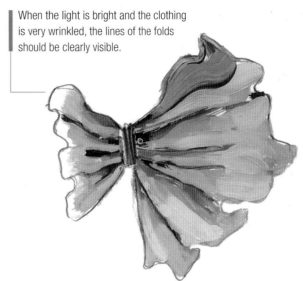

3. The colors have been applied "alla prima," with some of the mixing done on the support. Blend the different yellow tones to keep the brushstrokes from being isolated and without cohesion. Paint the shoes with ochre lightened with white. Even though the paint is very thick, avoid covering the initial violet lines that emphasize parts of the outline.

4. Finish the white dress by making a gradation of titanium white with gray violet. The paint should be thick and show the brush marks that follow the direction of the folds. Sketch and blend in the stripes and patterns. Then paint the flesh tones with a mixture of ochre and lightened carmine.

A Pair of Figures with **Chiaroscuro**

Chiaroscuro is a technique that is often used when the scene is illuminated by a single source of light, like an interior, for example. The following exercise puts this technique into practice using acrylics to represent a pair of female figures at a table that is illuminated by a lamp. This light is close and warm, but still quite dark, and requires strong modeling on the volumes. The flesh tones should be treated delicately, and some highlights should be applied to the most prominent parts of the faces. Middle tones should dominate nearly the entire scene and emphasize the calm atmosphere in the picture.

The two clothed female figures are illuminated by the artificial light of a lamp that creates interesting chiaroscuro effects.

The Process of Illuminating the Figures

Starting with a dark background, you will progressively paint the impact of the light on the figures. Start with the lightest shadows and move to the illuminated areas of the figures, finishing with the highlights, the points where the incidence of light is strongest. The highlights are ineffectual if you overuse them or spread them around the painting. They must be concentrated only in the areas where they contribute to the contrast and emphasize the effect of the volumes. In this way, as you paint, you go through a process of illuminating the model whose volume emerges from the darkness little by little.

1. Prepare the support by painting it with a mixture of Prussian blue, burnt sienna, and a little violet. Do not make a flat layer; it should be a gradation where the blue is lighter on the left from the effect of the lamp that lights the scene.

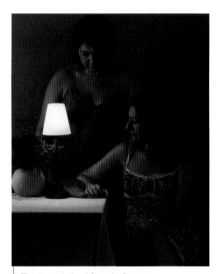

2. Wait for half an hour for the background to dry; then draw the scene directly with a medium brush charged with thick pure violet that has barely been diluted with water. Apply it very loosely, making a base that will indicate the extension of the first strokes of color.

The Violet Sketch

Drawing with bright blue or violet over a background of a lighter version of the same color is a very common technique among artists. It keeps the lines of the drawing from contrasting too much, and working with colors from the same range begins a process of integration from the first phase of the work.

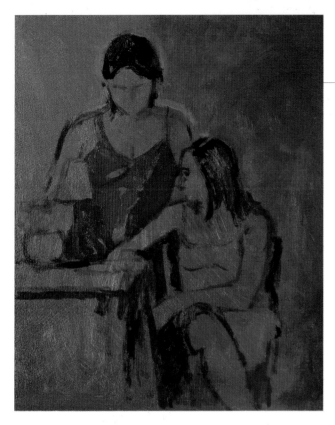

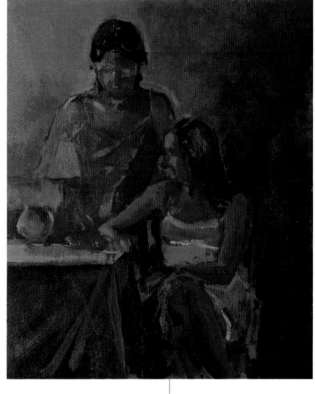

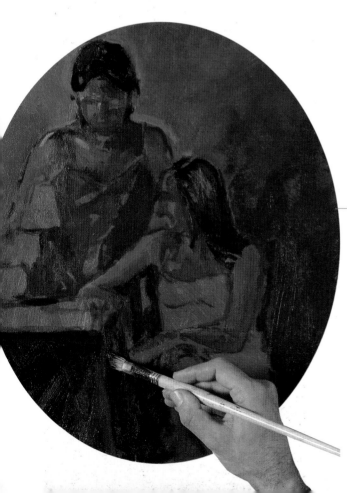

The first phases of the painting begin with resolving the intermediate tones, which consist of a range of violets.

3. Paint the first dark strokes of burnt sienna mixed with violet in the figure's hair. Then, with a mixture of different shades of violet and carmine, sketch in the dress of the standing figure, indicating the edge where the areas of light and shadow meet.

4. Browns like burnt umber and ochre are mixed with a little violet so the colors in the painting will integrate better. Using this combination of colors, paint the cloth on the table. Then add a first suggestion of the flesh tones with a mixture of burnt sienna, a touch of violet, and white.

5. Acrylic paint dries very quickly; this allows you to add new colors without worry that they will mix with the previous ones. Paint the dress of the seated figure with ochre and a bit of violet; then add some brushstrokes of warmer colors on the flesh tones. Mix carmine and red to emphasize the intensity of the scarf on the table.

The Use of the Background Color

The figures should be built up little by little with strokes of adjacent colors. Fill the spaces of the painting like the pieces of a puzzle. In some cases the paint should not completely cover the background, with small areas left alone so the blue on the support can suggest a random shadow or outline the edge of a part of a figure. When working on colored backgrounds, they should also be allowed to participate, striving to show through between the brushstrokes. It makes no sense to cover them completely.

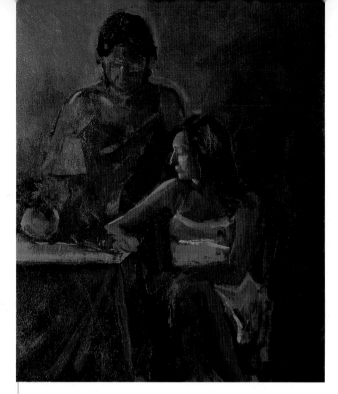

6. Paint the first illuminated areas on the seated figure with mixed carmine, a touch of ochre, and white, using a fine round brush. Make gradations blending the new paint with the previous applications. You are not striving for a portrait, but to reproduce the lighted areas with very few details.

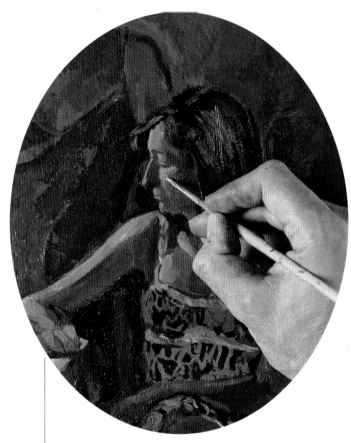

7. Add new touches of light on the hair and face; then use burnt umber to suggest the pattern on the dress. It should be made with simple brushstrokes, leaving some space between the design and not trying to be too specific.

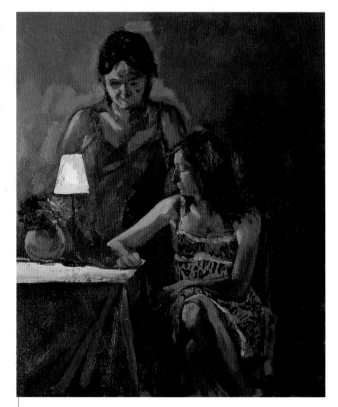

8. Continue by gradually lightening the flesh tones by applying washes that add more light to the ones underneath. Paint the lampshade with violet gray, white in the center, and yellow on the edges. Then add the first highlights to the face of the standing figure.

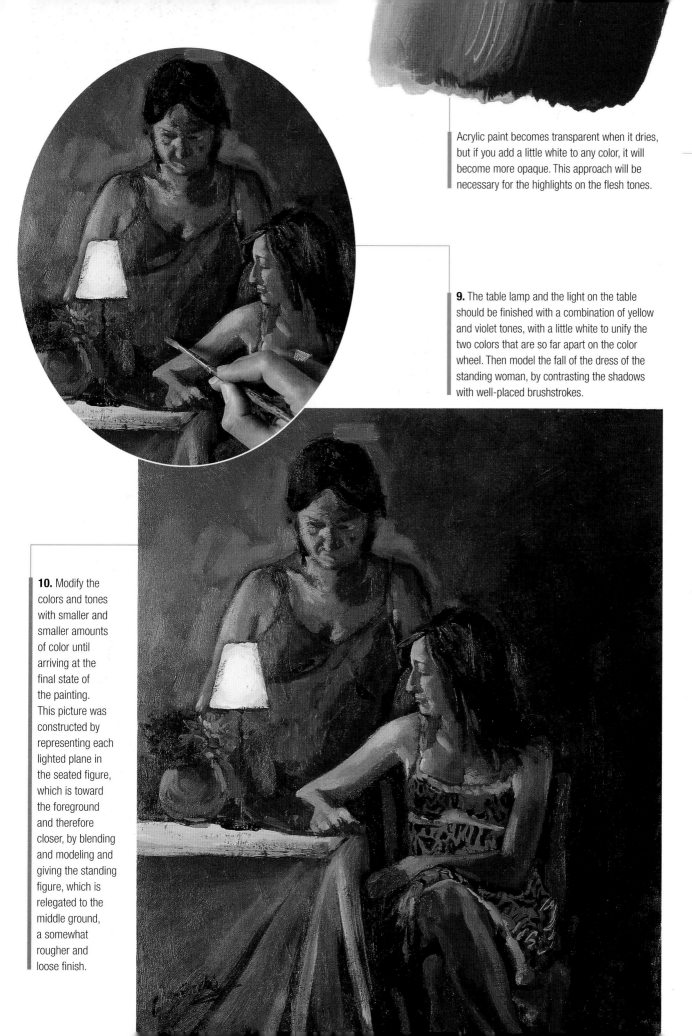

Acrylic paint becomes transparent when it dries, but if you add a little white to any color, it will become more opaque. This approach will be necessary for the highlights on the flesh tones.

9. The table lamp and the light on the table should be finished with a combination of yellow and violet tones, with a little white to unify the two colors that are so far apart on the color wheel. Then model the fall of the dress of the standing woman, by contrasting the shadows with well-placed brushstrokes.

10. Modify the colors and tones with smaller and smaller amounts of color until arriving at the final state of the painting. This picture was constructed by representing each lighted plane in the seated figure, which is toward the foreground and therefore closer, by blending and modeling and giving the standing figure, which is relegated to the middle ground, a somewhat rougher and loose finish.

Incidence of Light
on a Leather Jacket

Of the many textures that can be found on articles of clothing, leather requires special attention. It has an intense sheen that is accentuated on the outward surfaces of the folds. Shiny leather contains in its texture a great variety of contrasts that alternate between areas that are completely dark to medium tones, and with surfaces that have a satiny sheen that strongly emphasizes reflections. In this exercise we have a seated model wearing a leather jacket; her bent arm creates many pronounced wrinkles that create an interesting arabesque line and weak contrasts on the texture of the leather. Use charcoal; white chalk; dark brown, raw sienna, and sanguine crayons.

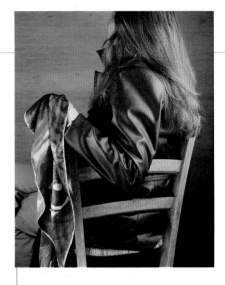

This is a detail of a seated figure with a leather jacket. The bent arm creates an interesting play of light and shadows.

1. Make an initial sketch of the figure with the tip of a sanguine crayon. We are especially interested in the position of the arm, the shape of the scarf, and the lines of the prominent folds. The face is hidden by the hair and does not present any particular problems.

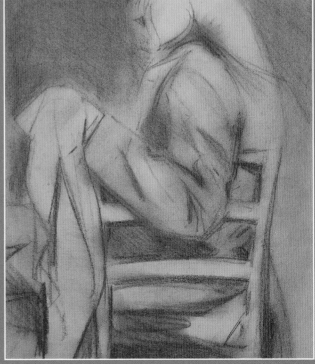

2. Shade the background with a small piece of the sanguine crayon to make the figure stand out. Use your hand to blend everything, spreading the pigment across the entire surface. You want to create some atmosphere and a mid tone on which you can easily create white highlights.

Two Drawing Phases

When working with colored chalk, the shininess of the leather is created in two clearly differentiated phases. During the first phase you make the drawing and shade the folds, leaving much lighter tones in the lighter spaces, barely shading them by blending with your hand and some sanguine. In the second phase you add the white to complete the texture and then add the satiny highlights that are typical of leather.

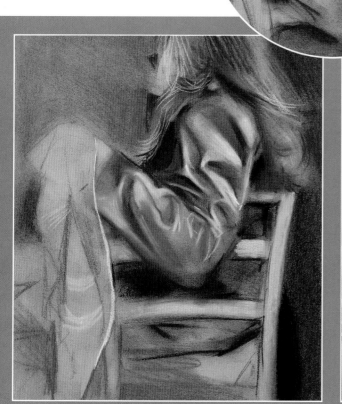

3. Work on the hair with dark brown chalk, applying direct, fine lines to represent its texture. Darken the folds on the arm to make contrasting shadows, and emphasize the lighter areas with small white highlights.

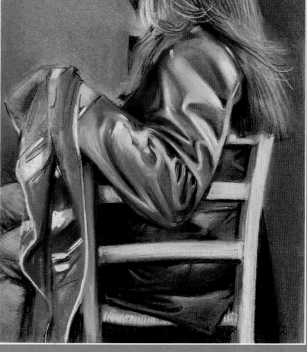

4. Continue defining the form in the chair, which stands out against the dark brown background, strengthening it with heavy charcoal lines. The values on the folds become lighter and lighter because they contrast with the applications of charcoal. Add more dark brown chalk, making it darker along the edges where more accuracy is required.

5. Use the charcoal to bring back some outlines and increase the contrast in the darkest areas. Blend each new addition of color with your finger to describe the modeling of the figure. Finally, strengthen the highlights with white chalk, which will help express the volume of the folds on the arm of the jacket.

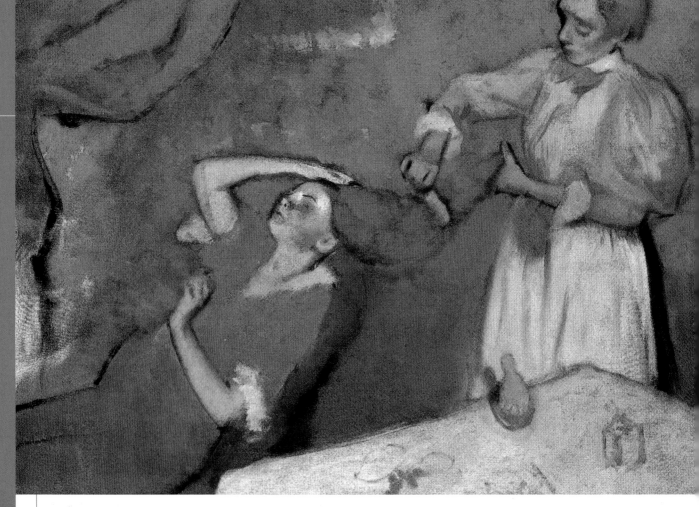

Edgar Degas (1834–1917), in his oil *Combing the Hair*, uses color, as seen in the dominant reds and oranges, to integrate the figure into a warm environment. Just a few linear brushstrokes of dark violet are needed to indicate the outline of the figure and the folds in the curtains.

The Figure in **Its Environment**

Rarely does a figure appear in isolation; it is usually integrated in a context, with a background in the form of an interior scene containing everyday objects, or an urban setting where it is related to other figures in an outdoor space.

Paintings where the subjects interact with their surroundings, or in a specific context, are much more interesting than the representation of a nude model posing on a platform in an art school. The reason for this is that they tell a story as they capture the figure in action; a group of people in conversation, a couple walking through the streets, a woman reading in the window, and so on. These are not just representations of the figure, but also depictions of human activity and daily life, and their presence adds life to the space they occupy.

The Amount of Detail in the Space

Before drawing a setting filled with figures you must consider the balance among the parts: the relationship between the figure and the background. You need to decide whether to give importance to the architecture or the interior or exterior space it contains. If the figures are to be the center of interest, the background will be a scene in the shadows painted with simple strokes and lines, a simple structure that situates and frames the scene.

Figures and Flowers

Many artists incorporate flowers when painting the female nude. Flowers are a metaphor for the beauty of the feminine nude in relation to the beauty of nature. The colors of the flowers enhance the work. These natural elements can be included without having to literally describe their shape and presence in the painting; they can be suggested with strokes of bright colors that evoke the presence of a vase with flowers.

A few structural lines fix the limits of the interior space. The figures are treated with quick, nervous lines, with the nearer ones being captured as gestures.

The contrasting colors that suggest the fruit trees in the background are painted with very loose brushstrokes that reinforce the austere colors of the figure.

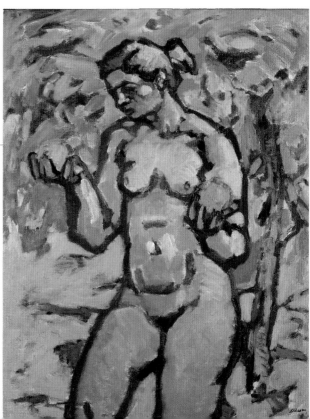

From Posture to Gesture

Nude models tend to position their bodies in rhythmic and harmonious poses to create an attractive model for the artist. But when figures are depicted in their environments, they act and move in more natural ways, they touch each other, lean on each other, and gesture when they communicate. Therefore, when representing a group of people, you must try to describe those characteristic movements that can be frozen in a gesture, with more rigid and natural postures than those of an artist's model in the studio.

Relating the Figure to the **Background**

On most occasions, the figure being represented is not totally isolated but is shown in a context where he or she carries on an activity, extending the representation outside of the figure itself to create a background space created with a combination of sketched forms and various areas of color that suggest depth, light, and atmosphere. The background can range from the most simple to the most complex. It does not have to be deep; it can consist of a chromatic and even abstract treatment around the figure, constructed with a series of brushstrokes and free applications of color.

Nude and Patterned Background

Including a patterned or colorist background comes from the idea of dressing the model, of adding to the painting a larger range of colors and contrasts than those used for the figure. This is a way to dress the figure in its context and to make it more interesting artistically, with a greater painterly feeling.

It is evident that a nude figure can exist completely independently without the need of a background; however, many artists take advantage of introducing a greater number of elements into the painting for added shading and values.

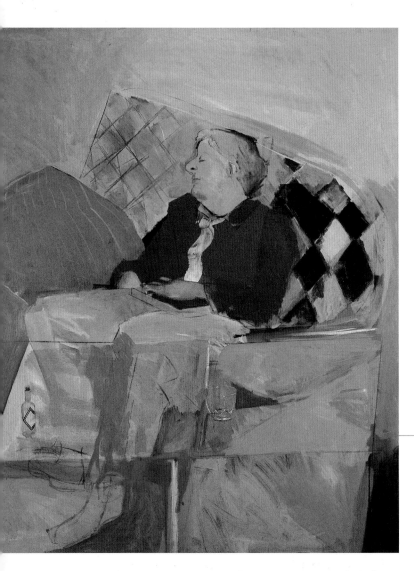

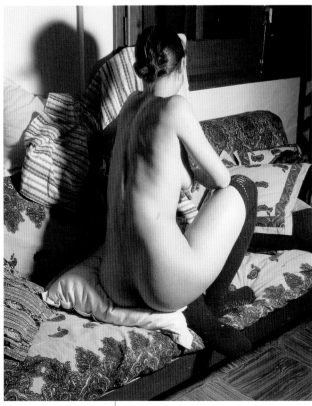

Patterned backgrounds add interesting colors and designs to the figure study.

Adding strongly colored components to the background, like cushions and patterned fabrics, gives the nude a more painterly feeling.

To Explain or Suggest?

When you wish to make the figure the protagonist of the piece, it is better to suggest the atmosphere that surrounds the figure rather than to show it in detail. You can sketch the interior of a room, the buildings in a street, the furniture, or the rear of a garden by applying more or fewer abstract lines and shapes. This means that these colors may be introduced without having to describe the shapes of the objects behind the model. The artist can create areas of contrasting colors that simply evoke something without describing it: a sofa, a balcony, and so on. You should choose the freedom of making a loose gestural line or brushstroke rather than imposing the realism of the actual model.

The Contrast Illustrates the Outline

Although the colors of the figure and the background are very different, they help each other by emphasizing the outline of the figure through contrast. The unity of the work is achieved by modeling the flesh of the figure and the colors of the background equally.

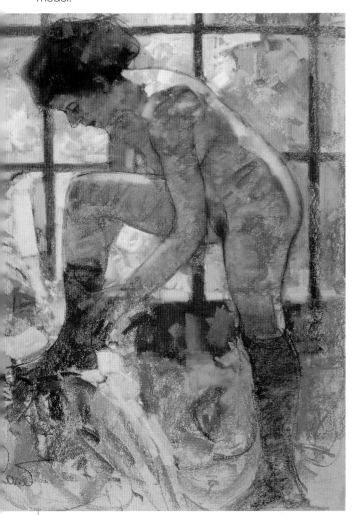

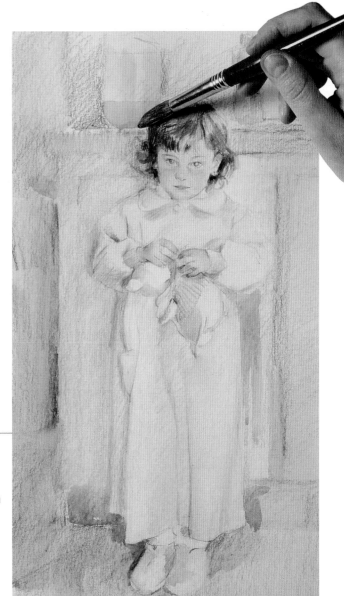

The background suggests a window, a physical space, but it is constructed with a series of abstract areas of paint that strive to balance the flesh tones of the figure.

It is better to suggest the background than to try to illustrate the furniture and objects in detail. Nothing should take the importance away from the figure.

Figure in an Interior:
Environment and Atmosphere

Including a figure in an interior allows you to introduce perspective and new and interesting plays of light that can affect the way it looks. In such cases, the figure is not an isolated object, a simple element superimposed on a background; it should be integrated and blend into the atmosphere of the place. Interiors offer many possibilities as a setting in which to place a figure: next to a bookshelf or a window, in a large salon, and so on. This requires careful control of the relationship between the lights and shadows, as well as the forms and textures of the materials that can be introduced, like tapestries, curtains, tablecloths, cushions, and rugs.

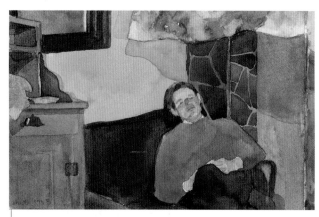

Friends and family seated in a corner of your home can become patient and uncomplaining models.

The Model at Home

The opportunities for drawing a human figure at home are numerous, including family members sitting quietly, friends visiting, or children playing. If you frequently observe the static poses they adopt (on the sofa, standing in the kitchen, sleeping in bed), you will create a visual memory of their physical forms, facial expressions, and different postures in various situations and rooms of the house. To start with, it is best to paint the figure in front of a flat wall or a window to avoid possible problems with perspective. As you build your confidence, you can add more depth to your scenes, placing them in one of the corners of a room, which requires drawing diagonal lines, and constructing a space in perspective before placing the figure in it.

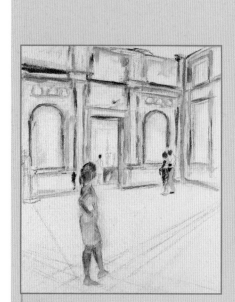

When drawing a figure in an interior, first resolve the placement of the model with respect to the space and then draw in the background and interior architectural details.

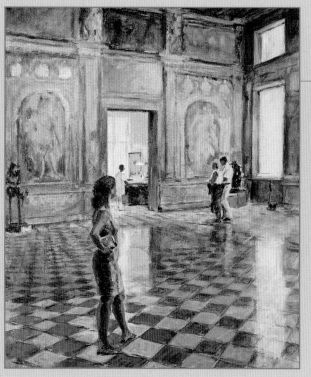

One of the most popular approaches for representing light and integrating the figure in its environment is to give the painting a monochromatic tendency, avoiding exaggerated contrasts of tone and color.

Environment and Atmosphere

The figure can be integrated into the environment of the room, the atmosphere, or even specific lighting conditions by using blending techniques, colors, and chiaroscuro. The atmospheric effect is an optical sensation that is caused by the moisture in the air and particles contained in it, although in interiors it is also associated with certain types of illumination. In these cases the environment in the room softens the edges, and the integration of the figure into the background is more fluid and without abrupt changes and interruptions. The work should be finished with a light blending to unify the silhouette and any possible abrupt changes in tone between the figure and the background.

The Sleeping Figure

There is no better occasion to draw or paint a figure than when it is sleeping, since it maintains the same posture for long periods of time. In addition, the artist can intervene as if painting a still life, slightly modifying the light or changing the folds of the sheets as desired.

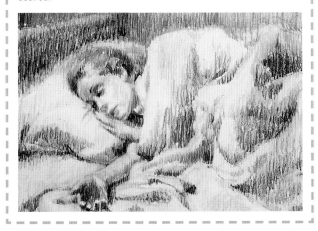

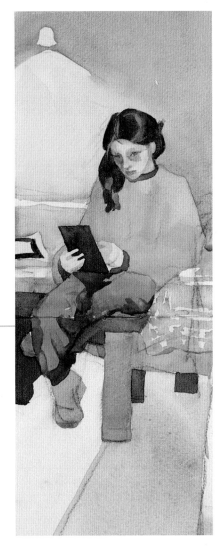

The lighting conditions in the interior are important when describing the figure. The furniture should be suggested with simple geometric shapes that will not take focus away from the model.

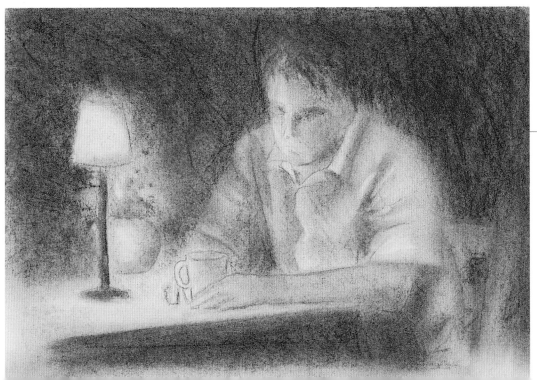

You can create a very atmospheric environment by blending, blurring the edges of the figure to integrate it into the background.

The Figure in **Urban Spaces**

One of the most interesting places for representing the figure is an urban environment: moving through the streets, walking through a park, or relaxing on the terrace of a bar or in a cafeteria. Drawing the perspective in an interior is not very important, but the role of architecture in an urban scene is so important that ignoring it can be considered foolish. The perspective can be indicated by projecting some lines to a vanishing point to determine the angles of the façades and to show the way they become smaller in the distance. These same lines can be useful for emphasizing the distance of the street or establishing the scale that will help you illustrate the diminishing size of the people as they move farther away.

Draw the Static Poses First

In a busy place like this street with a multitude of figures in movement, it is a good idea to draw the city environment first, noticing the lines of perspective and the depth of the space. The façades and the urban elements should just be sketched, with few details. Then, make representations of the seated people, because they usually spend more time in one position than people who are standing. Finally, start on the moving figures; you must observe them for quite a while, trying to memorize everything you see, especially the body types (whether the people are short, tall, fat, or thin) and clothing. Use just a few lines to draw all this information on the paper.

If the people move too fast and you do not have time to represent a complete individual, you can draw various fragments and then assemble parts from several of them to compose an entire figure.

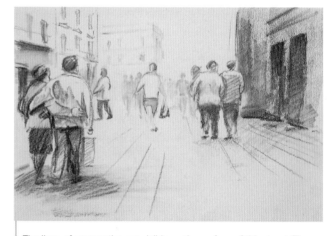

The lines of perspective are visible on the surface of this street. They give the scene depth and help control the diminishing height of the figures as they move away.

The Greater the Distance the Less Detail

When painting or drawing, you must consider how far you are from the figures. The nearest ones are more detailed, with their features and clothing simply sketched. As they get farther away, the details fade, the features blur, and the outlines of the bodies become indistinct.

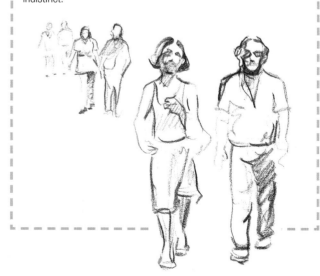

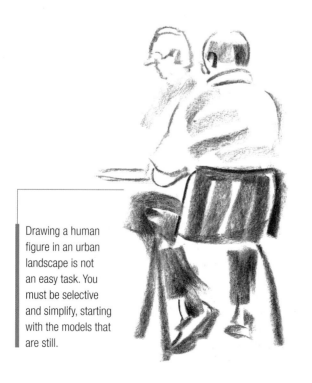

Drawing a human figure in an urban landscape is not an easy task. You must be selective and simplify, starting with the models that are still.

With a Few Brushstrokes

When painting cityscapes with oils or acrylics, the figures should be painted with just a few quick and accurate brushstrokes, trying to suggest with no details. The form of the head and the positions of the body parts, which are necessary for understanding the figure's posture, can be resolved with the first strokes of brown paint. Then it is the torso's turn, which can be filled in by directly mixing a couple of colors. Finally, work on the legs, the contrasts of light on the clothing, and the hair. The feet can be left unfinished.

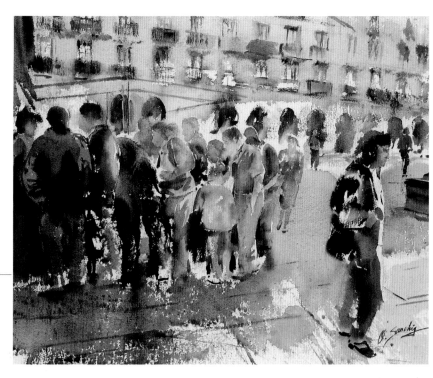

The figures are handled in a loose manner, not very detailed, and even blurred. All these factors help explain the feeling of hustle and bustle and constant movement communicated by the figures.

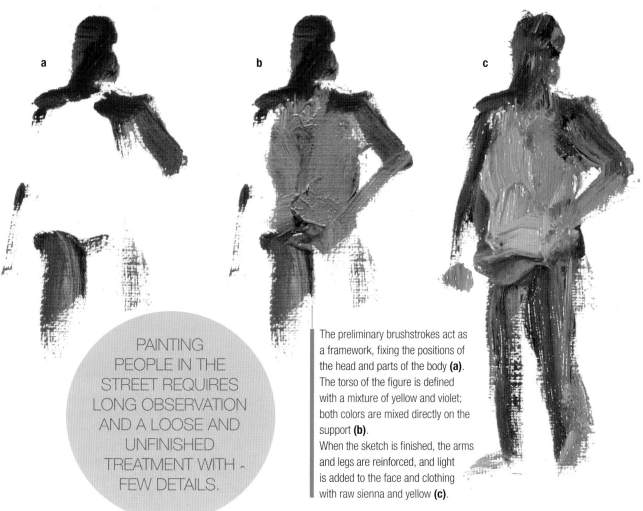

a

b

c

PAINTING PEOPLE IN THE STREET REQUIRES LONG OBSERVATION AND A LOOSE AND UNFINISHED TREATMENT WITH FEW DETAILS.

The preliminary brushstrokes act as a framework, fixing the positions of the head and parts of the body **(a)**. The torso of the figure is defined with a mixture of yellow and violet; both colors are mixed directly on the support **(b)**.
When the sketch is finished, the arms and legs are reinforced, and light is added to the face and clothing with raw sienna and yellow **(c)**.

Interior with **Figure**

When you are representing a figure in an interior, paint it with the same light conditions as the room, matching it to the atmosphere so that the figure does not clash chromatically. Here we propose representing a young girl in a well-lighted room, where the values of the light and the use of lightened colors play a fundamental role. Although the subject may seem complex at first, it is not if you ignore the details, leave out the objects in the background, and focus your attention on the form and modeling its light and volumes. This exercise was done with dry pastel sticks and charcoal.

An intense lateral light bathes the figure and the interior, which makes it a very attractive subject for painting with pastels.

1. Lay out the preliminary sketch with blue pastel. It should be strictly for composition, outlining the framing and deciding the position and size of the figure with respect to the background.

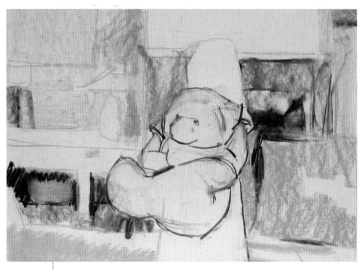

2. The lines organize the scene. They outline the shape of the figure and define the furnishings in the background with horizontal and vertical lines. Go over the initial drawing with charcoal, adding shading and additional lines on the teddy bear.

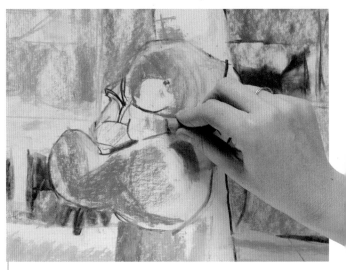

3. Apply some generalized areas, choosing a color for each part and using the sides of the pastels on the paper. These will be the blocked-in base colors, establishing a chromatic base over which you will shade and add more details.

With a Few Brushstrokes

When painting cityscapes with oils or acrylics, the figures should be painted with just a few quick and accurate brushstrokes, trying to suggest with no details. The form of the head and the positions of the body parts, which are necessary for understanding the figure's posture, can be resolved with the first strokes of brown paint. Then it is the torso's turn, which can be filled in by directly mixing a couple of colors. Finally, work on the legs, the contrasts of light on the clothing, and the hair. The feet can be left unfinished.

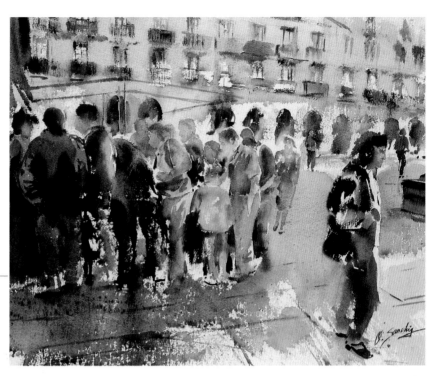

The figures are handled in a loose manner, not very detailed, and even blurred. All these factors help explain the feeling of hustle and bustle and constant movement communicated by the figures.

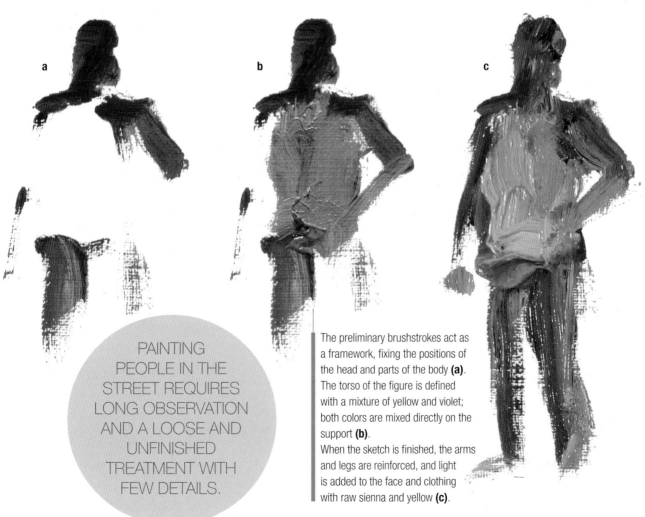

a

b

c

PAINTING PEOPLE IN THE STREET REQUIRES LONG OBSERVATION AND A LOOSE AND UNFINISHED TREATMENT WITH FEW DETAILS.

The preliminary brushstrokes act as a framework, fixing the positions of the head and parts of the body **(a)**. The torso of the figure is defined with a mixture of yellow and violet; both colors are mixed directly on the support **(b)**.
When the sketch is finished, the arms and legs are reinforced, and light is added to the face and clothing with raw sienna and yellow **(c)**.

A Street **Market**

The best way to paint people moving through the streets is to learn to sketch, to make quick and precise strokes that are very gestural and effectively explain the form and posture adopted by each figure. This means painting the head with just a brushstroke, the body with a couple or three, mixing the colors directly on the support, and suggesting arms and legs with a continuous thick stroke of paint. In this exercise done in oils we demonstrate how to work in this manner. It is a matter of capturing what is essential about each figure with very gestural brushstrokes to communicate the hustle and bustle of a small street market.

The figures are sketched with a few brushstrokes, and part of the paint is mixed directly on the support.

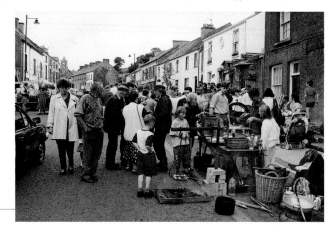

A local market is an urban scene that is full of figures that are moving from one place to another. There is little time to capture it.

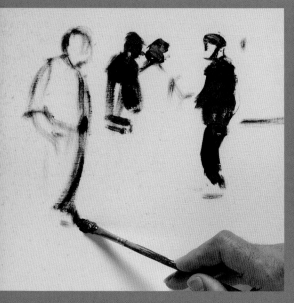

1. Since we are representing a scene in a loosely sketched style, we will paint without a preliminary drawing. Synthesize the central figures with a well-charged brush, using just a couple of colors. Here the brush becomes a useful drawing tool.

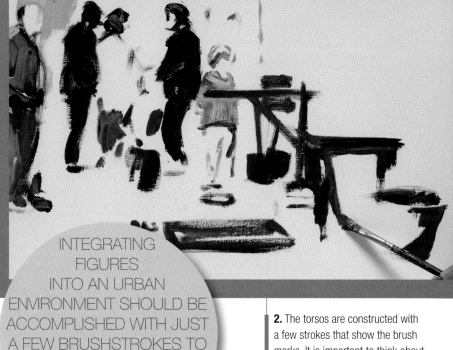

INTEGRATING FIGURES INTO AN URBAN ENVIRONMENT SHOULD BE ACCOMPLISHED WITH JUST A FEW BRUSHSTROKES TO CAPTURE THE GESTURES AND THE ACTION RATHER THAN THE DETAILS.

2. The torsos are constructed with a few strokes that show the brush marks. It is important to think about each brushstroke, the placement of the paint, and the direction of the stroke to best suggest the object being represented.

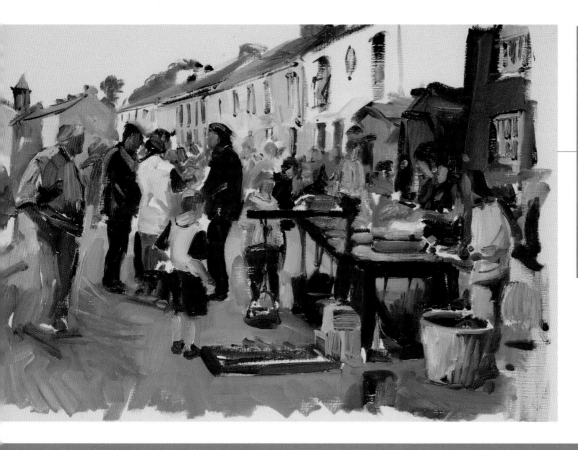

5. Finally, when the people and the houses have covered the open areas, add some lines with a fine brush to represent the openings in the façades and the rooftops. At no time should you apply these kinds of lines to the figures.

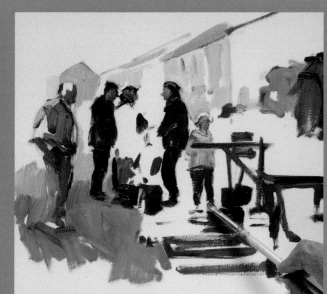

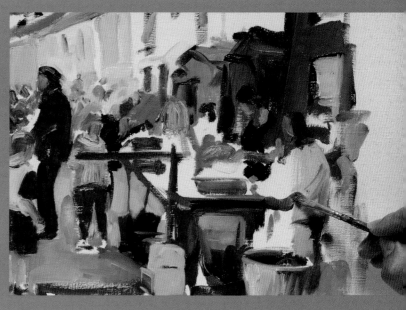

3. The façades of the houses begin appearing behind the figures and, if possible, are indicated more simply than the figures. Start painting the skin tones of some pedestrians with a mixture of sienna and ochre. Always apply the oil paint thick, without diluting it with turpentine; thus the brush marks will be clearly visible and add expressiveness to the painting.

4. Even though the figures are represented with a few brushstrokes, they should describe the attitude of the figure and the action it carries out, noting the positions of the arms and legs. You are not painting static mannequins, but people that are moving and taking part in some activity. To finish the painting, use a fine round brush to add some details to the façades, like drawing the lines of the roof tiles and the windows.

Interior with **Figure**

When you are representing a figure in an interior, paint it with the same light conditions as the room, matching it to the atmosphere so that the figure does not clash chromatically. Here we propose representing a young girl in a well-lighted room, where the values of the light and the use of lightened colors play a fundamental role. Although the subject may seem complex at first, it is not if you ignore the details, leave out the objects in the background, and focus your attention on the form and modeling its light and volumes. This exercise was done with dry pastel sticks and charcoal.

An intense lateral light bathes the figure and the interior, which makes it a very attractive subject for painting with pastels.

1. Lay out the preliminary sketch with blue pastel. It should be strictly for composition, outlining the framing and deciding the position and size of the figure with respect to the background.

2. The lines organize the scene. They outline the shape of the figure and define the furnishings in the background with horizontal and vertical lines. Go over the initial drawing with charcoal, adding shading and additional lines on the teddy bear.

3. Apply some generalized areas, choosing a color for each part and using the sides of the pastels on the paper. These will be the blocked-in base colors, establishing a chromatic base over which you will shade and add more details.

4. The colors of the background are the same as those that show up in the figure and that create the atmosphere. Blend the colors to model the face, the arms, and the bear, leaving the paper white in the areas that receive the most light.

5. When the values and the harmonization of the painting is accurately established, you can draw the features and go over some of the outlines of the figure with light black lines made with charcoal. Darker applications of color should be added to the background.

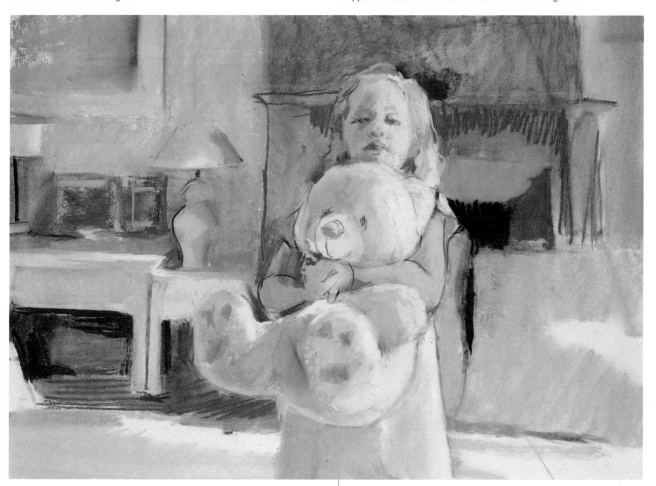

6. The facial features of the girl and the details of the bear require careful work. To finish, bring back some of the lost outlines, in the background this can be done by using unblended lines in several colors.

Two Figures in an Interior **with Watercolors**

The following subject, two figures seated on an interior staircase, will be painted following the classic watercolor style. Accurately rendering the light in an interior is very important in creating the atmosphere of the painting. The window, an element that is always present in interiors, can be seen as a surface where light passes through; it reinforces the sense of intimacy and determines the appearance and coloring of the figures. This work shows considerable virtuosity in its treatment of the light and shadows and in its ability to capture the likeness of the two people.

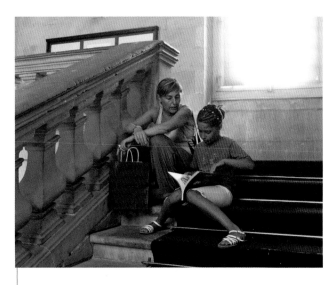

The model establishes a formal dialogue between the interior space and the exterior through the strong light that comes through the window and falls on the two figures seated on the stairs.

1. The preliminary sketch for the watercolor is done with a pencil of medium hardness, so the line is just dark enough to see. Draw the balustrade, the stairs, and the window frame, and only indicate the relevant anatomical features and positions of the figures.

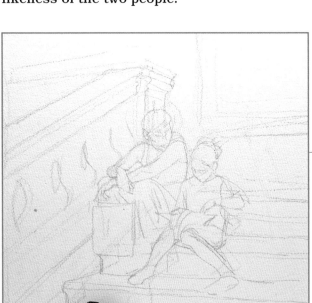

Normally the artist draws with a pencil or lead holder with a hard, or H grade of graphite to avoid as much as possible the lines showing through the final painting.

2. Before painting with watercolors, apply a reserve with white wax crayon where you wish to preserve the white of the paper. The applications should be very exact.

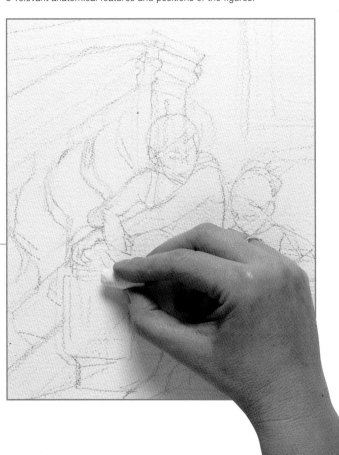

3. Begin by painting the background. Wet the area of the window with a clean brush, wait a few seconds, then apply a wash of Payne's gray. Painting on wet will cause the paint to spread across the damp paper.

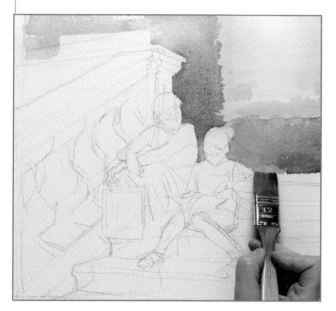

4. Paint the back wall with a wide brush, mixing burnt umber and sienna. Work carefully and do not go over the lines and onto the figures, leave the bodies and the balustrade unpainted.

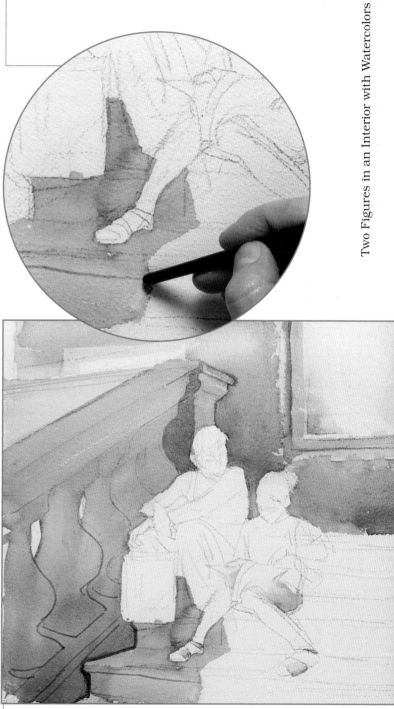

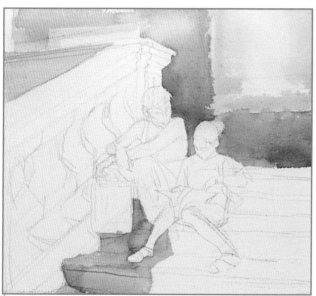

5. Begin painting the stairs in the stairway with blue gray. First apply a wash, and while it is wet go over the pencil lines with the tip of a very fine brush. The indentation will collect some of the color and form a kind of sgraffito.

6. When the previous washes have dried completely, apply a medium gray to the balustrade, leaving the empty spaces between them unpainted. Wait again for the paper to dry before spreading a single shadow on the upper part of this architectural element.

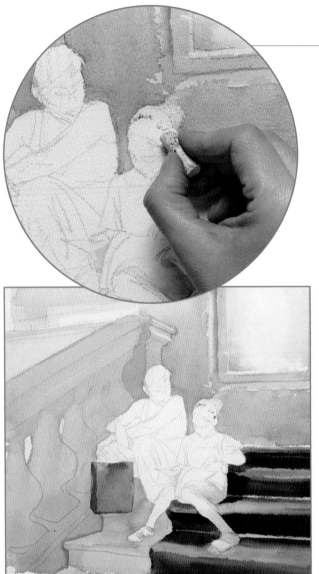

7. Combine different colors of wax crayon on the girl's headband: dots of yellow, blue, and red that will resist the watercolors, so that they will not be ruined by later applications of paint.

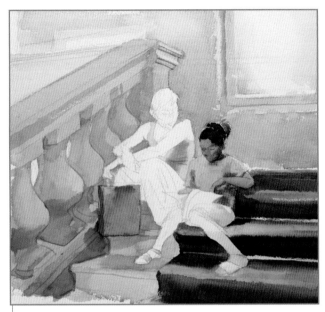

9. The red carpet that covers the stairs is the last large area of color in the interior. Paint it with a mixture of violet and burnt sienna, differentiating the light and shadow on each step. After you have painted it, you will see the space with all its potential light and color. The figures are still white, waiting their turn. From now on, it is a matter of developing the clothing and skin tones of the figures.

8. Apply new gray tones to the balustrade to give it a more volumetric look with the shading. Paint the tee shirts with a base color and add blue brushstrokes to the wrinkles. Mix sienna with ochre, and use the two values to suggest the flesh tones of the girl. Paint her hair with a very dark brown.

The colors can be subtly mixed in wet. It is a commonly used technique when artists wish to paint subtle contrasts or light values on the clothing of the figures.

10. The most interesting values in the painting can be seen on the faces and heads of the figures. Leave small white reserves on the parts of the faces where the light that comes in through the window is strong. The facial features are somewhat blurred, and the arms and legs have simple brown shadows that do not contrast very much.

11. A small amount of retouching on the upper part of the balustrade is left for the end, as is the creation of a second window, drawn in with burnt umber. Use the same color and the tip of a very fine brush to suggest the eyes and the shadows that form below the nose and mouth. The details in the composition are indistinct because of the faint contrasts caused by the strong blinding light that drowns everything.

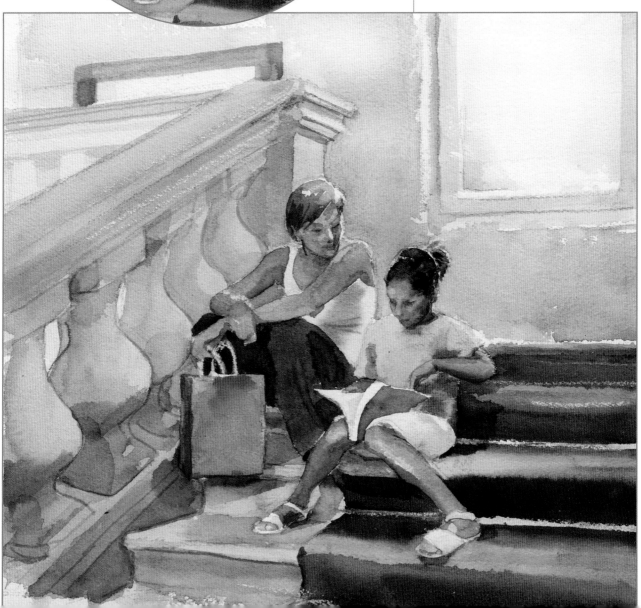

Backlit **Figure**

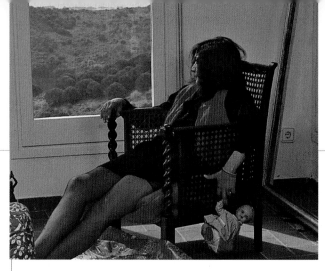

One of the most interesting aspects of drawing the figure in an interior is the incidence of light on the figure, the space, and the various surrounding objects. An often recurring theme is a model in front of a window, because of her calm and reposed attitude and because the light accentuates the contrast against a strongly lit exterior. This harsh impact of light causes the figure to be dark and emphasizes its silhouette. Oils allow you to change colors and correct them at any time during the painting process; the artist can add highlights at the last minute and create a stark contrast without muddying the cleanest and brightest colors.

A figure in front of a window is an attractive subject because of the strongly contrasting light and shadows produced on the body of the model while the light floods the room.

The Figure Emerges from the Shadows

When you represent a figure silhouetted against a window, the light that comes through is so intense that the interior is darkened and the figure emerges from the shadows because of the strong reflections of light seen on her skin and clothing. This subject is very expressive and allows you to combine three genres in one painting: figure, landscape, and interior.

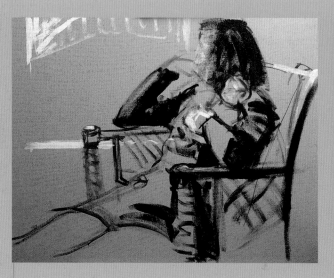

1. Block in the scene directly with a brush and diluted black, emphasizing the darkest areas of shadow. If you wish, you can also make a preliminary sketch with charcoal.

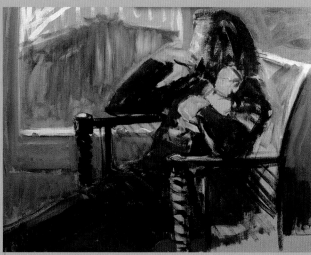

2. In the window, paint a brown background to suggest a landscape; then add some clothing to the model with red, and paint the legs with titanium blue mixed with black and burnt umber. Use the same mixture to cover part of the hair. Use these colors to create flat areas rather than to indicate volume.

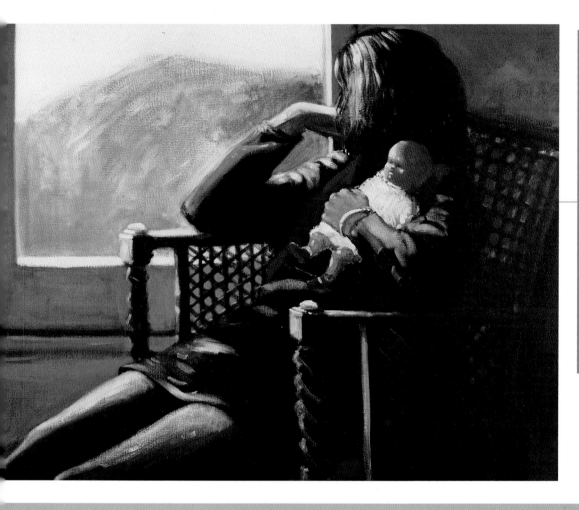

5. Use light gray to indicate the highlights on the outline of the figure to achieve the effect created by the backlighting. Darken the spaces made by the screen on the chair. The middle tones, like the satiny highlights on the legs, should be blended and modeled. Finish painting the hands more delicately and detail the texture of the hair.

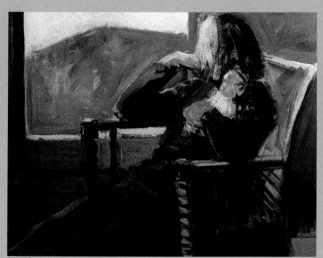

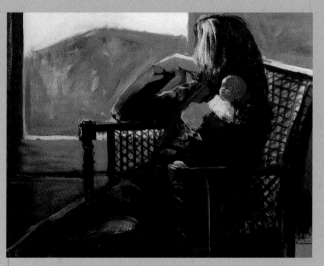

3. Continue to paint a chair over the previously applied base, as well as the first contrasts of light and shadow on the figure. Where they are illuminated, the hand and the hair should be painted with titanium white, and the mountain seen through the window should be painted with a thick mass of gray.

4. Darken the shadow on the face of the doll and detail its features with a very fine brush. Apply some thick gray paint to mark the wrinkles of the clothing. Once these highlights are placed, paint the screen on the chair with straight and vigorous lines made with single strokes of the brush.

Interpreting the Figure

An "interpretation" is the name for the personal way that each artists develops his or her own artistic intention, offering a vision that is modified, altered, and very different from the model, yet capable of showing more character and feeling. Basically, it is related to the creator's particular style and ability to invent, and it is necessary to add some real interest to the representation of the human figure and to awaken the interest of the viewer. Starting with a real model, our interpretation can transform the figure through the controlled distortion of the proportions of the figure, creating tensions and reactions with the brushwork and exaggerating the angles and curves of the outline to add more energy to the pose. The color and the fusion of different techniques and approaches also play a fundamental role in this transformation. In the following section, we show some examples of how you can represent the figure in a more creative and contemporary way.

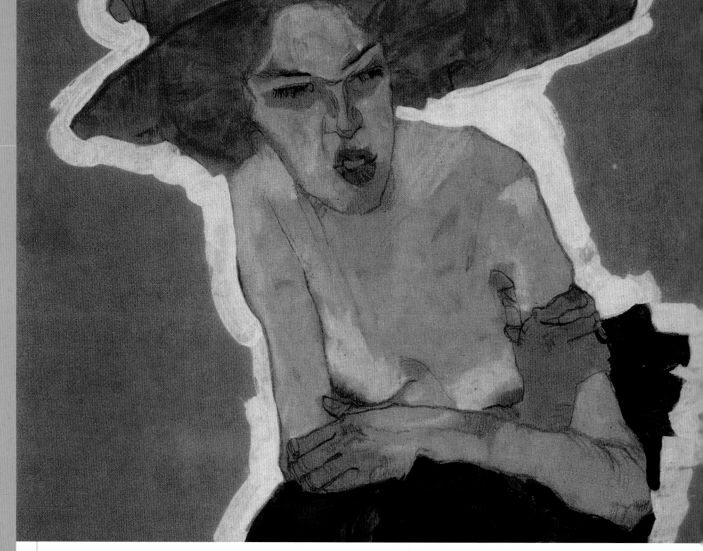

The Austrian artist Egon Schiele (1890–1918) had a style full of stylized figures that were successful because of the beauty and clarity of their lines, like this drawing titled *Talmada* (fragment).

A More **Creative Vision**

To achieve a creative interpretation of the human figure, you must begin with a life model; shell it and pick it apart until it is infused with your own experiences and states of mind.

Therefore, it is important to identify the human figure with aspects that go beyond academic perfection and steep it in meaning, to allow yourself to be carried away by artistic exploration, and to delve into the esthetic attitude that inspires all creative artists who attempt to paint the model exactly as they see it in their minds rather than as they see with their eyes. In this way, the artist deforms, moves, mixes, and alters the forms and the colors at his or her whim so that some elements and aspects of the figure are more clearly identifiable. This kind of interpretation individualizes the figure and impregnates it with the personality of the artist.

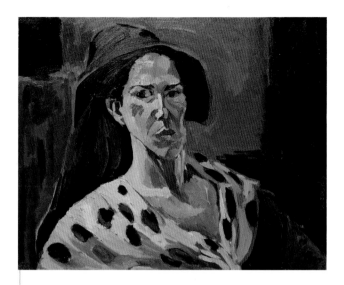

Deformation and stylization, combined with a personalized color palette, allow you to create very daring and original interpretations.

Pure Abstraction

It is very interesting to use painting techniques that are borrowed from abstraction as a way of approaching the nude figure. This treatment emphasizes formal aspects instead of a volumetric description of the body or a harmonious treatment if its proportions. It is not an attempt to physically describe the figure, the pose, or even the lighting conditions; it is an architecture of forms and colors based on the information the artist sees. The criteria governing this activity should be based on the first impression of the expressive power of the painting.

Forms That Create Tension

While a traditional academic drawing results in a balanced composition and a correct-looking model, a more contemporary and creative representation aims for the opposite effect: moving the viewer with the tension, strong contrasts, and perplexing points of view. Tension is the positive result of an unstable composition to activate the forms and break the monotony. The dynamic placement of the colors and the addition of a very bright and contrasting stroke in itself will create chromatic tension, a focus of attention that will perturb and threaten the apparent calm of a range of harmonious colors. There are several kinds of tension: dynamic, static, balanced and unbalanced, and unstable.

Many contemporary artists use techniques borrowed from abstract painting, like dripping and textures, to represent the human figure.

BEING CREATIVE MEANS MODIFYING REALITY: SELECTING, INCREASING, AND ELIMINATING PARTS THAT ARE MORE OR LESS IMPORTANT AND THAT PLAY A PART IN THE INTENTION OF THE WORK.

The Importance of **Color**

Limiting yourself to painting with colors that are too real, closely matched to the tones on the model, can become quite boring. Since color in itself is a bearer of meaning and emotions, you should use it to interpret the model in attractive and clever ways. Color fulfills two essential functions: it communicates information so that forms can be recognized, and it transmits expression. Using the different amounts of saturation and the creation of contrasts can be a great aid in distinguishing and placing the elements in an image, giving each component greater or lesser relevance.

Composing with Colors

Color, considered exclusively as a chromatic material, is used not only for coloring the forms of a figure but also for emphasizing them, making them stand out and indicating the correct order for reading them. The practice of putting them in a formal order is known as "chromatic composition." Colors are a strong compositional element, and the way they are distributed should be based on whether they have a clear meaning and an intention that coincides with the message that you wish to communicate. Here we have a simple experiment. It is a nude figure rendered with various chromatic interpretations. It is worth the effort to practice different versions of the same model; this will help develop your creativity and result in versions that are completely different from each other.

Color is the main reason we can see forms and contrasts. A painting can be made with just colors, without the use of a single line.

To work on your creativity using color, it is not necessary to look for different models. You can repeat the same subject using different chromatic interpretations to study the possibilities of contrast and harmony.

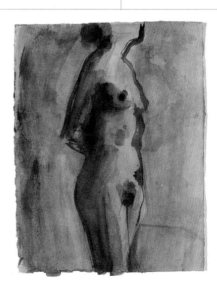
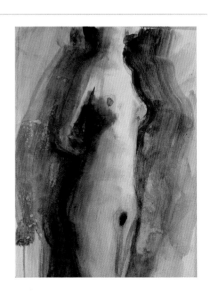

The Color Palette

Over time painters learn to personalize their palettes, adding favorite colors, those that they can relate to and with which they can work comfortably. In short, they choose the colors that they most identify with.

Nude with Complementary Colors

All models can be interpreted by using contrasting complementary colors. However, it is a good idea not to use the pairs fully saturated; lesser amounts of saturation will make more subtle contrasts and allow a greater number of shades and tones. The following exercise in oils, a nude figure that has been painted using the strong contrasts that exist between blue and orange, is proof of this. Begin painting using this pair of contrasting colors; then start modeling the tones by adding their adjacent complementary colors (colors that are next to each other on the color wheel) and white to soften the contrast and create a wide range of different values.

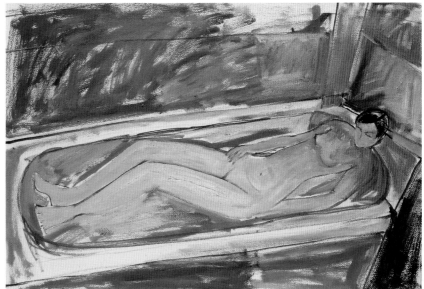

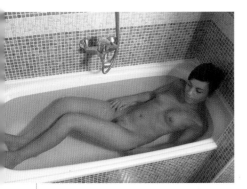

The nude figure in a tub was a very common theme among the Nabis painters, who were known for their interest in color. The most well-known of them were P. Bonnard and E. Vuillard.

The representation of the figure is based on the contrast between blue and red. A small amount of white has been mixed in to decrease the saturation.

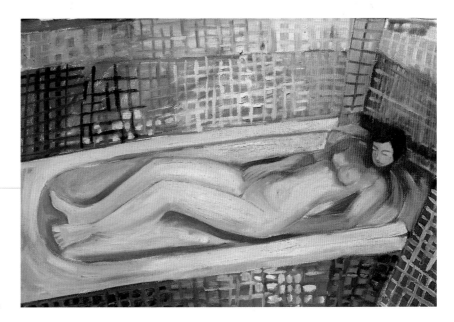

The figure and the space appear divided. There is a struggle between the intertwined complementary colors, blue and orange, mixed with a couple more that create a range of many varied colors that are full of multicolored light, highlights, and reflections.

Distortion and Stylizing
as an Approach

Today artists are in search of different strategies for presenting another vision of the human figure. The most common approach is to alter reality by distorting and exaggerating the form. When the basic structure of the figure is correctly proportioned, the artists can take liberties, like changing the proportions of specific parts of the body with the goal of creating a style that is more in line with their expressive needs.

Premeditated Deformation

Deforming and modifying the construction lines of the subject are the exclusive right of creative artists, of painters who invent colors and shapes from start to finish. Working from a life model, they can change the forms to achieve greater expressiveness, that is, to vitalize the form to avoid making a representation that is too correct and cold. Nothing keeps the painter from lengthening or shortening an arm or a leg to disturb the harmonious feeling of the painting. It is also acceptable to exaggerate the bending of the back or twisting of the neck when the style calls for it. But be careful, this approach requires experience, because it is based on human anatomy, and it must not be used as a pretext for disguising an inept drawing.

Distortion is a clever expressive approach and a way to achieve a very personalized interpretation of the figure.

This makes more sense when it is related to works that have a contemporary style.

Stylizing the Figure

This approach consists of avoiding representations that are too realistic in favor of a stylized or idealized view of the model, a sort of controlled distortion. To create a stylized figure, you only have to elongate some of the limbs, reduce the size of the head, and lengthen the neck. The proportions of the body are barely changed, except the legs, which should look longer. It is a matter of tastefully modifying the form of the body while maintaining an accurate and coherent proportional relationship among the different parts. This way the anatomical relationships are the same, although the lengths of the extremities and of the main masses of the figure have been modified. Thus, if the painter has angular style, all the forms of the figure should show the angularity.

A Few Lines for the Imagination

One of the charming things about drawing nudes with just a few lines that purposely distort the representation is suggesting the forms in a very gestural manner, allowing the viewer to guess and to complete them with his or her imagination.

Stylizing assumes making a completely distorted and personal view of the human figure. It is produced by a controlled and proportional deformation of all the parts of the body.

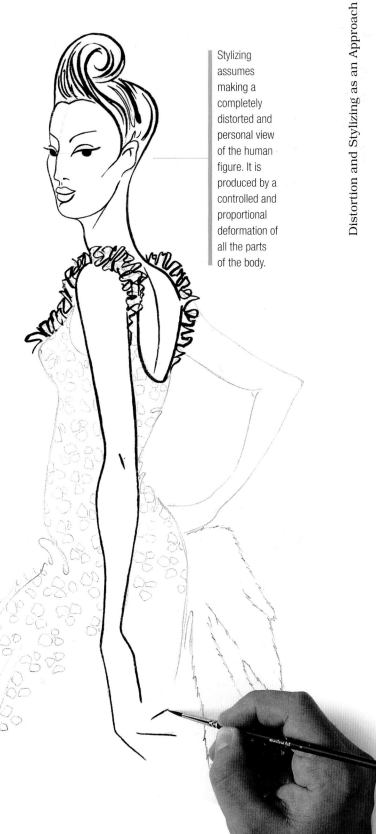

STYLIZING
THE FIGURE
IS NOT BASED ON
ARBITRARILY DISTORTING
THE PARTS BUT ON
SUBJECTING THEM ALL
TO THE SAME RULES
OF FORM.

Stylizing the Figure

In the following scene we attempt to create a distorted and at the same time stylized interpretation of a clothed figure. It will be painted in the Fauvist style, with a very loose drawing that is dominated by curved shapes. The proportions of the parts of the figure and the size of the head will be changed to make it more expressive. From a chromatic point of view, the goal is to synthesize the figure, using bright clean colors and a fresh, spontaneous brushstroke and not bothering to work with modeling. Use acrylic paint for this exercise.

The goal is to paint a very stylized and personal version of a seated figure with a tired expression.

1. The drawing is the most important phase for this exercise, because it will create a stylized figure with rounded forms. Quickly and loosely paint the flesh tones with a pink color made by mixing carmine, white, and a touch of yellow. Then paint the pants with pure naphthol red.

2. Continue painting the figure by areas. Use a very light violet mixed with shades of carmine, ultramarine blue, and gray to paint the sequined blouse. Then stylize the different tones on the quilt that covers the chair with a mixture of burnt umber, ochre, and white.

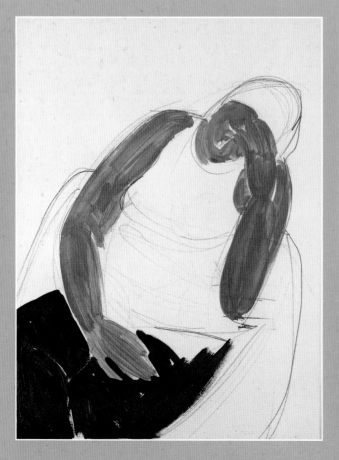

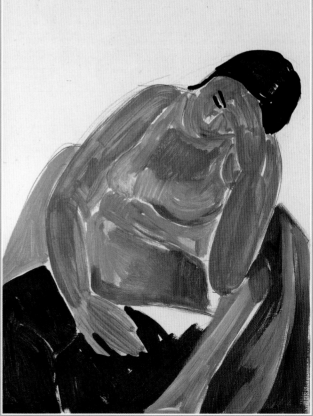

The Cloisonne Style

This is a technique for stylizing and emphasizing lines in the painting. It consists of separating the colored areas with very strong dark lines that are reminiscent of leaded glass. The Nabis were the first artists to employ this technique, although later it became a favorite technique of the Fauvists.

3. Paint the background last. Since the figure is mainly painted with reds, pinks, and violets, the background should be covered with ultramarine blue tinted with white. Press hard on the brush when spreading the paint, roughly and quickly so that the brush marks will be visible.

4. Let the paint dry for a few moments. With a medium round brush, outline the figure in black allowing the width of the line to vary, to make it look like cloisonne. Then use a fine brush and black paint to very delicately sketch in the features of the face.

5. Add additional shades and values over the previous layers of paint on the blouse. Try to create a sense of texture with short, juxtaposed brushstrokes. Use long strokes of burnt sienna to paint the striped pattern on the quilt. To finish, add the shadows on the pants and the right arm.

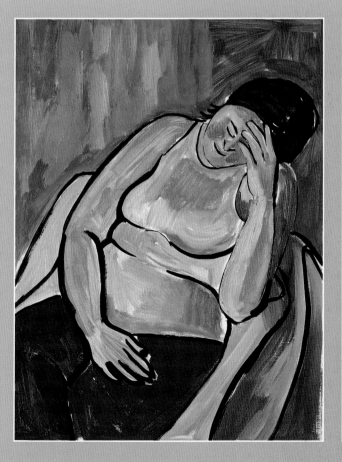

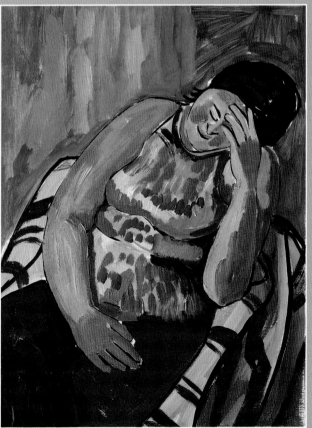

Stylizing the Figure

Nervous and Expressive Lines

Gestural painting emphasizes the value of the gesture, the loose wide brushstroke, the direction of the stroke, and the color of the paint where the figure is rendered with large vague areas of color that act to throw the viewer off balance. This manifestation of impulses liberates the colors from the subconscious while it agitates the surface of the painting as if it were trying to hold on to the artist's vital energy, which is transmitted through expressive and ample lines that are not as detailed but allow more working freedom. All the brushstrokes should follow a clearly visible direction. Do not try to make a very exact painting; you want to create a sense of movement communicated through the brushstrokes that dominate the entire work.

Apply the colors intuitively and not very realistically; mix them quickly, even hastily. This immediacy should be seen as something positive, because it adds spontaneity to the finished work.

When you paint with expressive brushstrokes, the figure seems rough and looks more dynamic.

Brushstrokes with Oils or Acrylics

Oil and acrylic paints have a naturally thick and smooth consistency, and you can leave very visible brushstrokes to emphasize the dynamic effect and make the figure more expressive. You should apply the brushstrokes in several directions to agitate the surface of the painting with a series of rhythmic lines that will also create attractive textures. In this style the figures seem sketched and unfinished; the approach reminds us of the Impressionists who tried to capture the light with small dabs of overlaid color. Flat and filbert brushes are best for working in this style since they hold a large amount of paint.

Work done with gestural brushstrokes is more effective if the combination of colors and the direction of the brushstrokes are greatly varied.

A Figure with Gestural Colors

Now we will begin a painting of a female figure with only wide brushstrokes of paint, a hastily applied mass of wide strokes of color, and an intuitive approach. The exercise should be done unhesitatingly and using a large amount of paint, so the first impression of color is the artist's subjective view, even though the results might seem sloppy. Shyness and fear of failure must be left behind, and you must accept the risk of making mistakes. The model is a seated female figure, and oils are the chosen technique.

1. Prepare the background with a mixture of several gray tones. The paint should be heavily diluted so the surface will not be too oily.

2. Tilt the support to encourage dripping and mixing of the gray tones. Wait a few minutes for some of the turpentine to evaporate before starting to apply the oil paint.

3. With no preliminary drawing, spread the paint very quickly and intuitively, suggesting the form of a body. The paint should be quite thick, only slightly diluted so that the brush will glide easily.

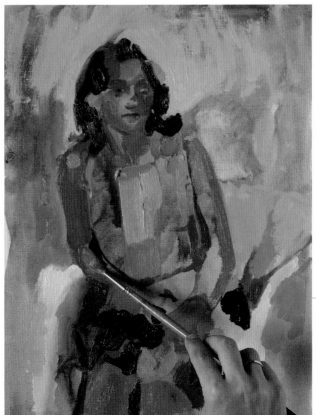

4. Resolve the figure with short quick brushstrokes that do not cover the white of the support to create a sketch-like interpretation.

Reclining Figure with
Different Interpretations

Next we will create several interpretations of the same subject. The model will be the same for all of them, but each one will be painted in a different style, changing the way the paint is applied and modifying the color ranges to achieve an interpretation that is subjective and far from academic. The goal is to experiment with distortion and to get used to putting down the ideas that we have in our heads, even if it means changing the formal content of the painting. The life model is only a reference that should submit to our requirements, and not us to those of the model. The artist cannot be enslaved by what the model looks like. You must choose the colors and painting style that works best for each case. The final interpretation should emphasize the aspects of form that interest you and that add character to the painting. The first two interpretations will be done in oil.

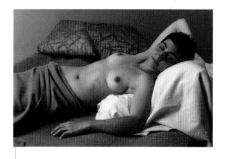

Here the model is reclining, showing a nude torso. In this scene the soft tones of the skin combine with very lively chromatic elements in the background.

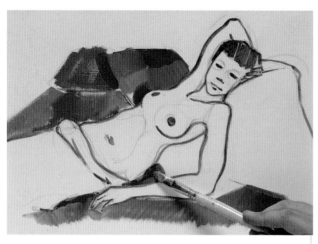

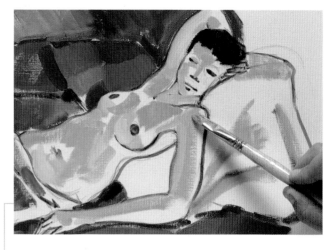

1. Make a pencil drawing, and then go over it with dilute ultramarine blue oil paint. It is a simple line drawing that follows the edge of the figure. First, paint in the background with red tones that are varied by mixing the red with violet and orange.

2. Cover the background with a mixture of slightly lightened blue and violet, using diagonal brushstrokes to indicate the direction of the light. Use two tones of blue to indicate the cloth. The flesh color for the most illuminated parts of the figure is made with carmine, yellow, and white, and very light green should be used for the middle tones.

3. This first painting is finished with the addition of orange brown and some yellow tones in the shaded areas of the skin. The flesh colors are not modeled but are built up with visible brushstrokes that are not blended at all. In the background the color should be reddened even more so the profile of the figure is in stronger contrast.

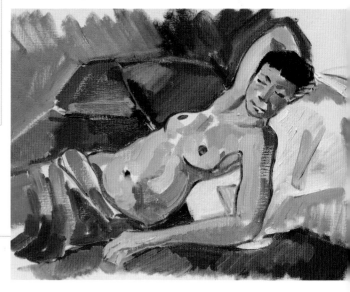

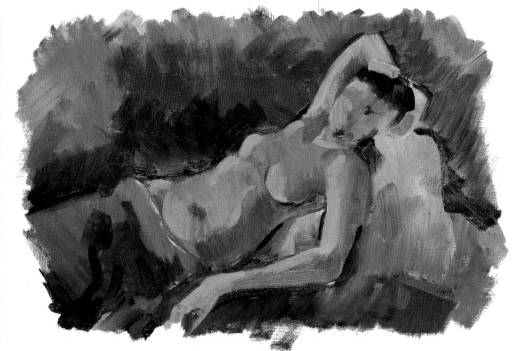

1. This exercise begins with a pencil drawing over which large areas of color are added. The real colors are completely ignored, to create a struggle among greens, pinks, and reds. The paint should be applied thickly with quick brushstrokes that barely define the figure.

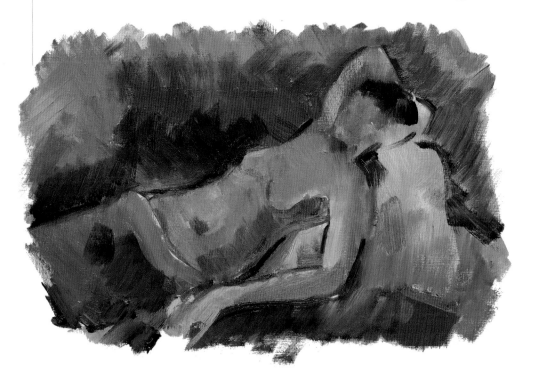

2. Complete this still-fresh base of the painting by adding new pink tones to the figure to differentiate the illuminated areas from those in shadow. Do not add indications of features on the face. The background looks like an abstract painting. Just a few strokes of dark color emphasize the outline of the figure and some folds in the sheet that covers the lower half of the model.

Little Drawing and More Painting

Little time is allowed for a preliminary drawing in this type of interpretation. A few linear references are enough, and the first applications of paint will cover them. The finished figure is created with accumulations of paint and contrasts between the colors rather than with a reference drawing that is used as a guide.

Greater Stylization of the Figure

In this interpretation the distortion of the form is even greater; the size of the head is reduced, and more importance is given to the length and curvature of the body. The pose is made more diagonal, and the rounder forms and the repetition of the folds in the sarong become more interesting for the stylization, the modification of the content to give the work more visual interest. On the other hand, the colors are less saturated, the skin tones are paler and constructed by modeling, and the cushions in the background that were so bright in the previous exercises are more diluted here and do not contrast as much. Realism becomes less important, but aspects important to the composition and the coherence of the proportions are not ignored, despite the liberties.

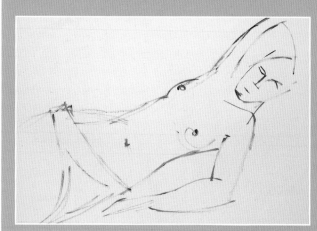

Mosaic of Colors

The background colors interact with the figure and become an important part of the composition. They can be applied as if in an abstract painting, the succession of colors forming a tapestry that acts as a counterpoint to the pale colors of most of the flesh tones and exciting the interest of the viewer.

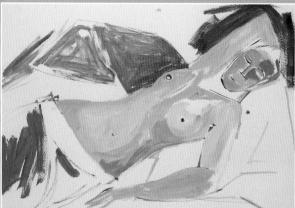

1. A free interpretation of the color requires a very simple foundation of lines. Just a few lines made with a fine round brush and burnt umber are enough. The drawing is not academic; instead, it is idealized and stylized to make the final results more expressive.

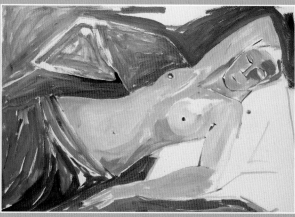

2. Paint the cushions with very loose strokes of pink and orange paint. Use lots of thick, dense paint. Build them up with wide brushstrokes that have a lot of movement to create an immediate feeling of vitality.

3. Spend more time worrying about the interaction between the different carefully orchestrated areas of color used to cover the white support than about the space or the model. The figure should be flat and nearly without volume.

4. The skin color is constructed by overlaying the different tones, using ochre shades over a base with pink tendencies. The brushstrokes should carry a lot of paint, and the brush should glide quickly across the surface of the painting. Work on several areas at the same time.

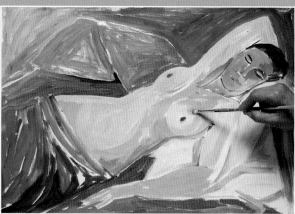

THE ABSTRACT QUALITIES OF THE FIGURE, THE RHYTHM, THE COLORS, AND HOW THEY RELATE TO EACH OTHER ALWAYS ELICIT AN EMOTIONAL RESPONSE FROM A RECEPTIVE ARTIST.

5. The colors and tones, which will be modified even more, already form a good base that suggests the light and shadows on the figure. The warmer colors on the bed perfectly counterbalance the pale tone of the skin and of the blues and violets in the composition.

6. In the finished painting you can see where parts of the shadows on the skin were retouched and brushstrokes added to the cushions to indicate the patterns. Any liberties can be taken if the approach to the nude is based on an easy, simple, stylized distortion that is pleasing to the viewer.

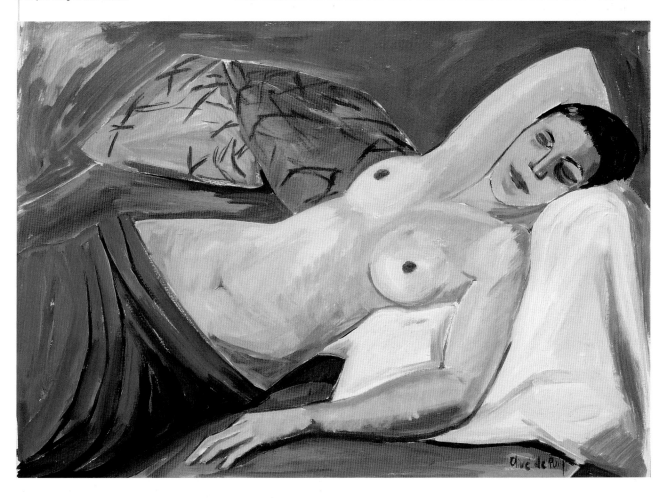

An Intuitive **Figure**

To paint this male figure with acrylics, you must first forget about achieving any kind of likeness of the real model and allow yourself to be carried away by a world ruled by distortion, imbalance, and above all color, the exaltation of the figure through linear brushstrokes of saturated colors. You must allow the intuition to guide the direction of the line and follow unplanned serpentine routes through the interior of the figure. You must expect the unexpected and not be surprised if the final interpretation takes another course from the one shown here.

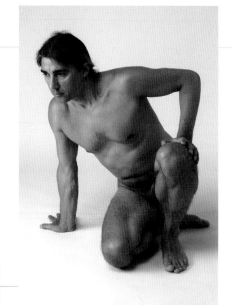

The model has adopted a forced, dynamic pose that favors a rhythmic interpretation of the figure.

Make a preliminary sketch with a graphite pencil, drawing very quick lines with the side of the point.

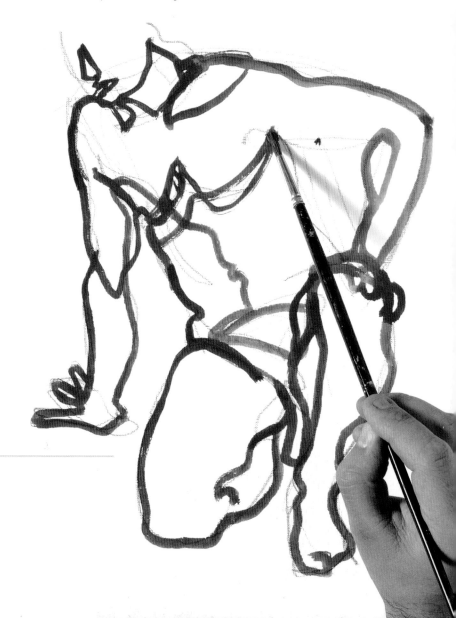

Paint over the line with phthalo red diluted in water.

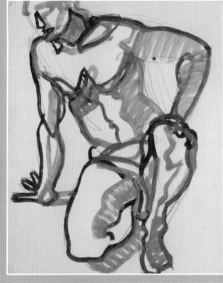

Allow the red paint to dry and go back over it with very diluted ultramarine blue. Add new lines that complement the previous ones, and make a first attempt at representing the shadows with zigzag lines.

To make linear strokes with acrylics, use a soft round brush and fluid paint.

Since the acrylic paint dries quickly, you can paint over it with new strokes of saturated green to outline the shadows without the risk of mixing them with the colors underneath. Finally, complete the background by covering the right half with a series of hastily painted orange strokes.

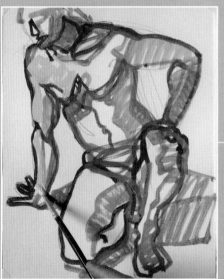

Use blue green to add a second value to the shadows on the figure, and paint the projected shadow seen behind him. Now is the time to add light to the illuminated parts of the figure using yellow ochre.

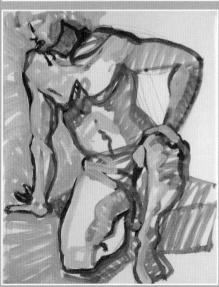

Use the ochre to paint the highlights on the figure and also half of the background nearest the light source. The brushstrokes should always be linear, which means that they should not completely cover the white of the support.

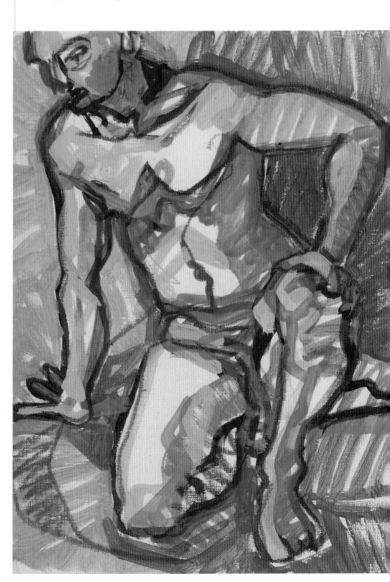

Colorist **Flesh Tones**

If building up the flesh tones of a nude figure with a realistic shaded style is sometimes complicated, the difficulty increases when you attempt a colorist interpretation with opposite colors, as shown here with greens and oranges. To successfully carry this out, avoid mixing too many colors on the palette. We recommend working like a pastel painter (an artist who paints with pastel sticks), applying strokes of nearly pure color to the support and mixing them a little to blend them with the adjacent colors, similar to the style of the Fauvist painters. This way you can build up the color of the skin with bright daring colors that normally would not be associated with it. This representation of the figure strays far from a classic interpretation to express a very emotional vision.

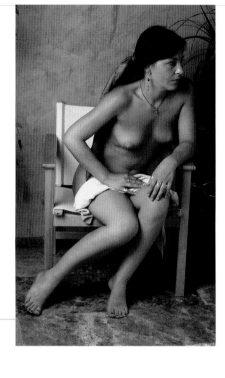

The goal of this exercise is to paint this seated nude figure, slightly leaning to the right, taking up the challenge of representing the skin tones with a range of greens and oranges.

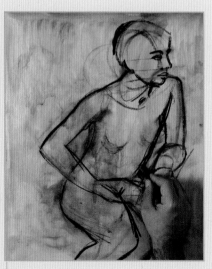

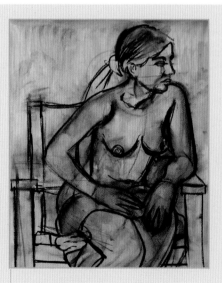

1. When you are working with bright, saturated contrasting colors, the white background can inhibit you and cause confusion. Before starting on the figure cover the entire support with a layer of ultramarine blue acrylic.

2. When the layer of acrylic paint has completely dried, draw the structure of the figure with a stick of charcoal. Capturing the pose, the leaning figure and the positions of the limbs, is essential. The figure has been framed closely, cutting off the legs to center the attention on the model's figure.

3. Begin defining each part of the body over the charcoal sketch. Emphasize the profile with a heavy line, trying to represent the curves caused by the prominent bones and muscles that are visible on the model.



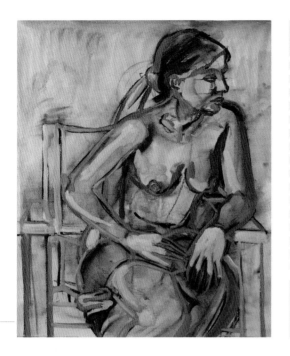

Two or Three Acrylic Colors

Artists that normally use oils usually have two or three tubes of acrylic paint that they use for preparing backgrounds. This paint, which is water based, dries quickly so they do not have to wait hours or days for the first layer of color to dry. This way they can begin painting with oils in just a few minutes.

6. Now is the time to develop the medium tones using two or three shades of mixed green that has been somewhat lightened and that is not too saturated. It can be mixed with a little indigo or yellow to create different shades.

5. Go over the entire outline of the figure with different variations of the color orange. Begin covering the lightest parts of the figure with light orange, which will act as a sort of highlight. This color should be used sparingly, concentrating it in very small areas.

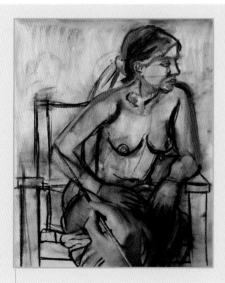

4. Spray the charcoal lines with a fixative. You must use a large amount to keep the black dust from muddying the red, orange, and yellow paint that will be used on the drawing. These very saturated colors will become the base of the painting.

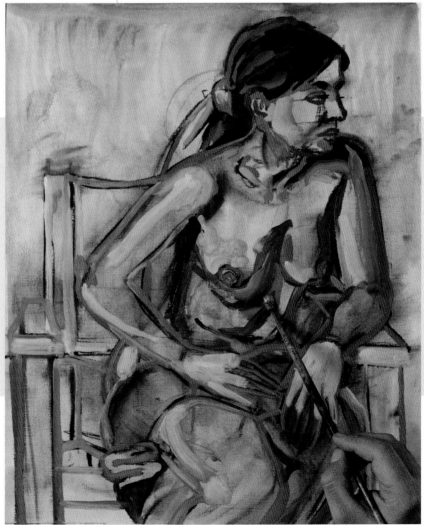

YOU
CAN PAINT
THE SKIN WITH THE
MOST UNLIKELY GREEN
TONES IMAGINABLE, AS
LONG AS THE REST OF
THE COLORS YOU USE IN
THE PAINTING CREATE A
GRACEFULLY BALANCED
COUNTERPOINT.

7. Little by little, cover the model's skin with the mixed light green, creating a lively contrast with the brightest areas of yellow and orange. Then apply the first brushstrokes of light violet tones to the background.

8. Use three tones of green to construct the legs, repeatedly brushing the edges of each color to create gradations that indicate more roundness to the legs. The trunk and the arms are finished with a mixture of green, yellow, and white to develop a less vibrant transition to the orange. The chair is simply a prop and is of no interest; it should be finished with flat areas of beige.

9. Cover the arms of the chair with a very light shade of burnt sienna, each stroke forming a gradation. The cloth or sarong is lightly painted with pure turquoise blue and a lighter shade of turquoise. The interesting part of the work resides in the figure, so the secondary objects are treated in a very simply and stylized manner.

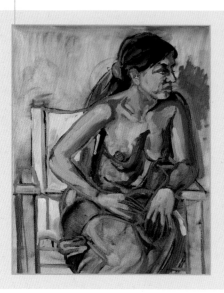

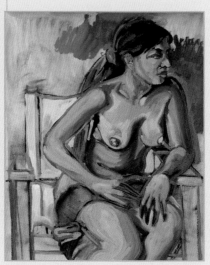

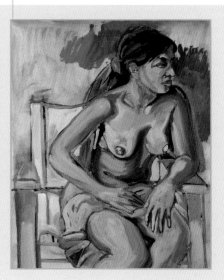

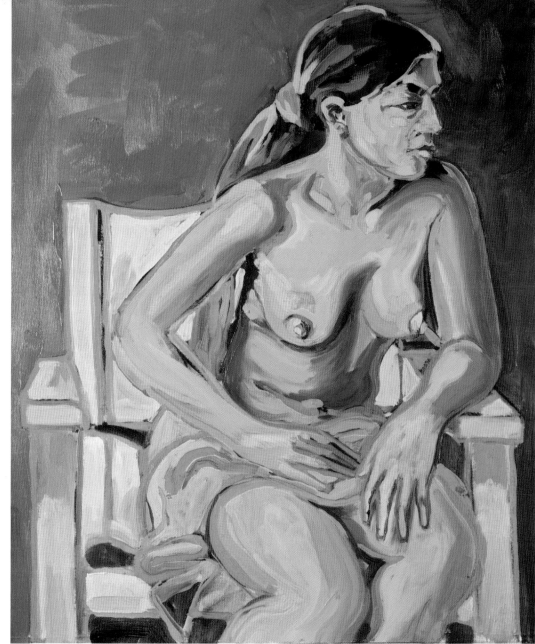

10. In the course of this exercise, the different applications have hidden the initial drawing made in orange. After you have worked on the contrasts of light and modeled the volume of the figure, go back to defining the outline with a fine round brush with the intention of bringing back the strength of this strongly contrasting line.

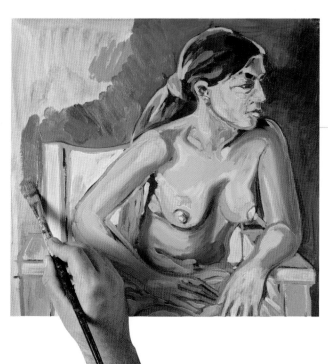

11. When the figure is completely finished, begin covering the background. Mix cadmium violet with cyan blue, and use the combination of the two to create a gradation to fill the empty spaces around the model. The paint should be heavy and thick so that the brushstrokes will be left on the surface.

12. The light comes from the left, which creates a gradation on the background that goes from the lightest color, cyan blue with a little white, to the darkest, violet and cobalt blue. The background color acts to make up for error, better outlining the profile of the figure where necessary. The final result is quite attractive, a nude figure treated in a lively manner, with a contemporary interpretation and a surprising choice of colors.

Interpretation of a
Nude in an Exterior

In this section we will be painting a seated female nude figure in a garden. She is in a relaxed posed, and the context favors a very colorful treatment of the subject. The exteriors suggest more complex themes than in an interior, where the walls of the room limit the space. Outside of the house, the model can appear on a patio enjoying the sun, reading, or just relaxing. In addition, she can be surrounded by plants, flowers, furniture, and other brightly colored elements. With this change of scenery we attempt to achieve an extremely colorful interpretation with ranges of very saturated colors.

This nude figure will be painted outdoors in a sunny garden. The colorful background will look like a patterned surface that will act as a sort of screen.

1. The preliminary drawing is done with a sanguine stick, outlining the profile of the figure with simple lines. In the exterior the model usually projects a more carefree attitude and does not look like she is posing.

2. Paint the skin tones with cadmium red, blue, and orange using a sweeping motion of the brush, and then add blue and green to the background. The work is developed as a whole; the paint is applied equally to the figure and to the background, so that both have the same colors. Try to create an overall tone through a harmonious blend of the colors.

Background Painted with Pastels

The color treatment of the figure and the background should be unified when it comes to the line, the way the pastel stick is dragged, and the saturation of the colors. Within this premise lies the achievement of creating the colorist environment or atmosphere of this work.

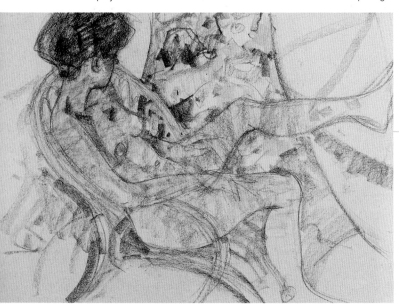

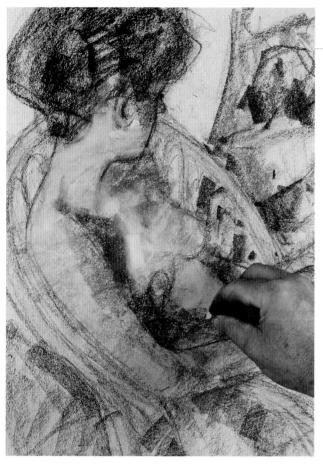

3. As the work progresses, increase the pressure on the flat pastel sticks so that the forms and the volumes will become more specific. The warm colors should begin to predominate on the model's flesh, and violets and blues should cover the background. The juxtaposition between light yellow and red promotes a sense of volume in the figure.

4. The contrast between the light and shadow can be resolved by clearly outlining the areas of light with bright yellow and the shaded areas with magenta, carmine, and red. Then, colors of different intensities and value on all the parts of the figure should be blended together.

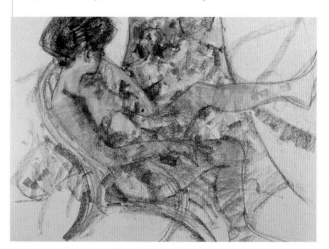

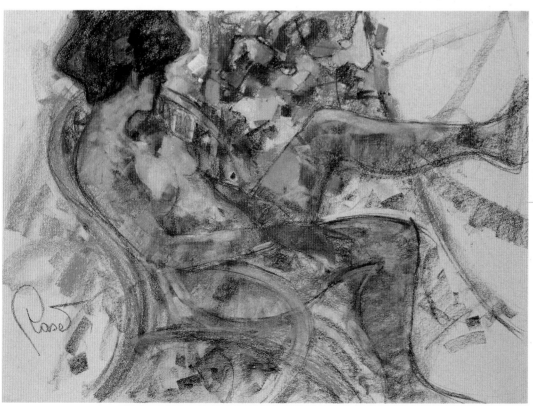

5. Blend the strokes of pastel colors to make the color covering the figure more dense and solid with respect to the background, which is dominated by greens, blues, and violets that are not blended. The lines that define the outline of the figure and others that indicate the neck and the face are still visible. However, the colorist interpretation that communicates a very lively and joyful atmosphere is the protagonist of the painting.

Interpretation of a Nude in an Exterior

Figure with Neutral
Colors and Sgraffito

The following interpretation is more radical than the previous ones. It is painted with oils, a traditional technique, but the layout of the painting, the range of colors, the technique used in applying them, and the way of maintaining the drawing are quite different from what we are used to. We will be painting a clothed figure with some loose brushstrokes, blending neutral colors (e.g., grays and browns) that will then be completed with a fine and precise line drawing made using the sgraffito technique, scratching the thick surface of the oil paint with a stick of graphite. The result will be a figurative representation, but with a much more contemporary look, far different from any academic or realistic study. We will use oil paint over an acrylic base.

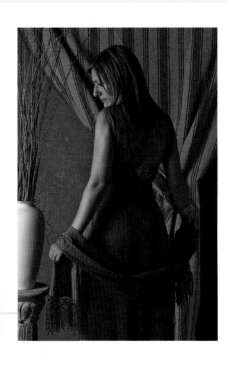

1. Before drawing, cover the background with a mixture of ochre, burnt sienna, and burnt umber acrylic paints. Apply the colors from light to dark, with the lightest ochre tones at the left and the darkest browns to the right. This order will indicate the incidence of light on the model.

This clothed figure is illuminated from a very specific source and accompanied by a few props: a vase with dried flowers and a curtain in the background.

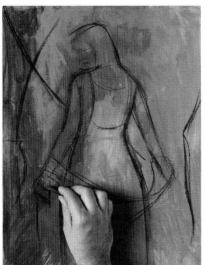

2. The layer of acrylic paint will dry in just 20 minutes, and then you can sketch the model. Draw with a stick of charcoal. At first the shapes should be very general and stylized; it is mainly a matter of situating the figure and controlling the proportions.

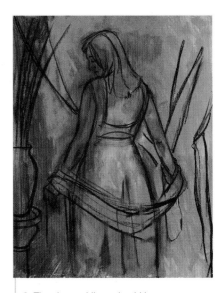

3. The charcoal lines should become darker and darker and look surer. Add just enough detail, for example, the shape of the hand or the locations of the facial features. You can also draw the folds in the curtain and the vase that is on top of a column.

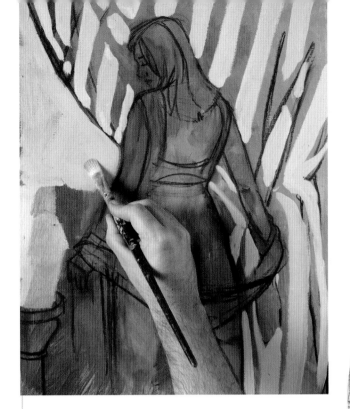

5. Paint the reddish edges of the curtain using carmine and orange toned down with a little gray. Without waiting for the end, as soon as you have painted an area, take a well-sharpened graphite stick and make sgraffito drawings in the fresh layer of oil paint. Draw the vase, the flower stalks, and the folds in the curtains with fine, delicate lines.

4. Leave the figure to one side and begin painting the background. Use very light ochre and gray to paint the more illuminated parts and to draw the lines of the curtain. Define the vase with two vague stokes of beige and light violet. The paint should be thick at all times, or you will not be able to make the sgraffito.

Neutral Colors

Neutral colors have a dull, grayish, or brown tendency. They are made by adding gray, white, or brown to any color in the color wheel. Because the level of saturation of these colors is reduced by this mixing, they create a range of colors that harmonize better with each other.

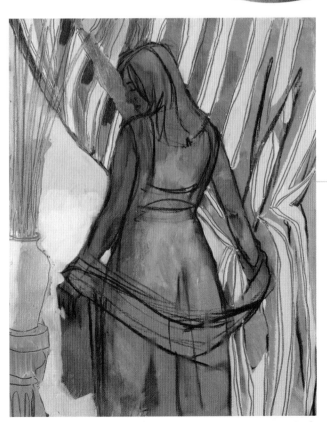

6. Paint the column using orange mixed with gray. Make a sgraffito drawing over it almost immediately to indicate its shape. Apply additional sgraffito lines over the lines of the curtains, to the right of the figure, remembering to frequently clean the accumulated paint from the point of the stick with a rag.

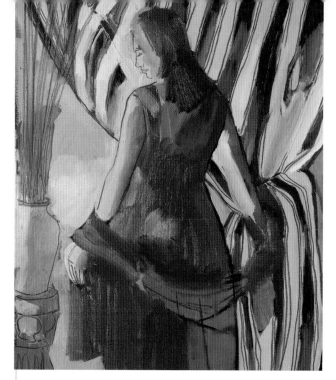

Drawing on the Painting

The goal of this phase of the painting is to resolve the background first. To do this, finish the curtain with a mixture of carmine, cadmium red, and pink. As you paint, indicate the folds on the fabric with sgraffito, which is a very expressive treatment. Then move on to the figure, working in the same way, with very loose applications that are then detailed using the graphite lines. This exercise can be defined as "a line drawing on a layer of fresh paint."

8. Paint the hair using burnt sienna and cadmium orange. It is not necessary to be very accurate with the paint, since you can rectify the outline with sgraffito drawing. Using a mixture of cadmium red, cadmium orange, and sienna, loosely paint the dress and shawl. The brushstrokes should go in the same direction as the draping of the fabric.

7. Paint the figure with light green in the lightest areas and use more burnt umber on the shadow of the back. Make sgraffito lines on the layer of paint as you paint each area so you do not lose the initial drawing.

9. Draw with sgraffito on the upper part of the dress; then paint the right arm, again using generalized applications of color. Finish the shawl with wide curving brushstrokes. The dripping done with diluted orange is used to indicate the fringe of the shawl.

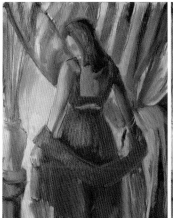
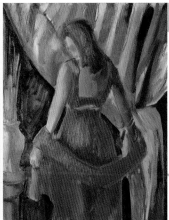

Loose Finishes

Contemporary painting tends to be loose and expressive, often avoiding the precision and realistic copying of the model. Here we present two approaches with two versions to represent the figure without sgraffito. The first is painted in a similar manner, sketchily with neutral colors, and in the second we darken the background color to achieve more definition in the outline of the figure and the curtain in the background.

THE ARTISTIC RICHNESS OF CONTEMPORARY PAINTING RESIDES IN COMBINING SEVERAL GRAPHIC APPROACHES: SGRAFFITO, DRIPPING, BLENDING, IMPASTO, AND SO ON.

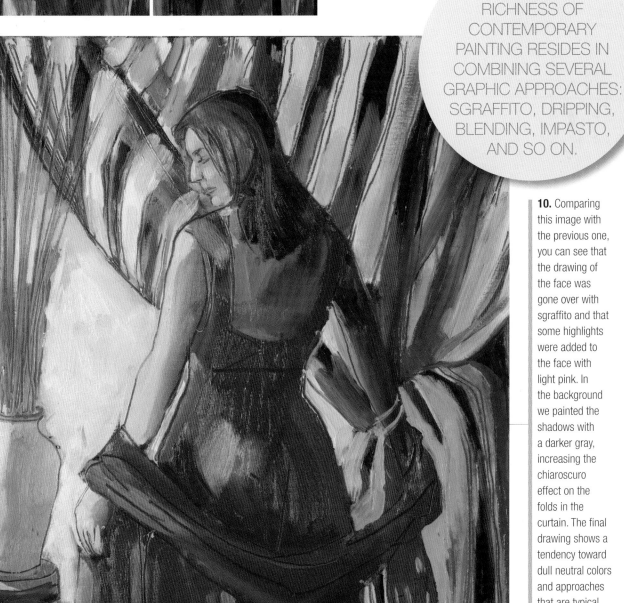

10. Comparing this image with the previous one, you can see that the drawing of the face was gone over with sgraffito and that some highlights were added to the face with light pink. In the background we painted the shadows with a darker gray, increasing the chiaroscuro effect on the folds in the curtain. The final drawing shows a tendency toward dull neutral colors and approaches that are typical of contemporary painting: dripping and sgraffito.

Figure with a **Colored Grid**

In this example we reconsider the process of the Divisionist painters, who divided the entire surface of their paintings into small areas of color. To create this painting, put a grid or graph over the subject you have drawn and apply the color cell by cell, forming regions of colors like a topographic map or the pixels on a computer. This exercise might seem like the adaptation of an electronic image to the context of a modern painting, but in reality it should be understood as an exercise in which the figure is broken down into small units of color, emphasizing the skill and ingeniousness of the work. We will use watercolor and gouache.

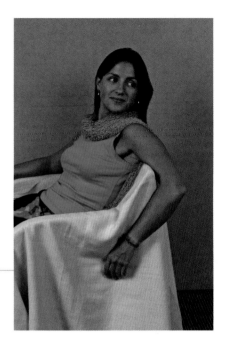

The model is seated on a covered chair, wearing an attractive green shirt. She is relaxed, with her arm hanging over the back of the chair.

1. Make a traditional drawing of the model. Carefully draw the form, focusing on the outline, with a graphite pencil. It should be just a fine line without any shading.

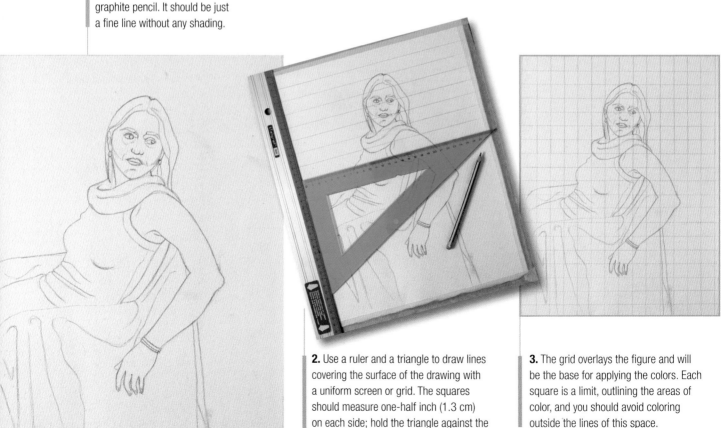

2. Use a ruler and a triangle to draw lines covering the surface of the drawing with a uniform screen or grid. The squares should measure one-half inch (1.3 cm) on each side; hold the triangle against the ruler and slide it up and down so that all the squares are drawn parallel.

3. The grid overlays the figure and will be the base for applying the colors. Each square is a limit, outlining the areas of color, and you should avoid coloring outside the lines of this space.

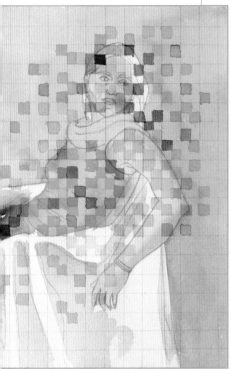

5. Break the figure into small units of color. Each square consists of one-half inch (1.3 cm) of space, which should not be completely covered with a single color, but divided into four parts. They do not have to be drawn with a pencil; just make an imaginary cross and keep the dividing lines in mind.

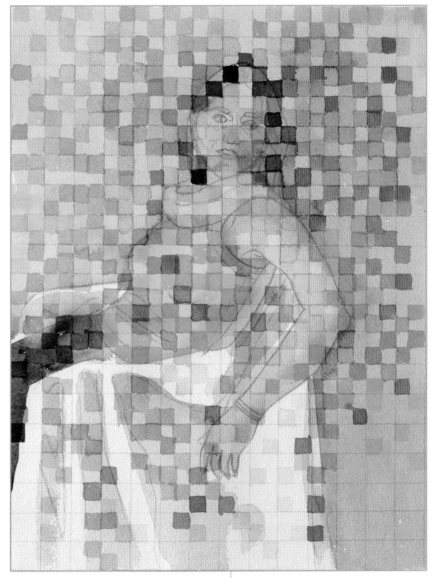

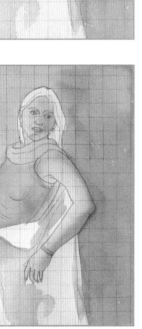

4. Rather than working on a white background, apply some large washes that cover each area with its natural color, except for the cloth covering the chair, which has a lot of white space.

6. Apply variations of the local colors in each zone. Thus, the background will be composed of different pink and orange tones, and the green shirt will be treated the same. Use very diluted, light washes on the white cloth.

7. The work is slow and meticulous. You must avoid applying a color right next to a still damp square, since simple contact between the two washes can cause one color to run into another. Each unit of color should be different and be kept isolated from the ones that surround it.

9. After arriving at this point we propose a variation. The intensity of the squares can be altered and shaded by painting regular shapes inside each one of them. In this way the more general form created with the grid has now progressed toward more detail.

10. New squares appear inscribed within the grid, allowing you to better place the eyes, the outlines and the edges of the figure, the background, and the profiles that should be very distinct. This partial overlaying of colors makes it possible to more richly develop the blue shadows in the lower part of the background.

8. Develop the shadows that appear on the white fabric with different shades of gray. Here the changes in tone should be very subtle, with barely perceptible washes in the lightest zones. The shadows on the arm are created with blue washes that are an interesting replica of the skin tones.

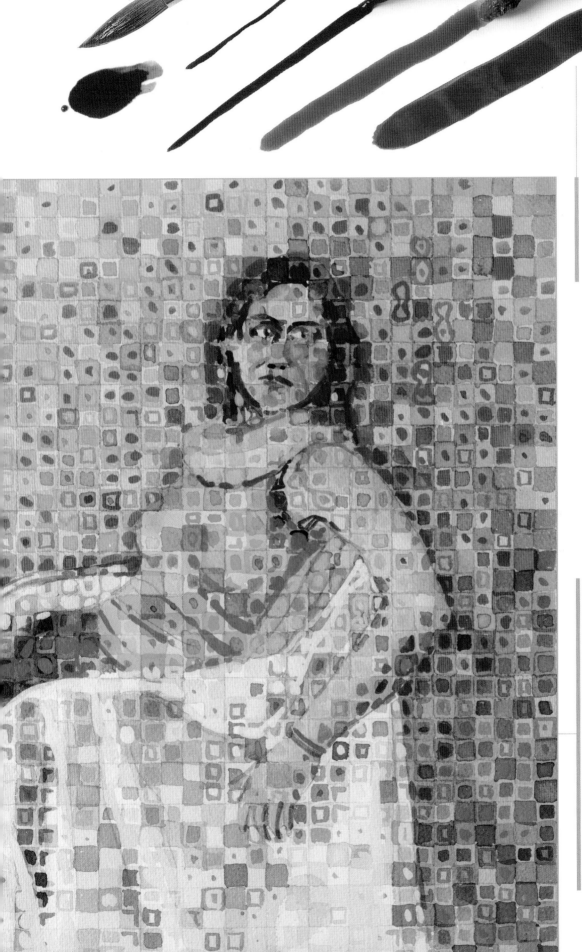

Using gouache will allow you to easily use very saturated and pure colors to make the final touches.

11. Use gouache paint to finish the exercise, because its better opacity and gloss will help you bring back the colors that have been altered by overlaying colored glazes. It is a paint that is appropriate for emphasizing the saturation and finishing the construction of the face of the model.

Analyzing the Portrait

The representation of a face is an intimidating subject, one of the most sophisticated and risky genres an artist can attempt. Capturing a likeness and facial expressions requires a mastery of drawing, which means it is only within reach of the most experienced artists. A good portrait should be a close likeness of the model, and that similarity will be determined by the artist's ability to render the model's most characteristic physical features, attitude, and by the psychological qualities it communicates. In this section, we will address a study summarizing the main technical, psychological, and iconographic aspects related to the model, beginning with the basic layout of the head and going on to the key details that will allow you to achieve a good likeness.

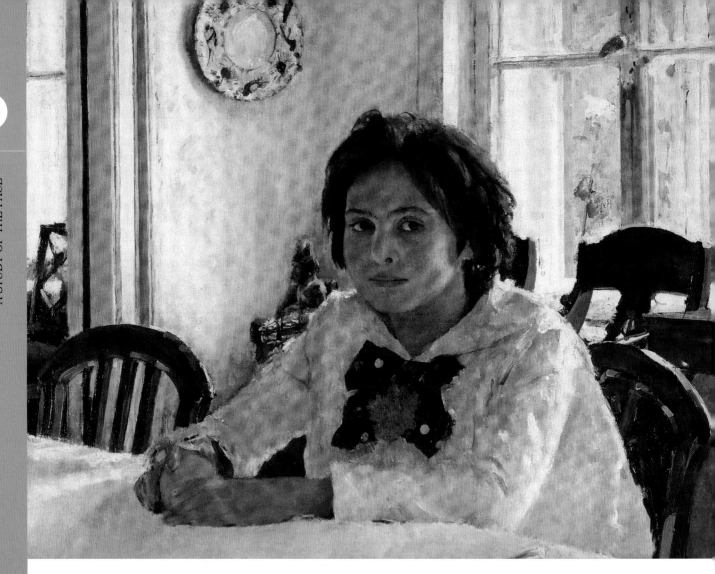

Valentin Serov (1865–1911), in his *Portrait of a Girl with Peaches*, was able not only to render the girl's features but also to capture the sweetness and character of the girl in her expression.

A Study of the **Face**

In the first part of the book we studied how to construct the human head, but the canon of the human figure serves no purpose unless it is accompanied by another canon for the facial features, their shape, how to finish them, and the variations that are likely to appear.

It is these elements, especially the eyes and the mouth, that communicate the likeness and capture the character of the person being drawn. Therefore, it is important to study and practice each of these features and render them properly. Accurately drawing the features almost totally depends on your ability to observe, to capture the specific shape of a feature and individualize it, to place the light and shadows correctly, and to model it to emphasize its volume and prominence.

The Face, Indicator of the Emotions

A representation of the face is much more than a simple anatomical copy, because this is where the different human passions are best reflected. The character of the person and the conflicts of the soul have an effect on the way he or she looks, while the play of facial muscles and the forms and placement of the wrinkles model the feelings that are being communicated. The character of the model is expressed through these expressive features. The firmness of the line or the decisiveness of the brushstroke helps to emphasize the forms of the face, to individualize it, and to capture the character and the feelings of the model in a free and loose manner.

Preliminary Studies

Before starting a portrait it is a good idea to make preliminary studies of the composition, the pose, the blocking-in of the figure, and even a few details, for example, a drawing of the hands or the outline of the lips.

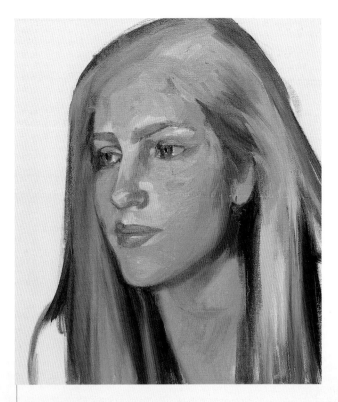

A portrait should capture not only the physical features of the model but also her character and psychology.

A good portrait relies on the drawing; therefore, it is important to constantly practice with different media.

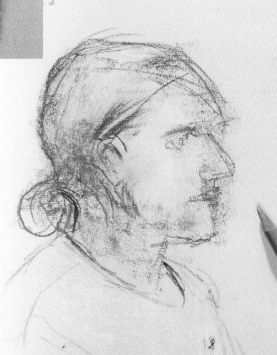

How to Proceed

The key to a good portrait lies in the capacity of observation. It should be approached empirically, from general to specific. First, sketch the basic structure of the face, indicating the general shape and the most visible or prominent angles. Only when these are correct should you move on to the details. You must keep in mind that very few eyes, noses, mouths, and ears look alike, and finding those miniscule differences is the key to achieving a likeness of the portrait model.

The Facial **Elements**

Before you begin to develop the entire drawing of the head in detail, it is important to stop and study the facial features. It is necessary to consider and analyze each one of the features separately to make it easier to create the portrait. In this section we make a practical study of the four most distinctive facial elements and give useful advice on how to properly resolve each one of them.

The Eyes

The eyes are located in the center of the face, symmetrically aligned. Before drawing them, you must remember that they are spherical and that they move in perfect coordination and in the same direction. When the eyeball moves around, the pupil stops looking round and seems more oval. Once you have understood this basic principal, you can draw the eyelids and the eyebrows, which should be seen as accessories that dress the eyeball. The curve of the upper eyelid is more pronounced than that of the lower one, which is softer. The eyelashes of both eyelids do not run completely around their perimeters; they are more concentrated toward the outside of the eye, with more and longer lashes on the upper eyelid than the lower. The eyebrows are located on the upper crest of the orbital cavity, and their shape tends to follow the curved shape of the brow.

The Iris and the Pupil

The pupil is completely black, and a white highlight should be left in it to represent the transparent wet surface of the eye, and also to make it look alive. The iris can be represented by different colors, but never a single uniform one since it is usually darker around the outside edge.

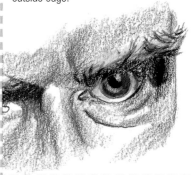

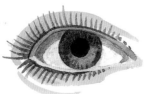

The pupil looks totally round from the front, but its shape becomes more oval if seen from the side.

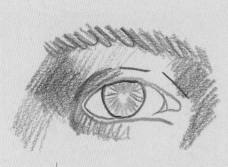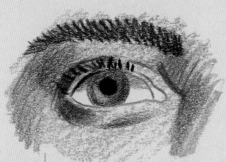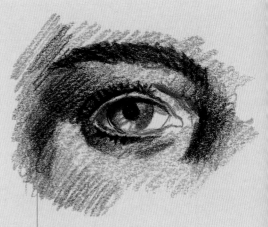

1. The process of drawing the eye begins with lines that define the iris, the edges of the eyelids, and the eyebrow.

2. Color each area and shade the eyelids and the outsides of the ocular cavity to show that this area is sunken.

3. Complete the shading with stronger contrasts. It is important to leave a clear area in the inside corner of the eye.

The Nose

Drawn in profile, the nose does not usually present any difficulties, but a front or three-quarter view requires you to use the outline or shadow that appears on the lower part and the gradations and reflections that model its sides. The key to drawing the nose when it is not in clear profile lies in literally imitating the play of light and shadow. Since the lower part of the nose is always in shadow, the bridge always has a long highlight, which makes it easy to understand its three dimensionality. Finally, you must keep in mind that the transition between the nose and the forehead, in young people, does not change significantly, but in older people it can have a marked groove or brow.

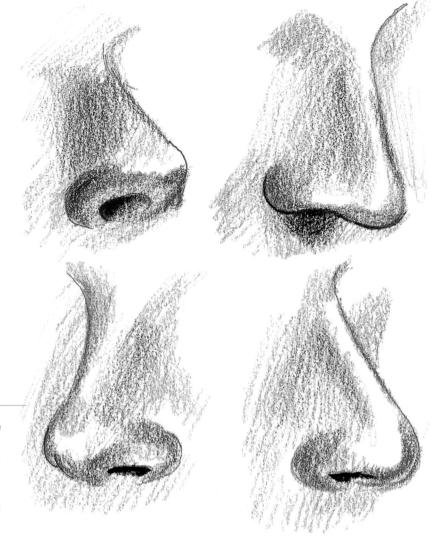

The more frontal the point of view, the greater the difficulty of the drawing, because the outline gives way to a mass of various lights and shadows.

It is important to draw the nose from different points of view to understand the difficulty posed by drawing it straight on.

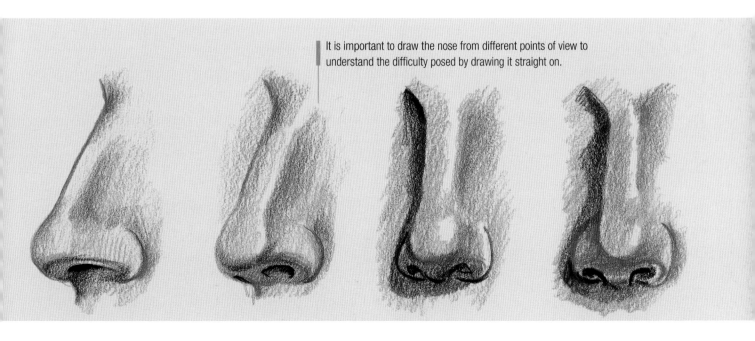

The Mouth and the Lips

The mouth, along with the eyes, is one of the most expressive parts of the face. If it is closed, it becomes a curved line that forms the corners. The upper lip can be defined by its characteristic fold in the middle and by the fact that it is somewhat longer than the lower lip. The lower lip is shorter, fleshy, and rounded. When drawing the lips of models, you will see that there are different kinds: thick, fine, wide, thin, fleshy, voluptuous, and so on. This is especially true of the female figure. It is important to accentuate the tonal difference that exists between the upper lip and the lower. The upper lip, in normal lighting conditions, is always more in shade than the lower. The outline of the base of the lower lip can be seen because of the shadow that it projects on the chin.

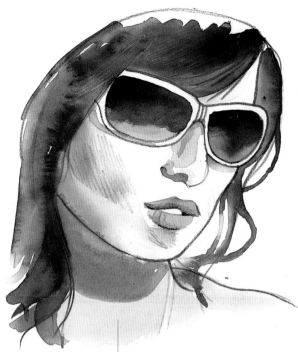

A smile causes tension and thinning in the lips. The row of teeth should be left white to indicate and emphasize the separation between them.

Women typically have smaller mouths than men, and their lips are fleshier and have a more sensual line.

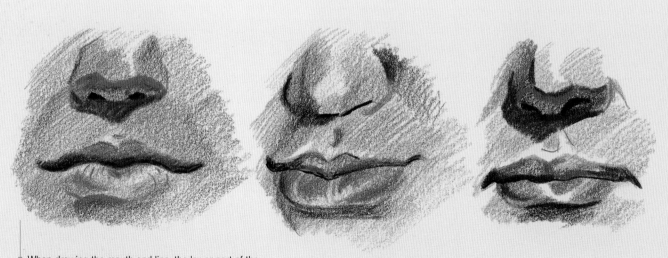

When drawing the mouth and lips, the lower part of the nose and part of the chin should be included.

The Ears

The ears are the least appreciated part of the face; young painters generally pay little attention to them. To properly resolve the drawing of the ear, you must only approximate its basic structure: its oval shape and concave volume. Seen from the front, the ears are a continuation of the plane of the face, but when seen from behind, they stand out from the plane of the back of the neck. The complicated relief inside the ear should not present any problems. Looking at the face from the front, it is important to note the complicated internal relief of the ear. Be careful. The cavities should not be represented with shading that is too dark; they should look like pictorial planes, not holes.

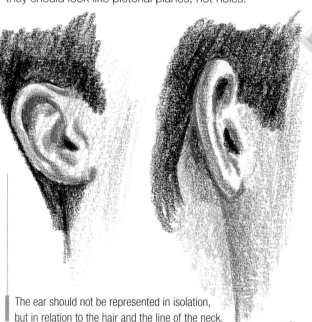

The ear should not be represented in isolation, but in relation to the hair and the line of the neck.

It is a curious fact that young artists tend to make the ears disappear, converting them into one of the least considered elements of the face.

To understand the shape of the ear, you must make studies from different points of view because their appearance changes substantially.

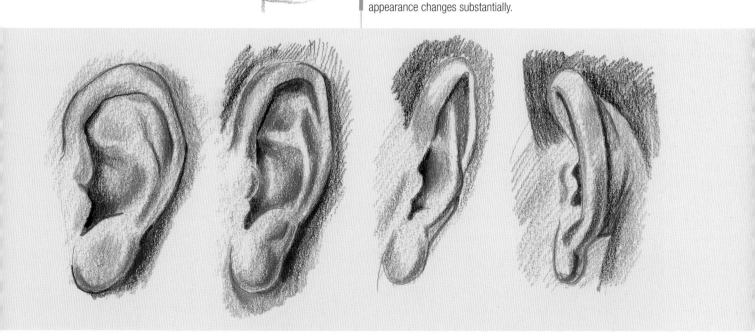

Achieving **a Likeness**

Up until now, we have been talking about a general representation of the face and the facial features in a general way, giving the novice artist several approaches to making a mental scheme that will allow him or her to carry out, after making the necessary adjustments, a portrait of an individual. In this section we give you further advice that will help you achieve a close likeness of the portrait model. The advice that is offered here relates specifically to aspects that should not be overlooked.

Measure and Compare

To place the facial features correctly, you must "capture" the shape of each one of them, developing them as individual parts. It is important to pursue perfection in the features, attempting as many times as is necessary to achieve a likeness, joining lines and constantly comparing the distances so that they can be adjusted to those of the model. It is a slow process that requires many corrections, but the result is very gratifying.

Accurately blocking-in and correctly measuring the position and size of each facial element are the keys to achieving a likeness.

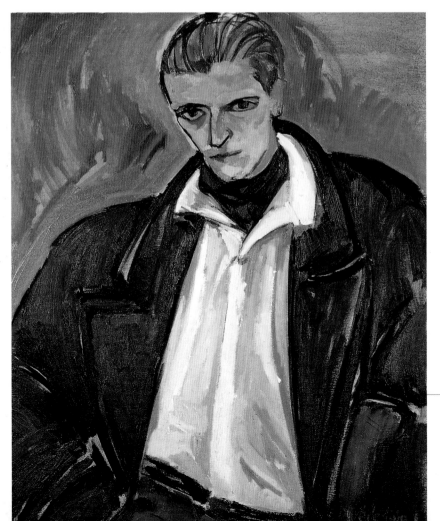

Make a Caricature of the Model

You are not a good artist unless you can penetrate the spirit of the model; therefore, you must try to capture the character by observing the facial features, and specifically their disproportions. In all individuals is hidden a caricature that must be captured. The painter should be a good physiognomist to catch it.

Exaggerating a specific attitude and even making a caricature of some aspects of the face can be a good way to make a recognizable portrait of the model.

The Pose of the Head and the Body

You must look closely at the head to characterize the model. The body should not follow its movement. Before starting, it is a good idea to study the physiognomy of the model, his or her character, and exaggerate it if necessary. A strong man should not just look like one; you must make him a herculean character. In this sense the pose adopted by the person should be adapted to his or her age (there are habitual poses for each age).

The Most Appropriate Shading

It is not the brightly lit area and the highlights that distinguish the model; rather, it is the halftones and the strong shadows. When you construct the face, you must carefully observe the edges of the shadows with the middle tones. You must avoid using too many highlights and reflections of color that can destroy the unity of the painting. Portraits of men can be well defined and have contrasting shadows that instill them with character; on the other hand, portraits of women should not be very dark, but rather as light as possible.

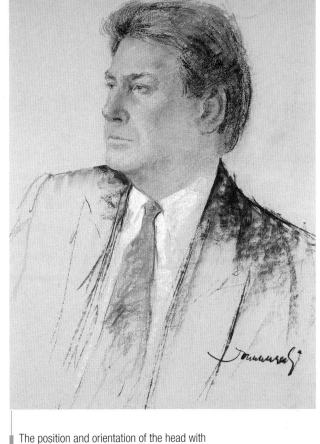

The position and orientation of the head with respect to the body is very important, especially in representations of half figures or busts.

In female figures the shading should be very light, with little contrast, and have progressive gradations that communicate a sense of firm skin.

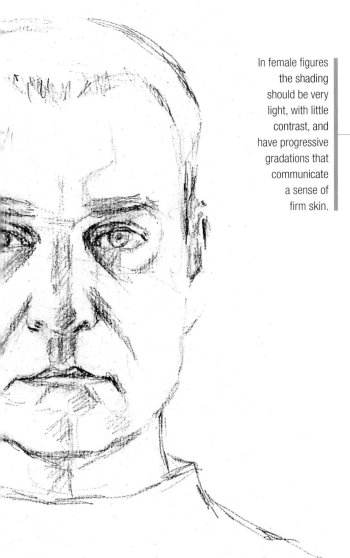

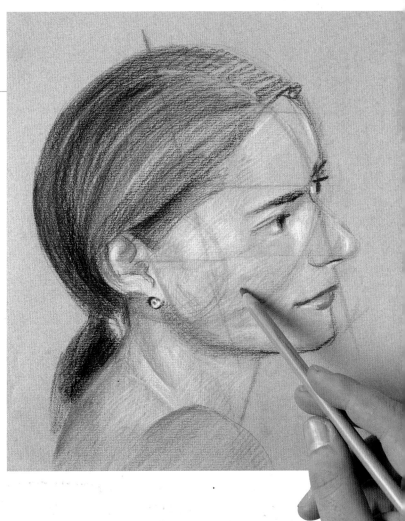

Representing Infants and the Elderly

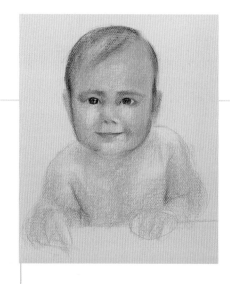

The canon for constructing the human head is adequate for representing a basic adult face; however, the heads of infants and elderly people have variations that should be commented on. The rapid growth of an infant and the effects of age change the shapes of the eyes, the nose, the mouth, and the ears considerably. A close look at what happens to the features during the different stages of the human being allow us to identify these variations and better capture them in portraits.

The features of an infant are very delicate, and the skin is very smooth, which can be represented by modeling.

Faces of infants are characteristically round, with large eyes, a small nose, and rosy cheeks.

In proportion to their bodies the heads of children are larger than those of adults.

The Infant Face

Children have much larger heads in proportion to their bodies. Their round faces also are substantially different with respect to adult individuals. The forehead is high, clear, and sometimes even more prominent and rounded. The eyes are large in comparison to the face, and the distance between them is greater than that of an adult. The ears, while proportionally larger, are located lower on the head. The nose is small, and the nostrils are more visible; the chin is round and not very prominent. The mouth is small and fleshy, and the cheeks are rosy and round.

Portraits of the Elderly

Representations of people of advanced age offer more artistic possibilities than portraits of models of any other age. This is because the facial elements are larger and more prominent; the features have become much more noticeable, with more very evident points of reference that make it easier to construct and draw the face. Representing individuals in this age group also can be fitted to the canon of the human head, but with a few physical differences that should not be ignored: a higher forehead resulting from a propensity to baldness, more visible bone structure of the cranium, more angularity in the temples, sunken ocular cavities, slack and loose skin, and an accentuated relief in the cheekbones. All these elements convert the portrait of a senior citizen into an experience bordering on a caricature.

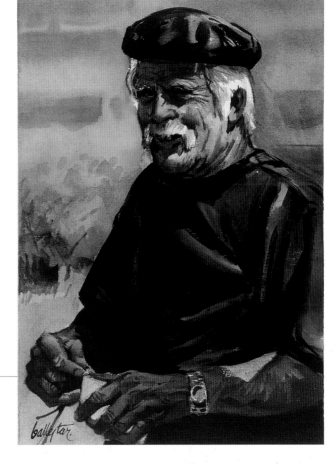

The prominent wrinkles in the forehead, around the eyes, and on the cheeks create many opportunities for developing strong contrasts in shading.

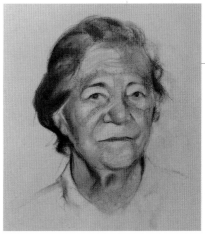

The looseness of the skin changes the look of an elderly woman's face, causing bags under the eyes and a sagging chin.

The face is the part of the body that shows age the most; the skin becomes loose, and the cranial structure is more evident.

A Male Head **in Oils**

Next we will show you how to construct the volumes of a male face with different values to create the flesh tones. The work is done in oils with barely diluted paint to enable blending values and modeling forms, creating smooth luminous transitions on the face. The modeling shows a slightly lateral light that projects enough shadows to cause the volumes of the face to stand out.

This portrait follows the classic compositional norms; it is slightly off center, with contrasting shadows and a light background that silhouettes the figure.

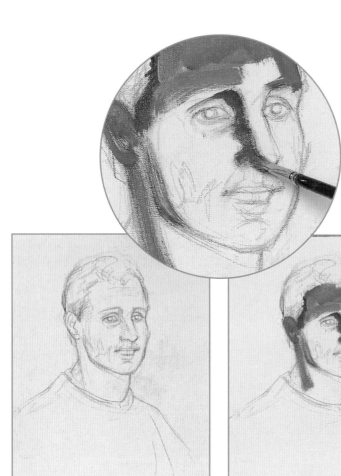

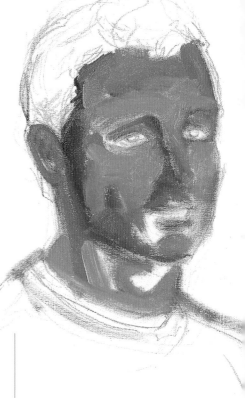

1. Draw the general outline of the bust with a graphite pencil and detail the facial features, carefully constructing the proportions. The pencil lines can be erased and corrected as many times as necessary until you achieve a likeness of the model.

2. Paint the flesh tones and modeling of the head with a mixture of burnt sienna, ochre, and carmine in different proportions, based on whether the tones have to be lighter or darker.

3. The shadows are of a redder tone, because they contain more carmine in the mixture; the lighter zones on the cheekbones have more ochre. The eyes and the mouth are left unpainted; they will be painted later in more detail.

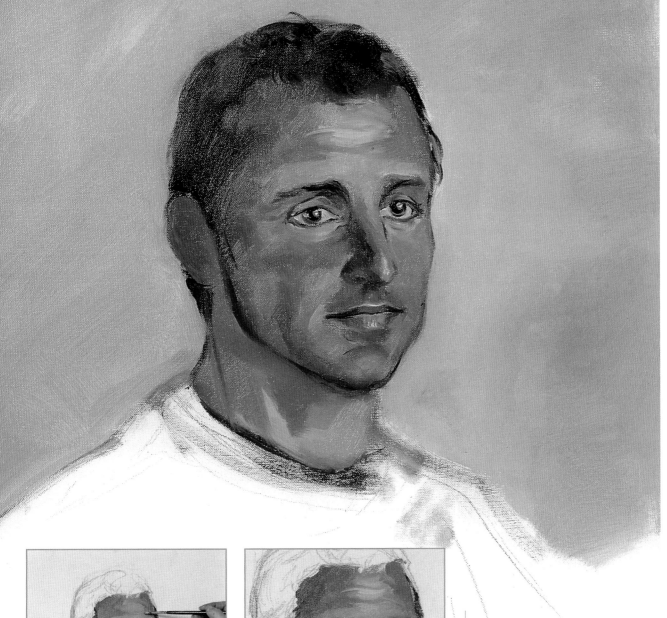

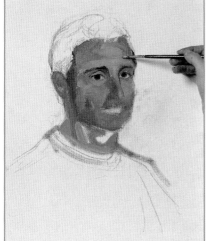

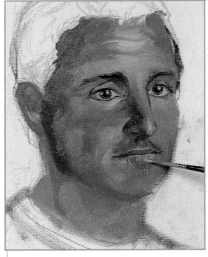

4. The forehead is painted with a very light color. The paint should be increasing in thickness. Use a fine brush and burnt umber with black to emphasize the shapes of the eyes and the eyebrows, areas of great importance for achieving a likeness and expression in the portrait.

5. The coloring of the head is quite advanced, and the flesh tones are looking more natural. Now is the time to resolve the mouth with a fine brush. Paint the line of the mouth and then the lips; the tone of the lower lip should be lighter than that of the upper one because it receives more light.

6. Prepare a plain gray and use it to cover the entire background. All that is left to finish the head is to paint the hair, using burnt umber, black, and sienna. Use this color to paint his outline against the greenish background, so that the painting has a finished look. The tee shirt is left unpainted, to give the painting a sketched feeling.

Constructing the Head
with Brushstrokes

Now you must put aside any respect you have for this genre and attempt to construct the face of a female model with strokes of different colors, blended together with the brush to model the flesh tones. We recommend that you consider this exercise a test or experiment, to practice constructing the face and controlling the colors to show the incidence of light and the volume of the head seen from the front. It is obvious, of course, that painting a portrait without having a mastery of drawing skills will probably not be a successful exercise, but for learning it is best to concentrate, at the moment, on the painting process, applying the color and the directions of the brushstrokes, and enjoying it.

The portrait will be easier if the light comes from the side and the face has a greater contrast of light and shadow.

2. Begin to carefully apply the first brushstrokes, without hiding the pencil drawing, which should remain visible until the portrait is quite advanced. Work with a fine brush making small brushstrokes, and avoid covering the outlines and edges.

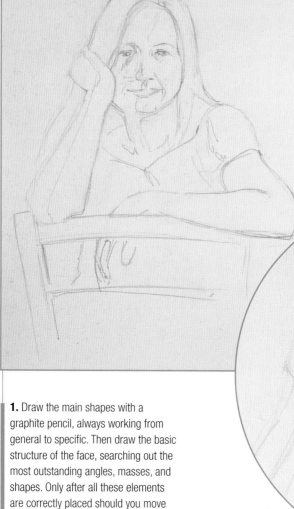

1. Draw the main shapes with a graphite pencil, always working from general to specific. Then draw the basic structure of the face, searching out the most outstanding angles, masses, and shapes. Only after all these elements are correctly placed should you move on to the small details.

3. Mix a pink flesh tone with carmine, white, and burnt sienna, and apply it to the shaded part of the face. Then add a little burnt umber and a larger amount of sienna to emphasize the shadow of the nose. The variations in color, like the yellow tone on the forehead, should be integrated by blending it with the previously applied colors.

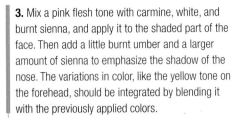

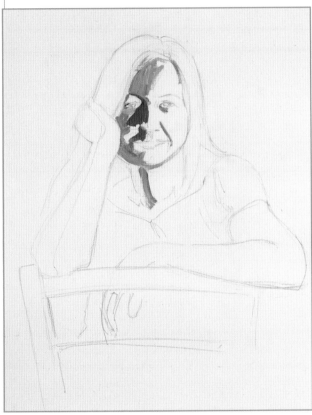

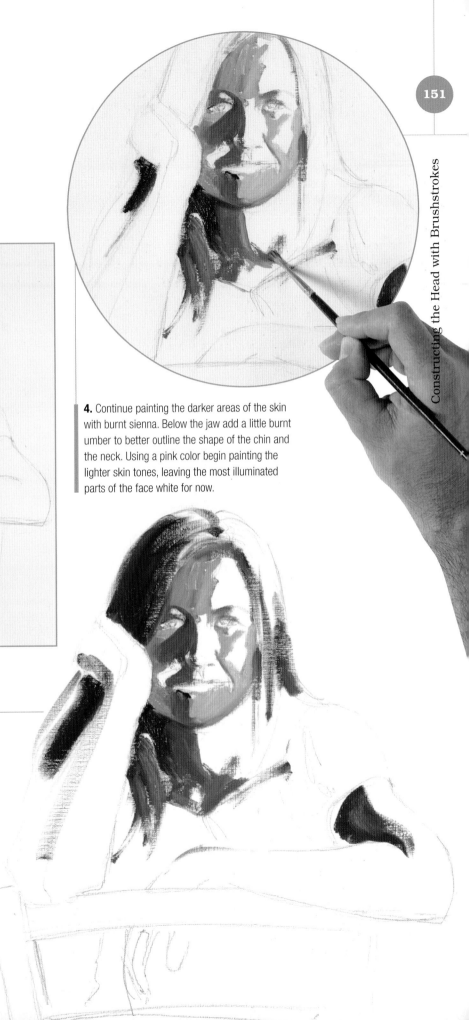

4. Continue painting the darker areas of the skin with burnt sienna. Below the jaw add a little burnt umber to better outline the shape of the chin and the neck. Using a pink color begin painting the lighter skin tones, leaving the most illuminated parts of the face white for now.

5. Sketch in the hair with raw sienna mixed with some burnt umber. It is important that the brushstrokes go in the same direction as the hair. In this first phase the dress should be left alone; just concentrate on rendering the color of the skin and the effect of the volume of the figure.

Constructing the Head with Brushstrokes

6. Do not leave the details for the end. They can be incorporated as you progressively add more strokes of paint. Using a round brush with a very pointed tip, indicate the shapes of the eyes with dark lines, mixed from violet and burnt umber. Mark the arch or the eyebrows very lightly and the shape of the eyes with a brighter and more contrasting tone.

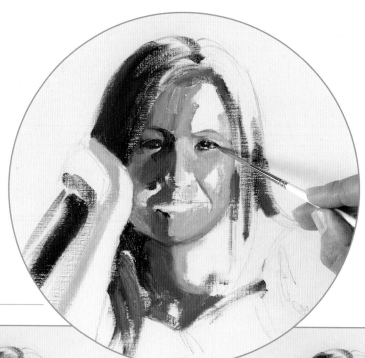

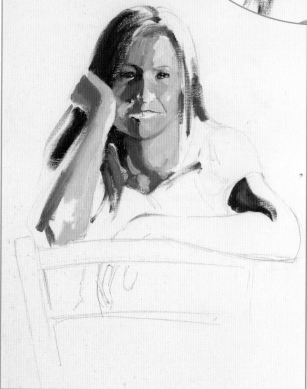

7. The color for the most brightly lit parts of the face is based on a very light pink. The three tones that describe the skin on the arm are clearly differentiated; they are three diagonal stripes that have not yet been blended. Do not be in a hurry to blend the colors; it is better to continue adding brushstrokes.

8. Use a dry brush to do some blending on the lightest skin tones of the neck and arm, where it is in sharper contrast to the shadow. The colors will mix by just caressing the fresh paint with the brush hair. Indicate the shaded parts of the dress with a mixture of violet, white, and raw sienna. The brushstrokes should follow the natural folds of the dress.

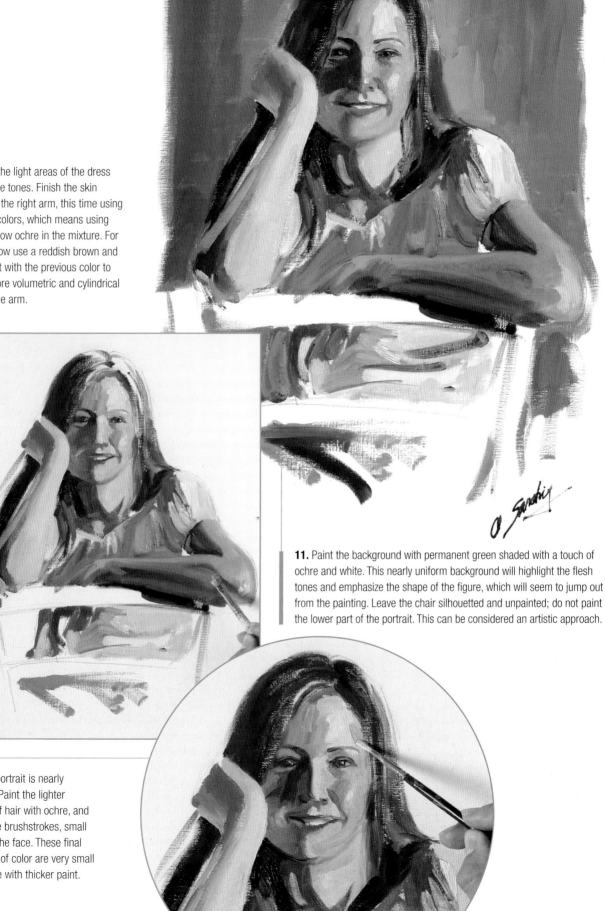

9. Paint the light areas of the dress with beige tones. Finish the skin tones on the right arm, this time using warmer colors, which means using more yellow ochre in the mixture. For the shadow use a reddish brown and gradate it with the previous color to add a more volumetric and cylindrical look to the arm.

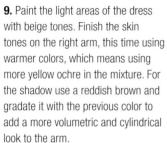

11. Paint the background with permanent green shaded with a touch of ochre and white. This nearly uniform background will highlight the flesh tones and emphasize the shape of the figure, which will seem to jump out from the painting. Leave the chair silhouetted and unpainted; do not paint the lower part of the portrait. This can be considered an artistic approach.

10. The portrait is nearly finished. Paint the lighter strands of hair with ochre, and add some brushstrokes, small dabs on the face. These final additions of color are very small and made with thicker paint.

Watercolor of **a Young Girl**

Children's portraits are notably different from those of any adult. The faces do not have the hard features that adults have. The shape is rounder, the size of the head is larger in comparison to the rest of the body, the nose is small, the cheekbones and chin are less prominent, the extremities are chubbier looking, and the hands are shorter and rounded. It is important to pay attention to these characteristics when making a preliminary pencil drawing, so that the finished drawing matches reality. All this should be combined with an accurate rendering of the flesh tones and the dress. We will be using watercolor for this exercise.

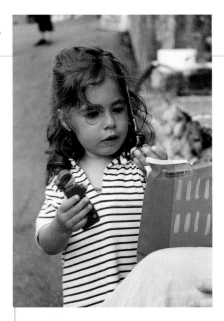

The goal is to paint a very young girl with a striped dress, applying the watercolor washes over a pencil drawing.

1. Carefully draw the outline with a graphite pencil. The drawing will serve as a reference during the entire painting process, in which you will be working with light watercolor washes. The drawing of some parts, like the hair, will be left unfinished, since it is an area that is not well defined and will not be addressed directly with a brush.

3. On this base of dry paint add new washes to darken the shadows of the skin tones on the face and arm; on the face you see the shadow of the orbital. Paint the main shadows on the dress with Payne's gray.

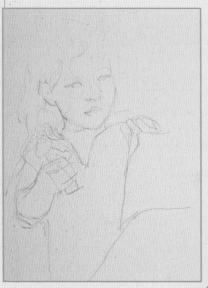

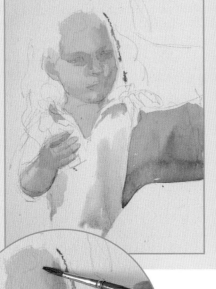

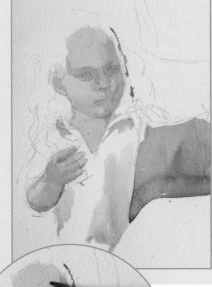

2. Paint the base colors on the face with a mixture of ochre and raw sienna and on the blue bag on the right with cobalt blue. Add the shadows over the still damp uniform wash on the face, using burnt umber.

4. Prepare a wash with Payne's gray and a touch of dark green, and cover the background with it, alternating strokes of dense color with others of diluted paint to create an irregular distribution of the colors. You do not have to be careful around the outline of the head since the hair still has to be painted.

Using Wax Crayons

Before applying a color you should decide whether you are going to make reserves with an eraser or with wax crayons, since both media repel water. All watercolorists carry with them several crayons of different colors for use on small details that will remain unchanged during the painting of the picture.

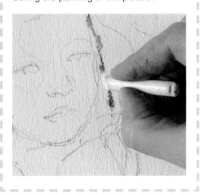

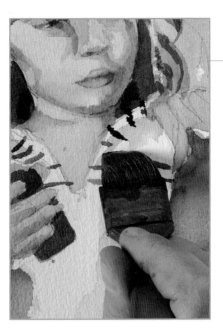

6. Use a medium flat brush and a mixture of blue and Payne's gray to paint the stripes on the dress. The bands should not be painted with a single tone. In the illuminated areas the gray is lighter and bluer, and the lines are finer; in the shaded areas the gray is mixed with a little carmine, and the stroke is thicker.

7. The background of the figure seems undefined, which helps concentrate the attention on the girl's face. Strengthen the shadows on the blue bag and on the wood figure that the little girl is carrying in her hand with a couple of blue and violet tones. The result is suggestive and spontaneous without details or lots of colors.

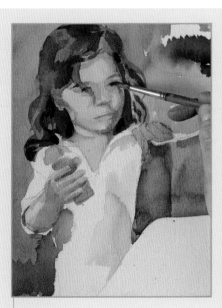

5. Paint the hair with a mixture of burnt sienna and burnt umber. The brushstrokes should follow the direction of the wavy hair without completely covering the gray background. Also paint the eyes with a brush that has a very fine tip.

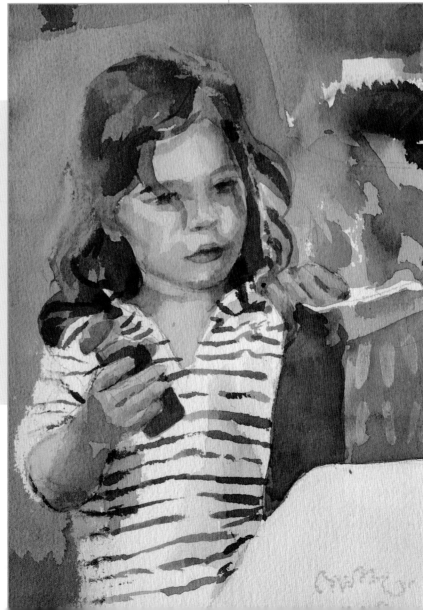

Watercolor Portrait with a **Linear Style**

When painting a portrait, it is normal for the paint to hide the detailed preliminary drawing. The exercise shown here is based on using the drawing as the point of the work, conceived as a guide, a structure that not only will be visible until the end but also will be strengthened and emphasized with washes. This means that, as the color is added, it will highlight the drawing with lines painted with a fine brush, giving it a permanent, discrete, and decisive presence in the final phases.

The model is a male figure in an interior with a natural pose and with no strong contrasts.

REPEATED APPLICATIONS OF DIFFERENT COLORED LINES CREATE VERY FLOWING AND NATURAL AREAS.

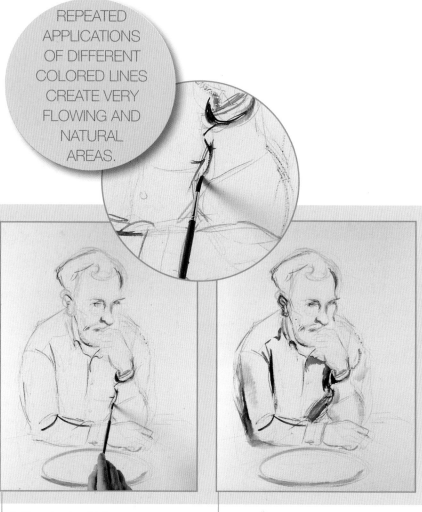

1. When drawing, it is important to pay attention to the structure, the basic forms of the body, the positions of the arms, and the layout of the head. Use a very fine round brush charged with Payne's gray to go over the lines of the pencil drawing.

2. The first brushstrokes should organize the positions of the hands, the folds, and the lines of the shirt. From the beginning the washes should be of a very restricted range of Payne's gray, violet, and burnt umber.

3. Use sienna and burnt umber to draw the head and go over the features of the face. The hair should be painted with just a few loose brushstrokes. Paint an irregular wash of Payne's gray on the background to contrast with the figure.

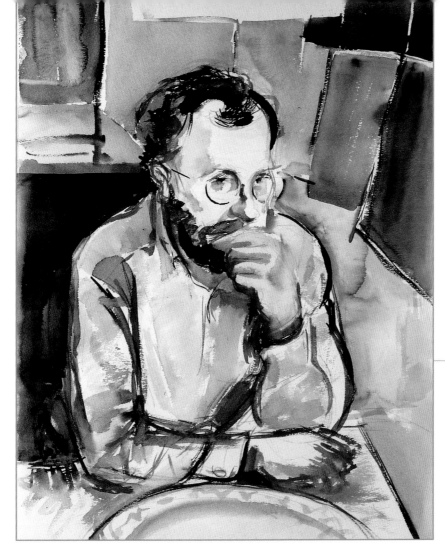

4. Although the head is the most detailed part of the work, the background should be constructed with large washes and saturated brushstrokes of barely diluted paint; just a few lines are enough to suggest the furniture in the background. Use a mixture of burnt umber and Payne's gray to tone down the most shaded parts of the figure.

6. In the last phase of the painting, the basic concern is giving form to the body with washes of different violet tones. These colors can be applied with a wide flat brush and very loose and free motions. Paint the eyes with a fine round brush and a light touch of blue, and then draw the inside edge of the glasses with utmost care.

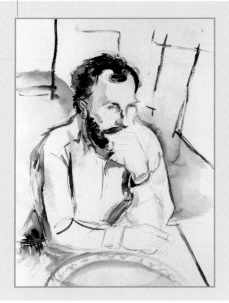

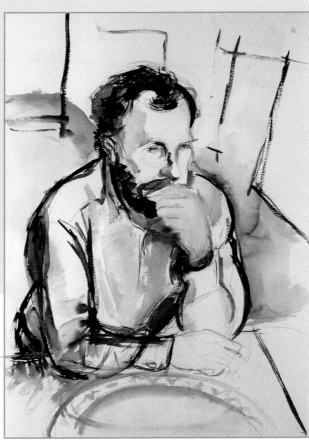

5. The hair is painted with very dark Payne's gray, in some areas mixed with burnt umber. The brushstrokes must imitate the curls and waviness of the hair and of the beard. The features are barely sketched with small strokes of brown paint that can be completed little by little.

Portrait of a **Senior Citizen**

We will end this book with the portrait of a senior citizen using a very expressive style that allows distortions and a wide margin of freedom in applying the colors. Seniors are good subjects for this kind of interpretation because their features are expressive, the wrinkles are very pronounced, and the bone structure can be seen in their faces and hands. We will use oils here; however, you can achieve similar results using acrylics or gouache.

We chose a model of advanced age, a subject that will open up numerous creative opportunities.

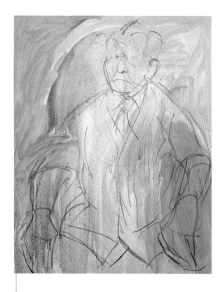

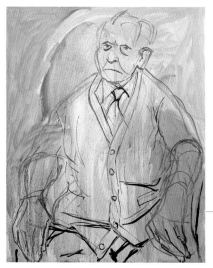

1. Paint the canvas with very bright, diluted colors: cadmium green, ultramarine blue, and ochre. Sketch the figure with a stick of charcoal, drawing the figure with large features without waiting for the paint to dry.

2. Complete the sketch with a brush charged with blue lightened with white. Try to clearly define the upper part of the figure and indicate the facial features. The drawing should be made with a certain amount of freedom; to stylize the figure the head and body have been slightly elongated.

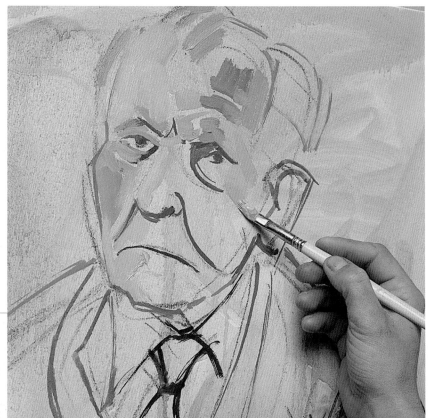

3. Construct the face with loose opaque brushstrokes, and give it volume using large flat strokes. Paint the illuminated side with applications of a light yellowish ochre tendency, while the shaded side should be resolved with strokes of a strong violet tone.

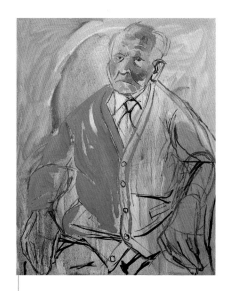

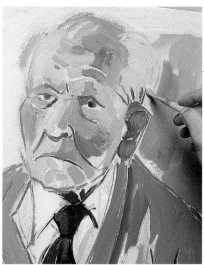

5. The work focuses on the face. Paint the ear with reddish colors, the cavities of the eyes with long brushstrokes, and the hair with pale pink. The background should be finished in two halves: more illuminated on the left with white mixed with a little ochre and the right with blue lightened with some white.

4. When painting the face or covering the jacket with blue, leave small spaces between the brushstrokes so that some of the colors of the background act as points of light on the face, the hair, and the clothing. The sweater is painted with three different blue tones, and the wrinkles can be treated very simply.

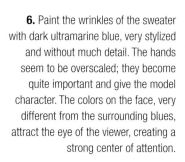

6. Paint the wrinkles of the sweater with dark ultramarine blue, very stylized and without much detail. The hands seem to be overscaled; they become quite important and give the model character. The colors on the face, very different from the surrounding blues, attract the eye of the viewer, creating a strong center of attention.

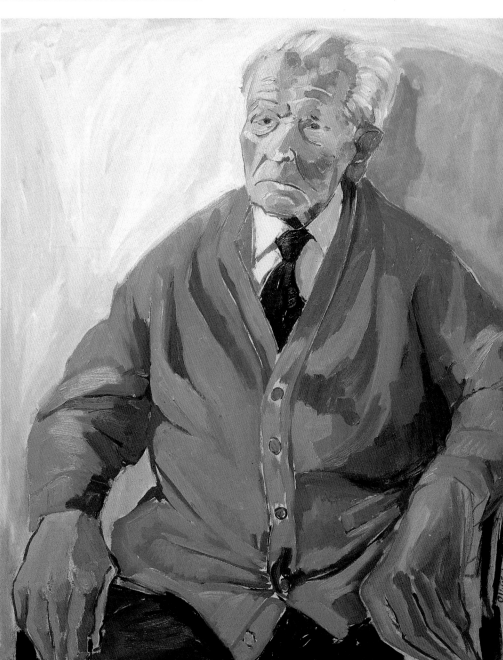

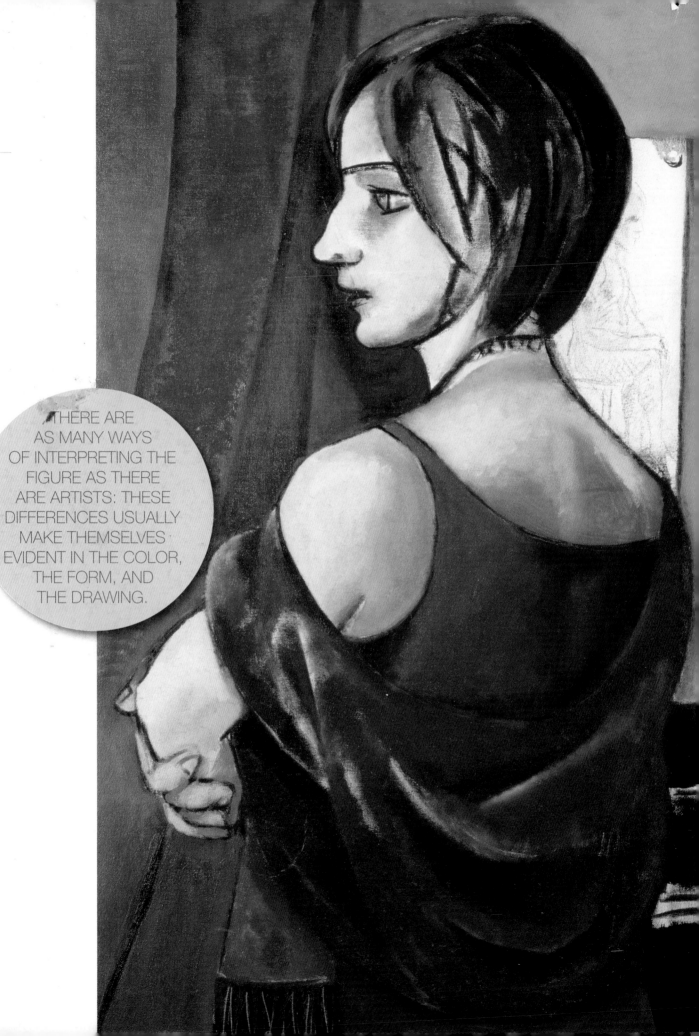

THERE ARE AS MANY WAYS OF INTERPRETING THE FIGURE AS THERE ARE ARTISTS: THESE DIFFERENCES USUALLY MAKE THEMSELVES EVIDENT IN THE COLOR, THE FORM, AND THE DRAWING.